PORTLAND
THEN & NOW

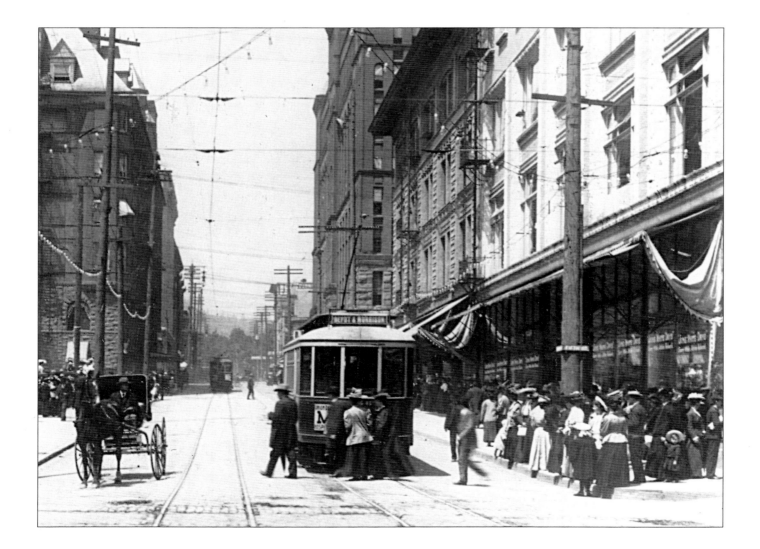

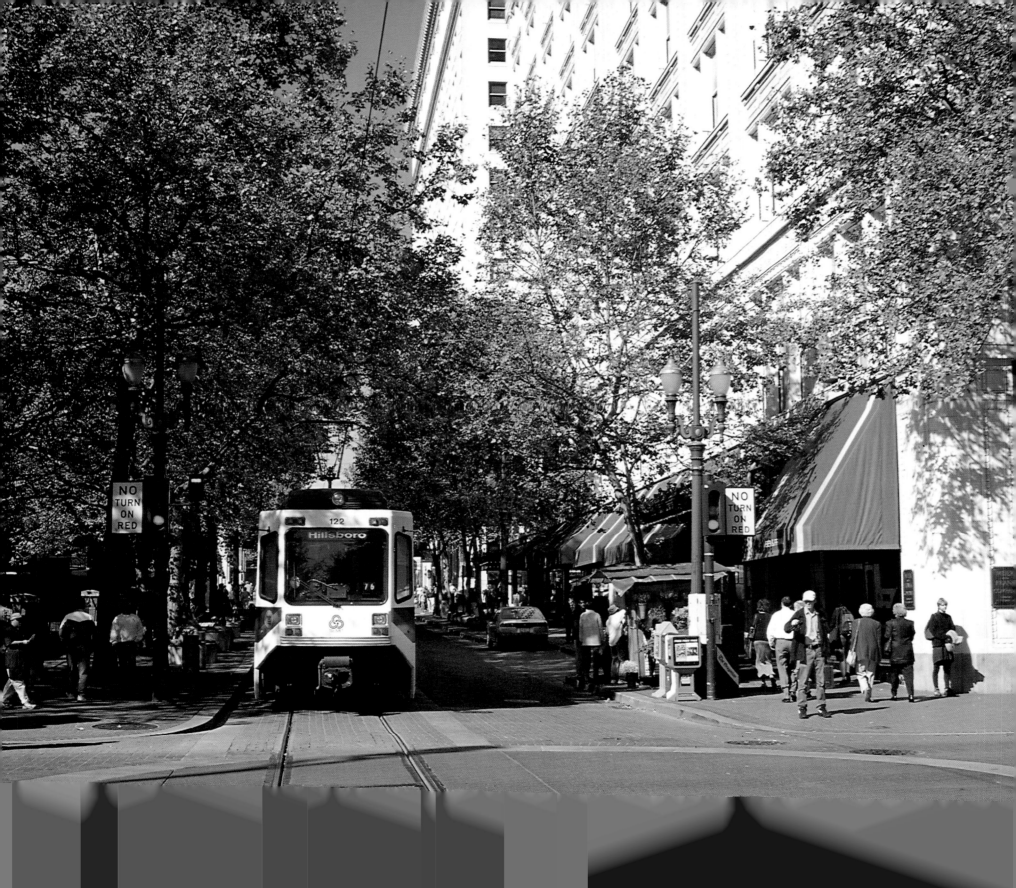

PORTLAND THEN & NOW

LINDA DODDS & CAROLYN BUAN

THUNDER BAY
P·R·E·S·S

San Diego, California

Thunder Bay Press
An imprint of the Advantage Publishers Group
5880 Oberlin Drive, San Diego, CA 92121-4794
www.thunderbaybooks.com

Produced by PRC Publishing,
an imprint of Anova Books Company Ltd.,
10 Southcombe Street, London W14 0RA, U.K.

ISBN-13: 978-1-57145-471-3
ISBN-10: 1-57145-471-3

Library of Congress Cataloging-in-Publication Data

Dodds, Linda.
 Portland, then & now / Linda Dodds & Carolyn Buan.
 p. cm
 ISBN 1-57145-471-3
 1. Portland (Or.)--Pictorial works. 2. Portland (Or.)--History--Pictorial works.
 3. Portland (Or.)--Buildings, structures, etc.--Pictorial woeks. 4. Historic buidings--Oregon
 --Pictorial works. I.Title: Portland, then and now. II. Buan, Carolyn M. III.Title.

 F884.P843 D63 2001
 979.5'49--dc21 2001017404

Printed and bound in China.

5 6 7 8 9 11 10 09 08 07

ACKNOWLEDGMENTS

Susan Seyl, Mikki Tint, Sharon Howe, Elizabeth Winroth, M. C. Cuthill, Todd Welch, Bob
Kingston, Steve Hallberg, and Sieglinde Smith, Oregon History Center; Brian Johnson, City
of Portland Stanley Parr Archives and Records Center; Judith Carroll, Albertina Kerr Center;
Rosalind Keeney and James Norman, Oregon Department of Transportation; Tim Hills,
McMenamins Pubs & Breweries; David Spencer, Multnomah County Library; Robert Goldfield,
The Business Journal; Steven Fidel, Powells Books; Nancy Niedernhofer, Oregon State Historic
Preservation Office; Harriet Watson, Reed College; Pat Burns, Bank of the West; Julie Speetjens,
Portland Courthouse Square; Duane Morris, photographer; Amanda Barnes Ashley, Pioneer Place;
Doug Obletz, Shiels Obletz Johnsen; Dennis Wilde, Gerding & Edlin Development; Arthur
McArthur, Jantzen; Gordon Dodds, Portland State University; Beth Sorensen, Portland Art
Museum; Sandra Strohecker Brubaker, Strohecker's; and Cielo Lutino, City of Portland Bureau of
Planning.

PHOTO CREDITS

All the black and white photography for this book was kindly provided by the Oregon
Historical Society except where individually credited (see the end of each caption for credits and
negative numbers).

Thanks to Simon Clay for taking all the color photography for this book with the following
exceptions:

© Warren Morgan/CORBIS for page 9;
© Duane Morris for page 41 (inset), courtesy of Pioneer Courthouse Square.

For jacket photo credits please see inside flap.

INTRODUCTION

Portland is a city of monikers. In its infancy it was called "Stumptown," for its inhabitants' hasty logging practices. In the late nineteenth century, bridges finally spanned the Willamette River, uniting Portland with East Portland and Albina, and the city became known as "Bridgetown." When boosters sought to portray its natural beauty, they called it "The Rose City." Whatever the name, Portland has always been a vibrant place with a strong sense of its own worth. Buoyed by the dreams of promoters, a natural resource-based economy, ready transportation, and the creative instincts of able architects, the city grew in a visually interesting way. Thanks to the tenacity of historic preservation interests and sometimes enlightened public policy, that visual record remains partially intact. With a complement of new buildings, Portland has arrived at a pleasing age when the "then" of the past is compatibly balanced with the "now" of today.

Portland's founding can be traced to 1843, when two settlers, William Overton and Asa Lovejoy, pulled their canoe into a forest opening on the west bank of the Willamette River, surveyed their surroundings, and decided to file a claim. When Overton's share passed to Francis Pettygrove, the new partners improved their property by expanding the clearing and building a log store at the foot of present-day Washington Street. The next year, they platted a sixteen-block town site along the river and reached back to their New England heritage for a name. Pettygrove, from Maine, preferred Portland; Lovejoy, of Massachusetts, suggested Boston. The decision rested on the flip of a copper coin that dropped in Pettygrove's favor. Portland it was.

The first frame house, prefabricated in Maine, was erected in 1847. By 1850 nearly 200 log and frame buildings were knitted together by streets dotted with stumps—sometimes whitewashed to avoid nighttime accidents. Now the settlement, with additional blocks and more than 600 residents, had begun to resemble an East Coast town, with a number of wharves along the river and newer homes in the latest architectural styles uphill. In 1851 the city was incorporated.

The first brick commercial structure appeared in 1853, followed the next year by the first building with cast-iron features. So great was the appeal of cast iron, with its capacity for ornate embellishment, that by the 1860s the city had acquired a rather sophisticated, almost European, appearance. Many of the leading architects who designed these creations were from the East or had been educated in Europe, where building innovations were widely embraced.

Despite disastrous fires that leveled twenty-five city blocks in 1872 and 1873, investors and businessmen in the 1870s and 80s erected even more elaborate cast-iron buildings, extending them five blocks west of the river. But by 1889 cast iron's appeal was waning, to be replaced by other architectural expressions. Nevertheless, into the 1930s and 40s a large stock of these "architectural pioneers" existed in Portland. Today, some twenty survivors remain, forming the largest collection of cast-iron buildings outside of New York's Soho District.

On the east side of the Willamette River, development occurred at a steady but slower pace after James Stephens initiated a ferry service in 1855. In the 1870s and 80s the east-side waterfront contained warehouses and docks while the land beyond was dotted with modest buildings. With the erection of the Morrison Bridge in 1887, horse cars that were already serving Southwest First Street began running along the streets—and into the soon-to-be annexed suburbs—of East Portland.

Despite periods of financial crisis, the 1890s saw an architectural watershed for the city. With her population now reaching 46,000, Portland boasted large, impressive new buildings, many in the American Richardsonian Romanesque and European Revival styles. One of the first was the Portland Hotel, a huge edifice that made a grand statement about its sponsors' expectations.

At the close of the nineteenth century, greater Portland contained 90,000 people. Five years later, the city hosted the Lewis and Clark Exposition. The fair brought the city to the attention of a larger public and by the end of the decade, Portland held more than 200,000 residents. Many lived in apartments and boarding houses, and the east side in particular grew as streetcar lines and four bridges provided the new neighborhoods with ready access to the heart of the city.

In the commercial center, a new wave of construction beginning in 1907 brought the light color and ornamental details of architectural terra cotta. The earliest of these buildings was the city's first skyscraper, the twelve-story Wells Fargo Building, but other dazzling examples soon followed, including the new Meier and Frank Department Store Building, the Seward Hotel, the Journal Building, and the U.S. Bank Building. The last was the black and gold art deco Charles F. Berg store, in 1930. Now approximately forty architectural terra-cotta buildings remain in downtown, comprising one of the largest concentrations of their type in America.

Following the terra-cotta period, construction downtown stagnated through the 1950s, although the groundbreaking glass and steel Equitable Building of 1948 introduced the Corporate International style to the city. Less than a decade later, planners began to devise an urban renewal program for the decayed downtown fringe and soon demolished many of the city's oldest buildings to make way for new development. Portland began to be thought of as an urban experiment, and ideas for producing a functional, aesthetically pleasing, and livable downtown abounded.

In the 1970s and 80s Tom McCall Waterfront Park was laid out along the Willamette River, a pedestrian-friendly transit mall was built downtown, and the Metropolitan Area Express, or MAX, light rail system provided a new form of public transportation. In the center of the mall, an ugly parking lot was transformed into the popular Pioneer Courthouse Square—a public space that features a whimsical mix of architectural elements and public art.

During the past two decades, a booming economy has added large office towers and public buildings to the city. Their varied textures, uses of glass, and silhouettes represent a Portland of "now" that provides a suitable background for the Portland of "then."

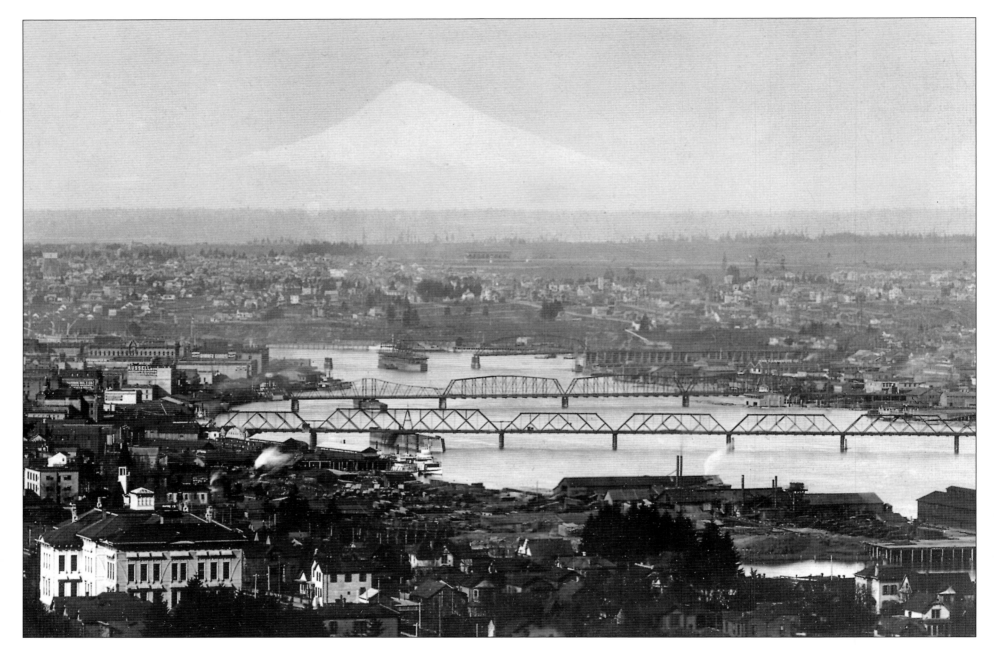

In 1894 Portland was a bustling port city, whose two halves were connected by four bridges (three of which are visible here). Prior to construction of the Morrison Bridge (second bridge, *center*) in 1887, East Portland and Albina on the east (*right*) bank and Portland on the west were separate cities. The three towns were consolidated in 1891. Visible in the background is Mt. St. Helens. *Oregon Historical Society, # OrHi 12420*

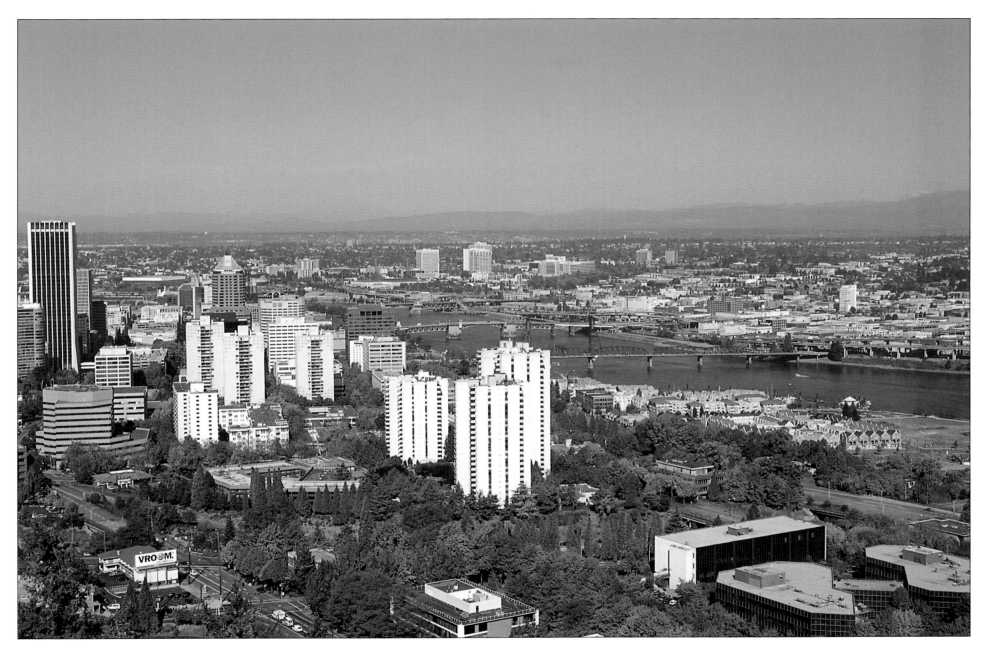

High rises, many of which were part of a major 1960s urban renewal effort, dominate the left foreground in this modern view of downtown Portland (*left*) and the inner east side (*right*). In the right foreground is the RiverPlace development, which includes a hotel, condominiums, apartments, shops, an esplanade, and a marina. Mt. St. Helens, minus its top since its 1980 eruption, is barely visible (*left of center*).

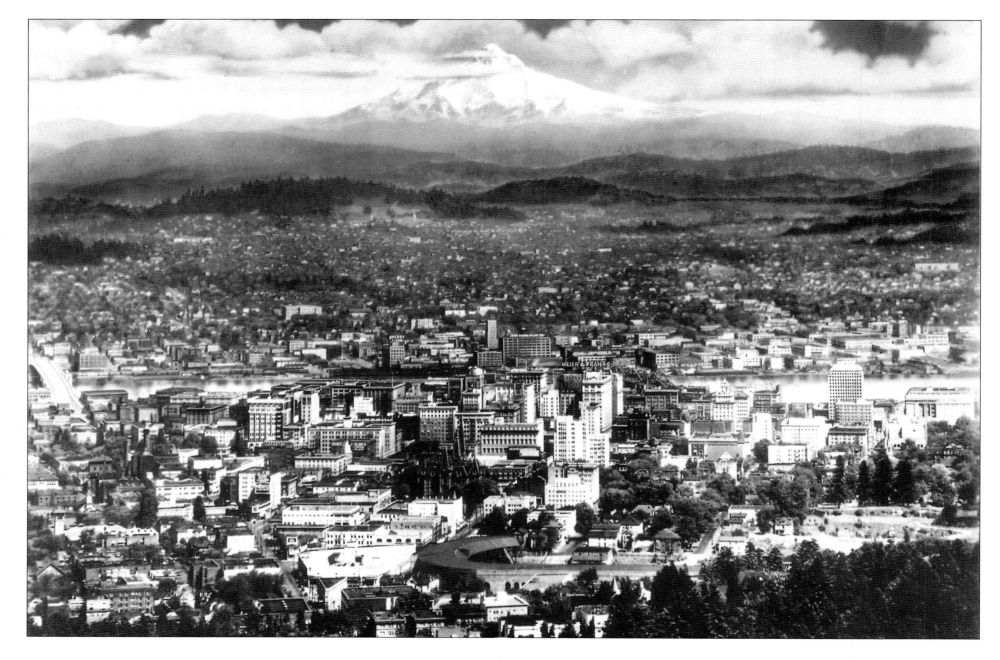

Mt. Hood, in the Cascade Range, looms above Portland in this 1928 view, which focuses on the city's downtown core. Here, several tall buildings fill the skyline—among them Meier & Frank, a locally owned pioneer department store whose neon sign is prominently displayed in the center of the photograph. The tall buildings of the city center contrast with the lower buildings across the Willamette River. *Oregon Historical Society, # OrHi 61553*

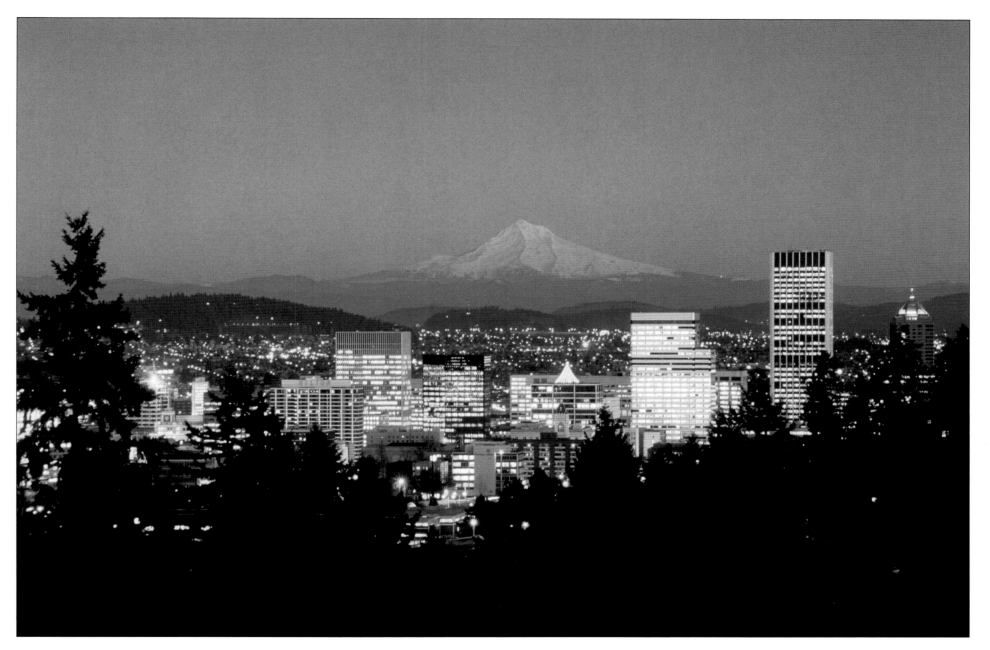

A technicolor sunset illuminates Mt. Hood and forms a dramatic backdrop to the twinkling lights of the downtown and inner east side. Recently named America's most livable city by *Money Magazine*, Portland enjoys a thriving economy, based in part on the many high-tech firms located in the nearby "Silicon Forest." The city is also within a short drive of Mt. Hood ski and hiking areas and the Oregon coast, with its free public beaches.

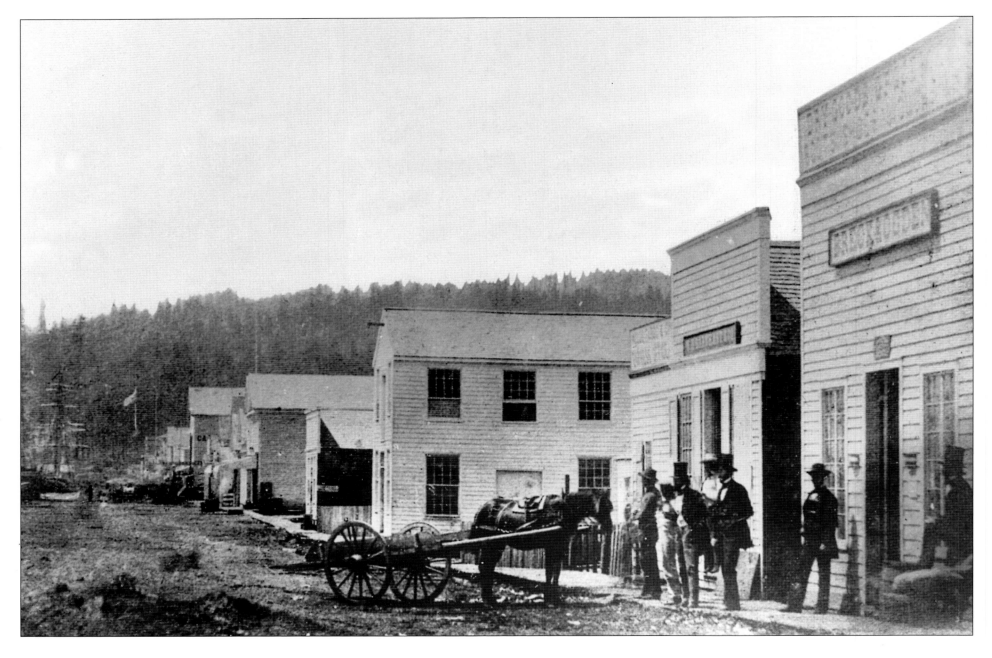

In 1852 Portland was a raw frontier village that clung to the banks of the Willamette River and centered on Front Street (*pictured here*) and First Street, one block west. Here, merchants in top hats pose by their white clapboard buildings, which housed such enterprises as a Chinese laundry, a hotel, a foundry, a bakery and confectionery, a newspaper, a stove and tin store, and a pharmacy. Note the ship's mast at the far end of the street. *Oregon Historical Society, # OrHi 949*

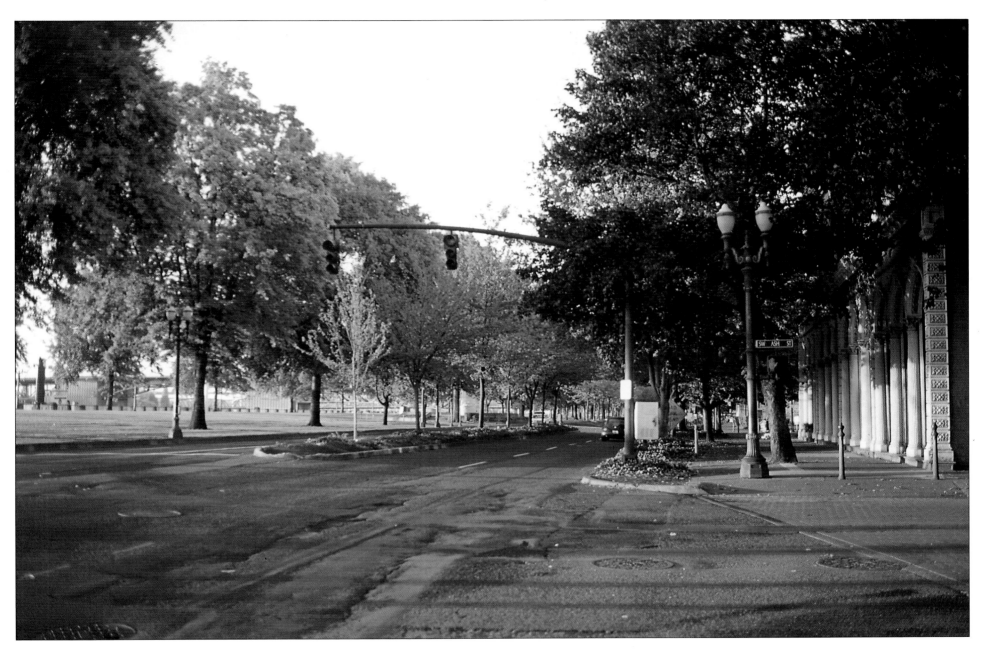

By the early twentieth century, ornate cast-iron-decorated brick buildings dominated Front Street, giving the growing city a European air. But today, little remains of Front Street's cast-iron architecture. As businesses moved away from the river, the area grew seedy and the grand old buildings were demolished to make way for parking lots and an expressway. The addition of Waterfront Park (*left*) and a parkway in the 1970s provided a place for strolling, recreation, and festivals.

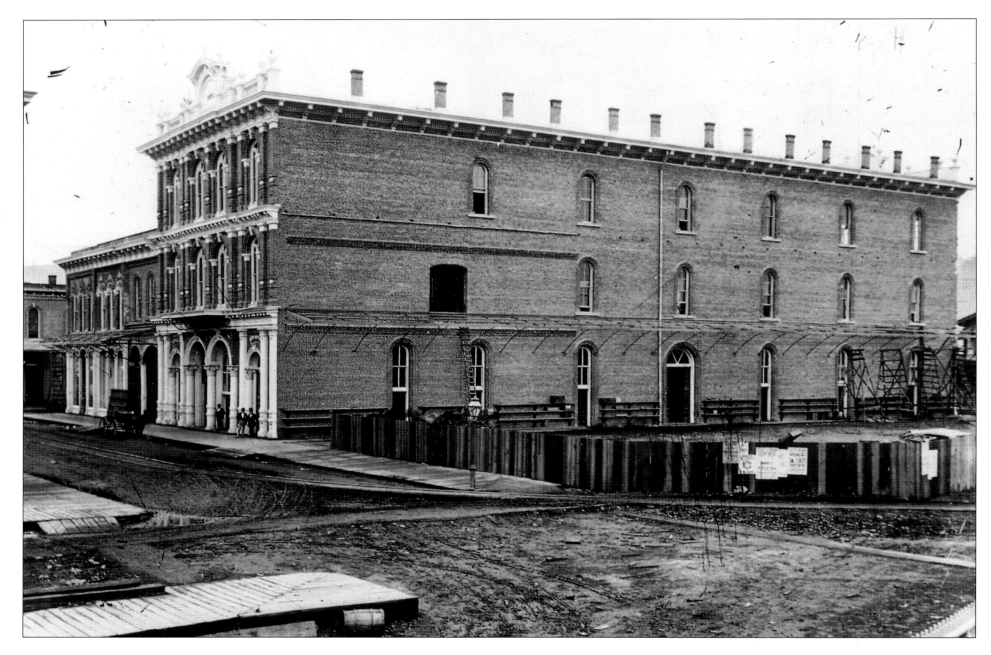

Despite its unfinished surroundings, the New Market Theater on First Street added a touch of class to early-day Portland. On the building's second floor, a plush theater hosted famous performers and dignitaries; at ground level, produce stalls with marble counters gave the city a first-rate public market. This 1873 photograph was taken one year after the main building was completed but before its elaborate north wing was added. *Oregon Historical Society, # OrHi 674*

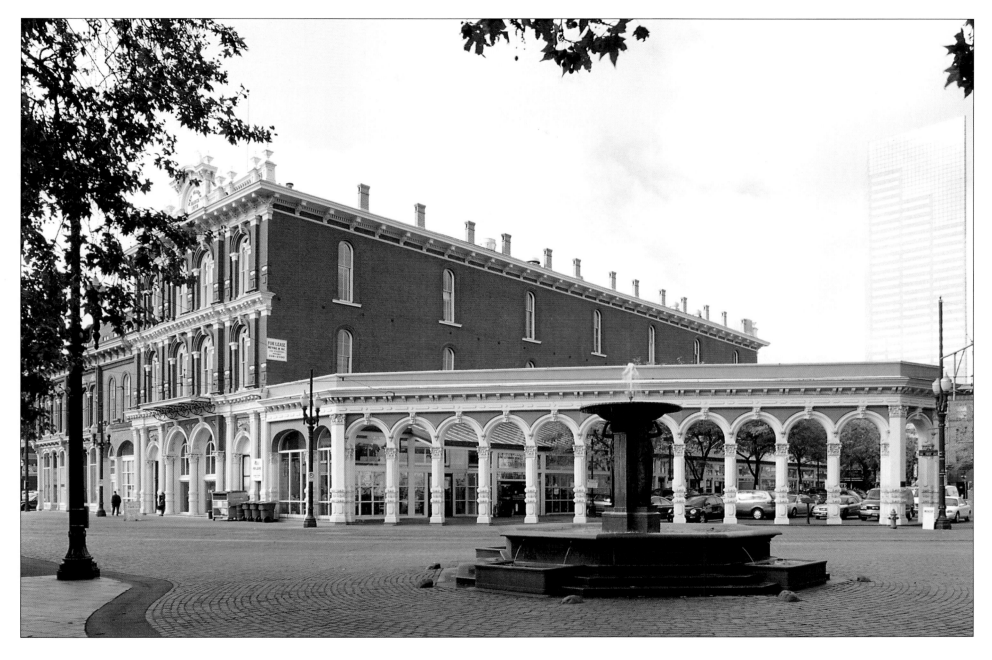

The New Market Theater, now an office and retail complex, incorporates arches from its old north wing in a long arcade. The north wing was demolished in 1956, and for many years the New Market was used as a parking structure. But in the 1970s it was restored as part of an effort by historic preservationists to establish the Skidmore-Old Town Historic District. In the background is the U.S. Bank Tower, known as "Big Pink."

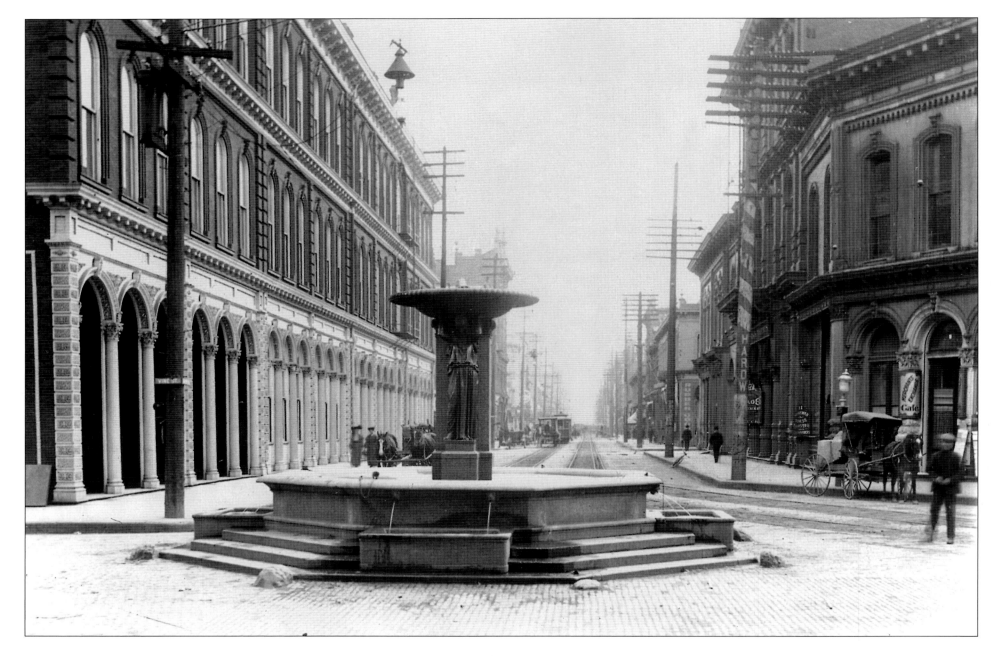

Looking south from Ankeny Street ca. 1900, this view of First Street is dominated by the Skidmore Fountain. The fountain was named after pioneer druggist Stephen Skidmore and completed in 1888 by leading New York sculptor Olin L. Warner with partial funding from Skidmore's estate. On the right the New Market Theater and on the left the nearly identical Ankeny and Lewis & Flanders blocks—both built in 1869—form elegant backdrops. *Oregon Historical Society, # OrHi 27417*

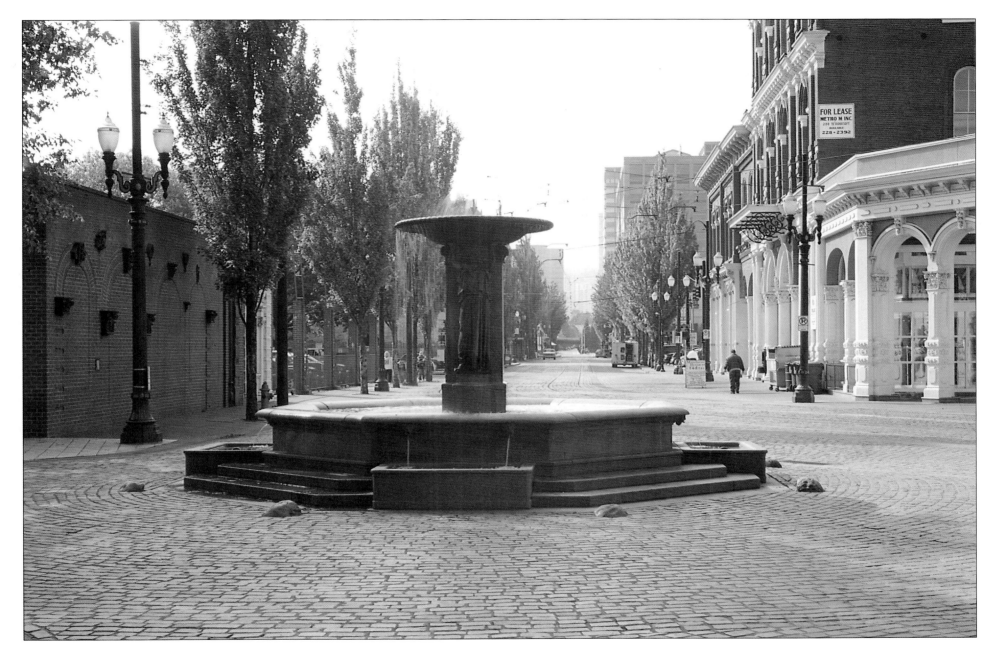

Ankeny Arcade, pictured on the left, memorializes Captain Alexander P. Ankeny, who built many of the city's brick and cast-iron buildings, including the New Market Theater (*right*). The Arcade occupies the site of the Ankeny Block, the state's largest brick building at the time of its construction in 1869, and incorporates elements of the cast-iron giants that were demolished by the mid-1900s.

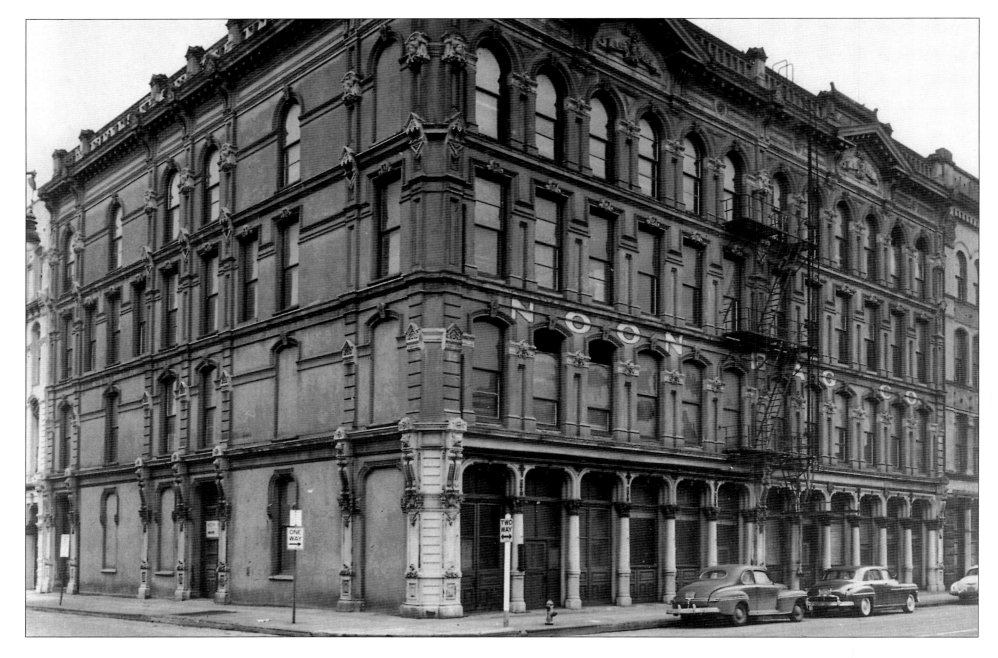

When the Blagen Block was built in 1888, it was an imposing commercial structure whose ornate colonnade of cast-iron columns was echoed by rows of columns in nearby buildings. At the time of its construction, the Blagen Block boasted a modern amenity—two steam elevators that took people and goods from the basement to the fourth floor. *Oregon Historical Society, # OrHi 59380*

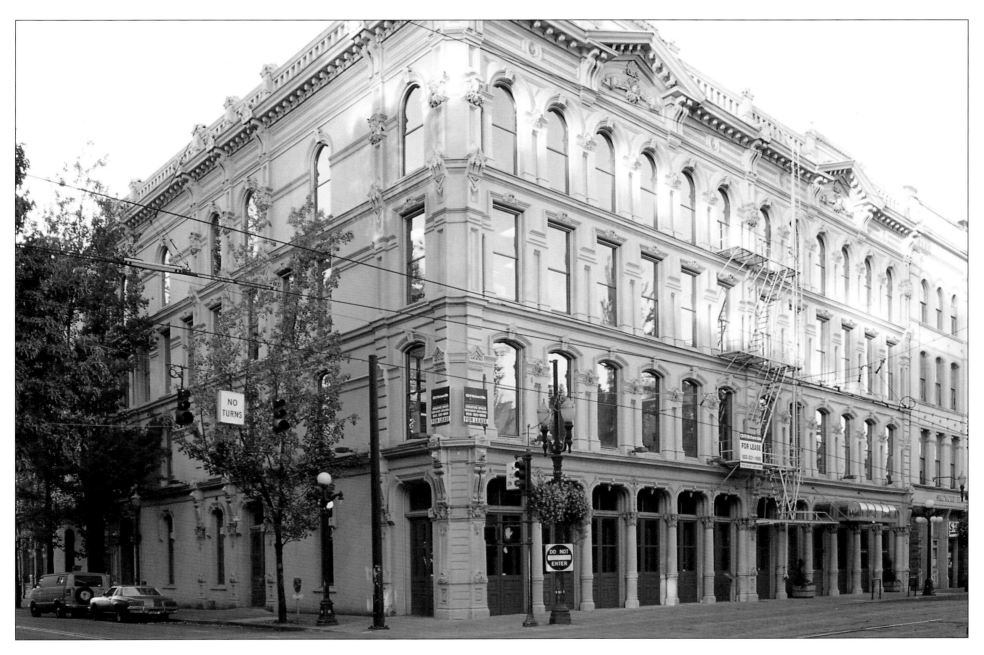

Once the location of the Noon Bag Co., the Blagen Block is now home to another long-term tenant, the Lighting Specialities Company. The building, which architect William Hawkins has called "the best remaining example of its type in the city and perhaps on the West Coast," was lovingly restored by his firm, Allen, McMath, and Hawkins, between 1980 and 1983.

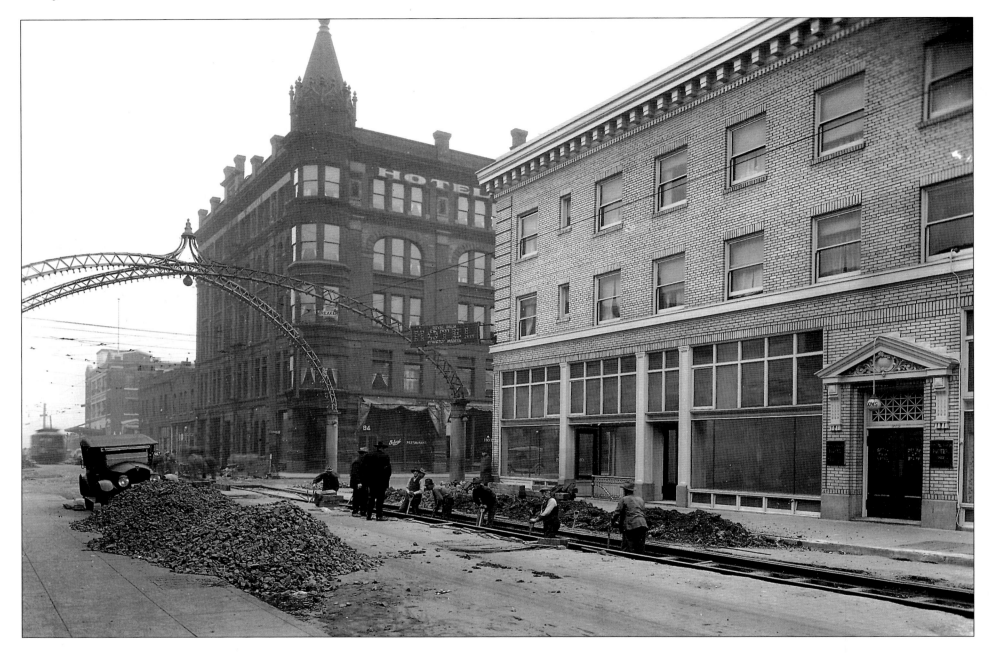

During World War II the Royal Palm Hotel at Northwest Third and Flanders (*right*) provided badly needed housing for African-Americans, who were barred from most hotels. At the time, many black railroad workers were seeking a place to live near Union Station. The hotel was owned by African-American businessman Kelly Foster and featured a barbershop, restaurant, and other amenities. When this photograph was taken, arcs of lights illuminated Third Avenue at night. *Oregon Historical Society, # OrHi 10493a*

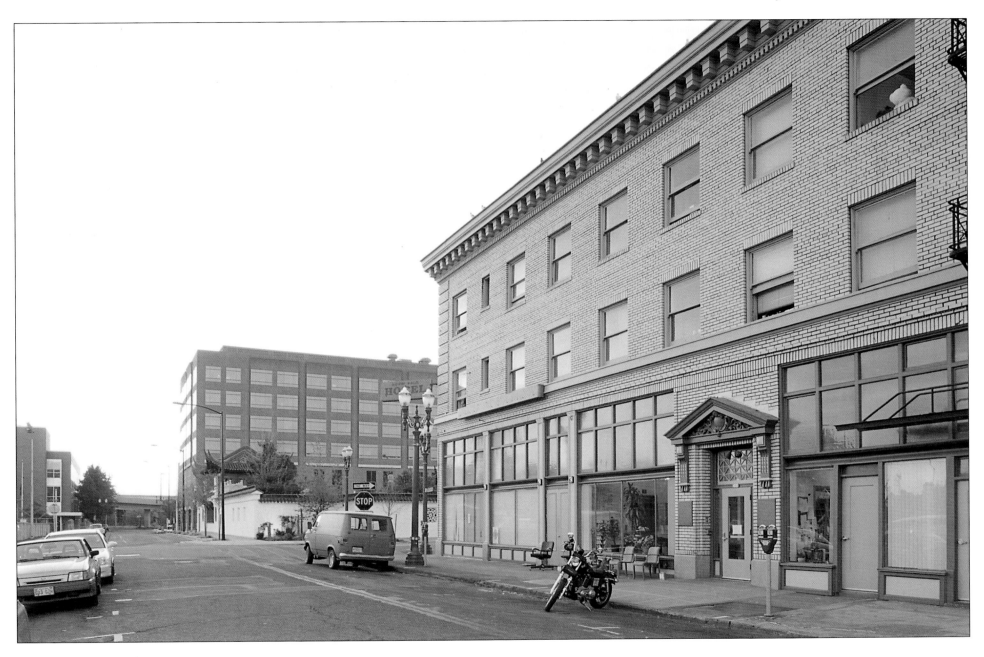

The exterior of the Royal Palm Hotel has changed little in the intervening decades. But in the next block, where the New Grand Central Hotel once stood, the city's proudest new attraction, the Portland Classical Chinese Garden (low white structure), graces the eastern border of modern Chinatown. The garden pays tribute to Portland's sister city, Suzhou, which is renowned for its beautiful gardens. Note the old Portland-style street lights, fittingly painted in Chinese red and gold.

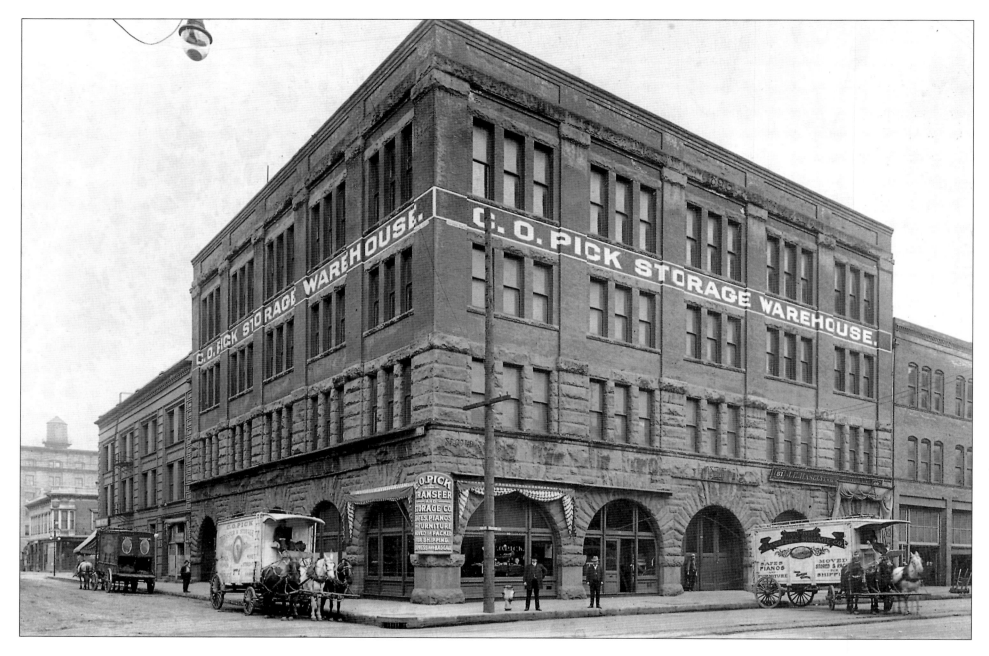

The Haseltine Building was erected in 1893 at Southwest Second and Pine streets on the northern edge of old Chinatown. At the time, Portland was home to 4,400 "Celestials," the nation's second largest Chinese population. The Haseltine was one of several Portland commercial establishments built during the 1890s in the Richardsonian Romanesque style. *Oregon Historical Society, # OrHi 54127*

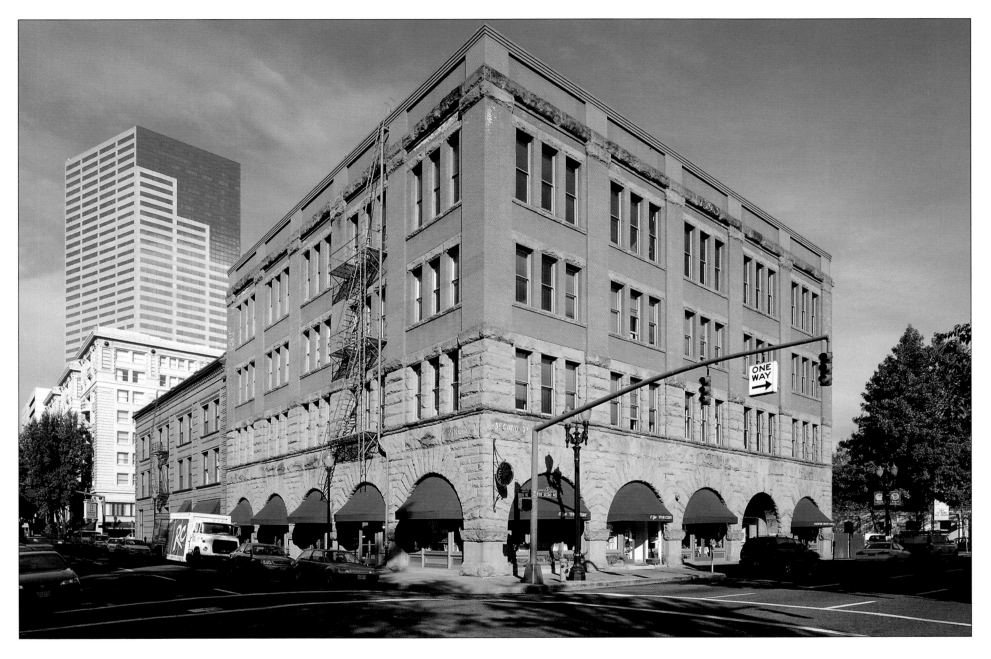

Today, the Haseltine Building looks much as it did when it was built. In recent years its ground floor has been occupied by decidedly upscale businesses, including restaurants and an art gallery—a far cry from the pedestrian uses it had in earlier years when it was a warehouse for a transfer and storage company and later, a wholesale hardware business.

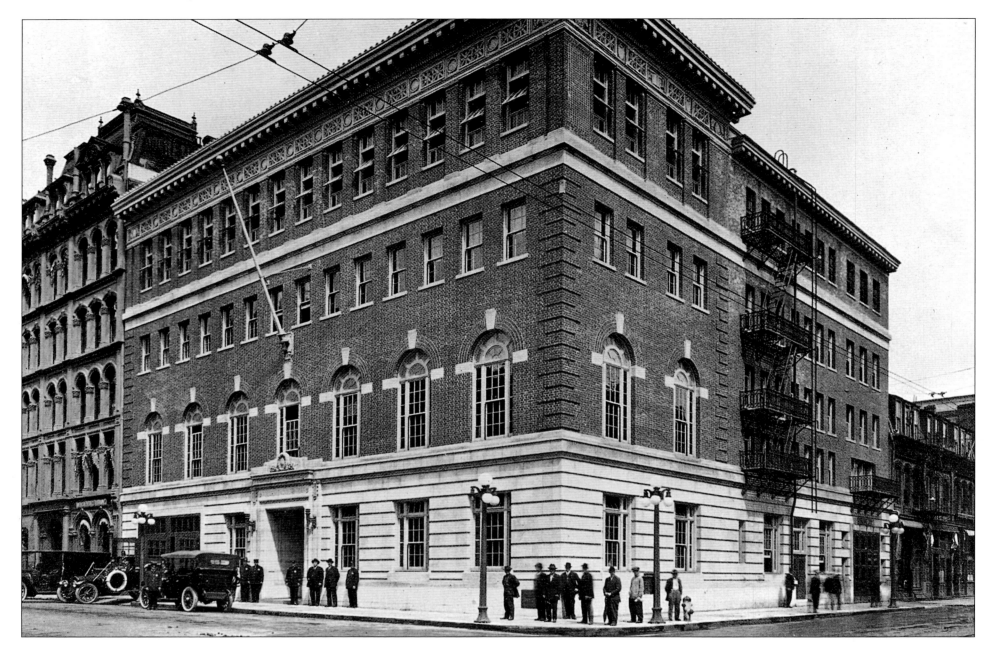

The completion of a new four-story police headquarters and jail at Southwest Second and Oak streets in 1913 coincided with an era of change for the forces of law and order. In that year the Metropolitan Police Force was renamed the Bureau of Police and steps were taken to clean up years of corruption and "palm greasing" by owners of saloons, gambling establishments, and houses of prostitution. *Photo courtesy of City of Portland Stanley Parr Archives and Records Center*

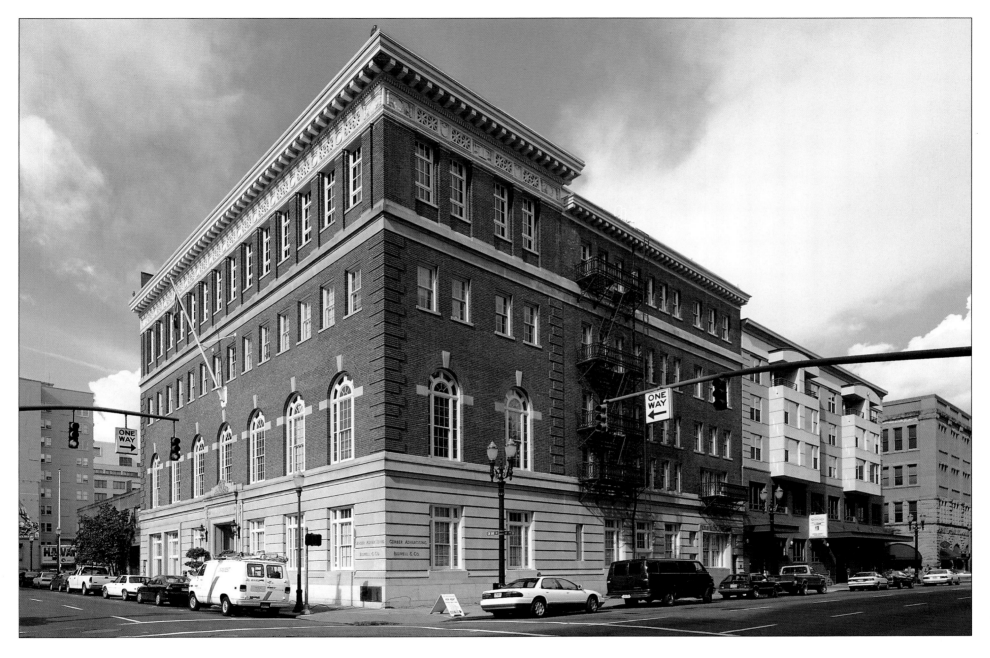

In 1983 the old Police Bureau building was vacated and operations moved to the handsome new Justice Center several blocks south on Third Avenue. Today, the exterior of the old police headquarters looks almost exactly as it did in 1913, while its interior has been renovated for use as offices. The north wing has been replaced by condominiums and parking (*right of center*).

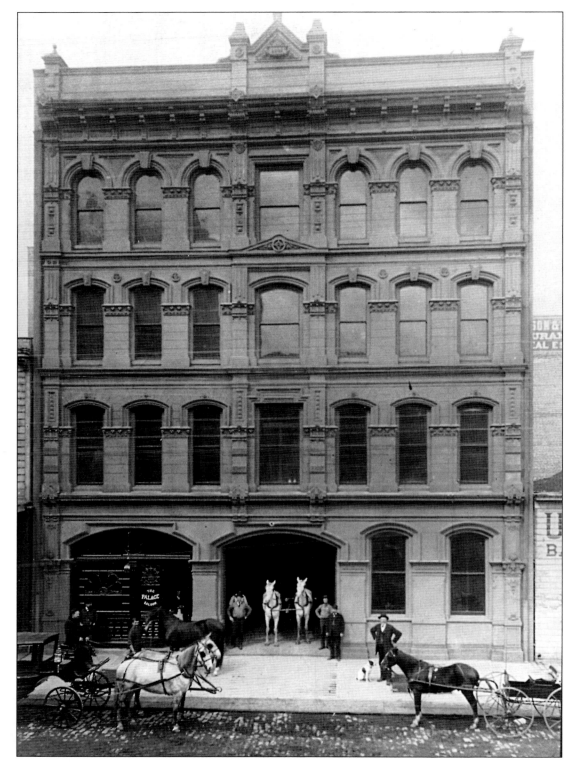

One of the gems of Portland's cast-iron era is the Grand Stable & Carriage Building at Southwest Second Avenue, designed by architect Warren H. Williams and built in 1886–87 in the High Victorian Italianate style for local business titan Simeon Reed. Here, visitors to the city could leave their horses and wagons; hire carriages for "Balls, Operas, Funerals, Riding, Calling;" or obtain transportation to ferry and train depots. *Oregon Historical Society, # OrHi 58507*

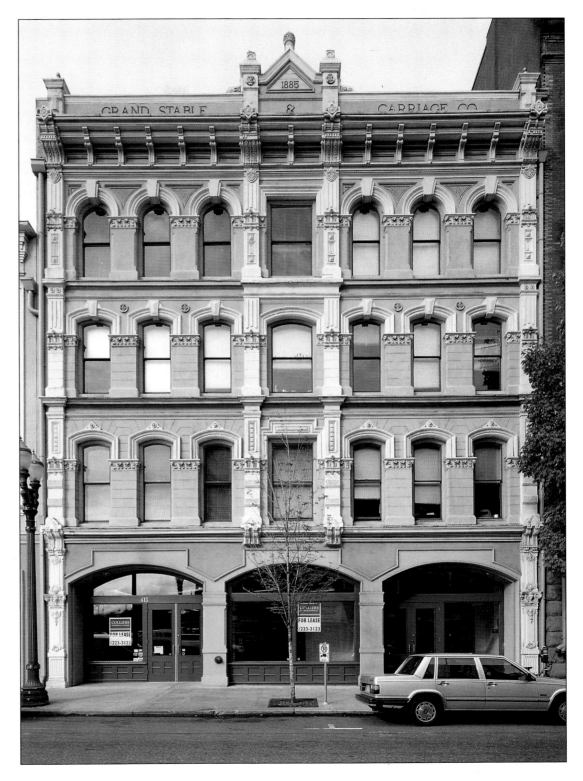

For many years, the Grand Stable & Carriage Building's first-floor arches were covered in an attempt to modernize the building, and its facade was marred by a large fire escape. Now the renovated structure is a showpiece that is listed on the National Register of Historic Places.

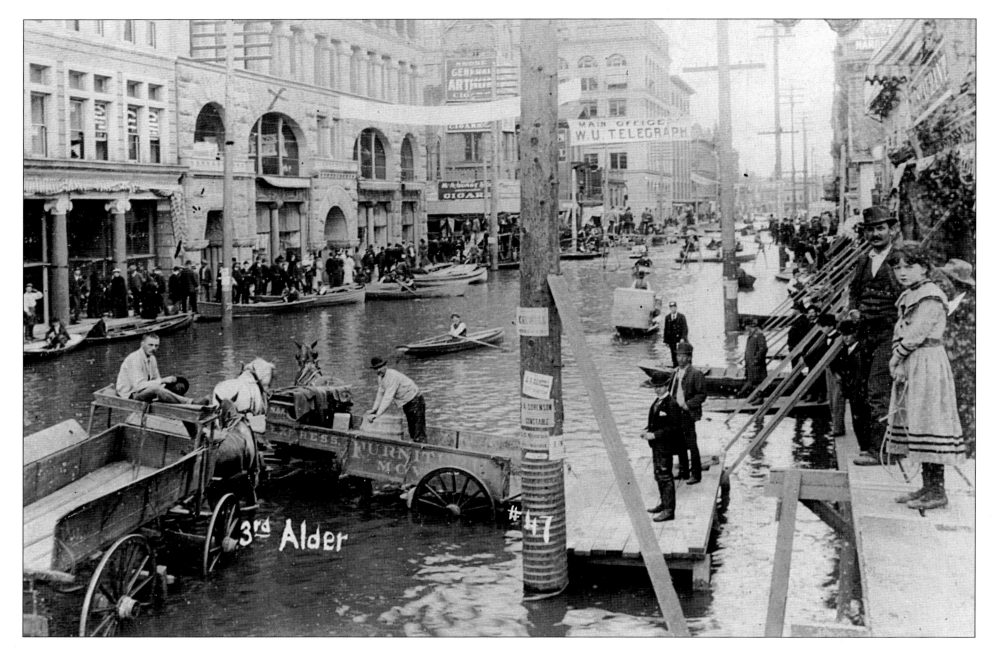

Of all the floods that plagued Portland in the 1800s, the flood of '94 was the worst. By June 6, when the Willamette River reached its peak, it had inundated dozens of city blocks, including Third Street (*shown here*). But business went on apace, as every available boat was pressed into service and people crowded the streets, to cross on temporary "board" walks and watch rowing races organized by some of the area's Chinese inhabitants. *Oregon Historical Society, # OrHi 102309*

Two of the buildings seen in the 1894 photograph still stand today—the classically detailed 1893 Hamilton Building (*left*), by architects Whidden and Lewis, and the 1892 Richardsonian Romanesque Dekum Building (*center left, with flag*), by McCaw, Martin, and White. Just beyond the Dekum is the Spalding Building (1911), whose architect, Cass Gilbert, also designed the U.S. Supreme Court Building.

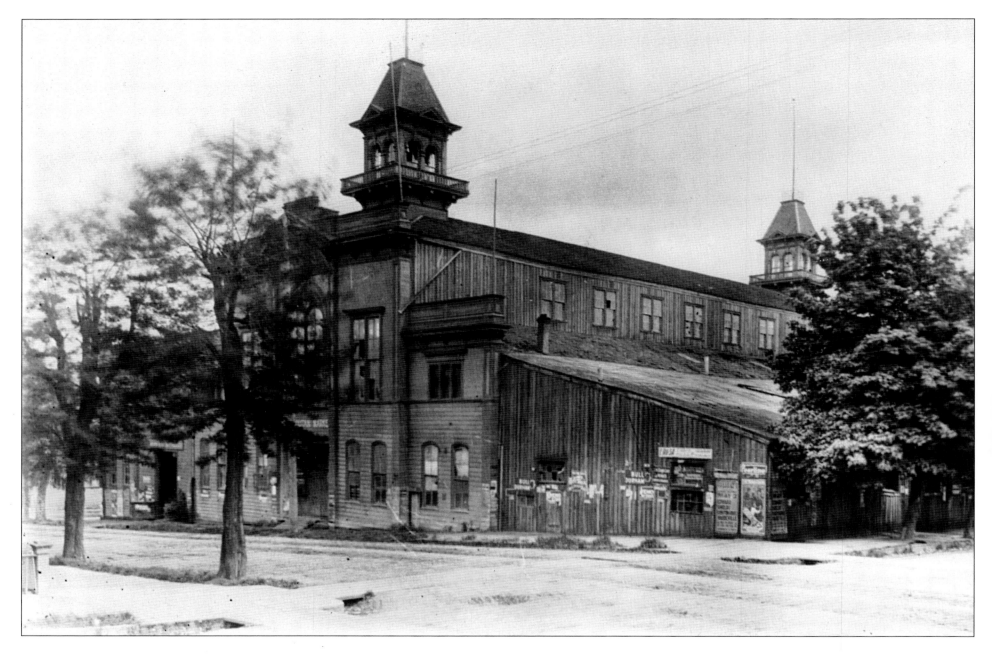

At a time when Portland's business enterprises were growing, the Mechanics Fair Pavilion, built in 1879, provided factory owners with an exhibition hall and residents with a sports arena and locale for large public gatherings. The Portland Mechanics Fair was held there from 1880 through 1888, and in 1890 it was enlarged for use as the Metropolitan Public Market. *Oregon Historical Society, # OrHi 47467*

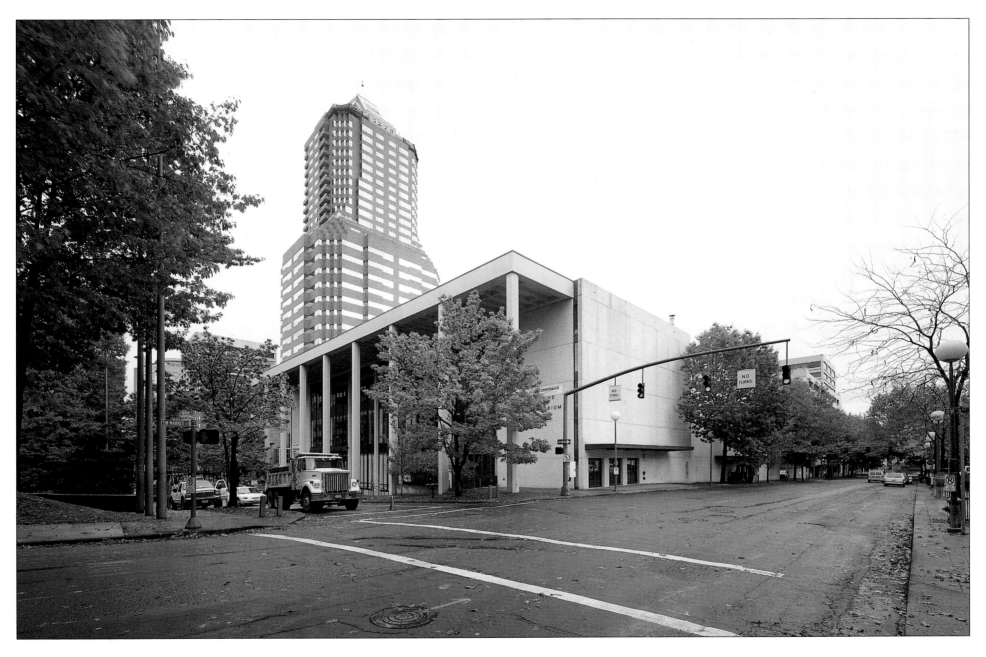

Where the Mechanics Fair Pavilion once stood on Southwest Third Avenue is Keller Auditorium, with the KOIN Tower in the background. The first Portland Public Auditorium was built on this site in 1917 and remodeled in the late 1960s—with only a small percentage of the old building retained. The remodeled building features tall, thin columns and vast expanses of glass.

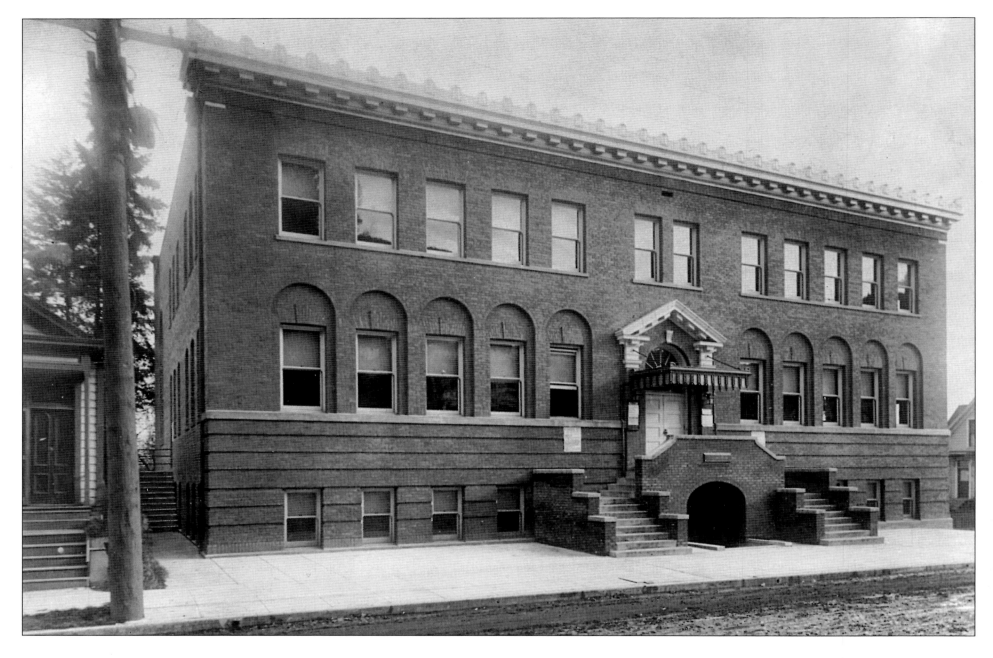

Neighborhood House, at Southwest Second Avenue in South Portland, was a Jewish settlement house that provided meeting rooms, recreation, vocational training, well baby clinics, and Americanization classes for the expanding immigrant population of the area and for anyone in need. Its second building, pictured here, was erected only five years after the first to meet a burgeoning demand for services. Among those who called Neighborhood House "home" was Mel Blanc, the voice of Bugs Bunny and Porky Pig. *Oregon Historical Society, # OrHi 48776*

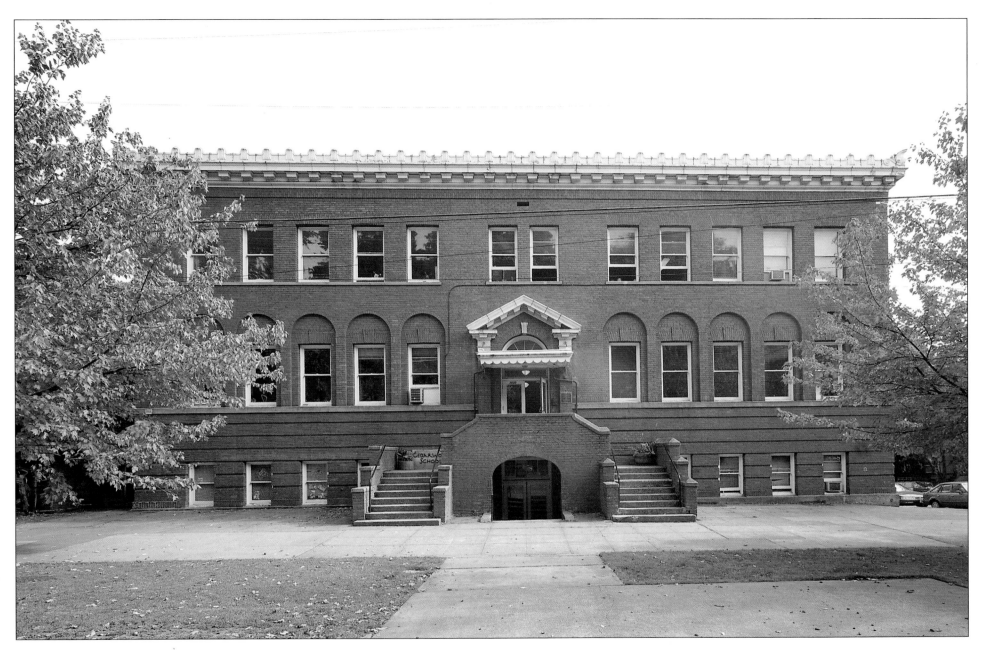

In the late 1920s and the 1930s, many young Jews left South Portland to establish homes in other sections of the city. But older immigrants treasured the Jewish neighborhood with its kosher butcher shops, bakeries, and grocery stores. In 1958, however, an urban renewal district was created in South Portland and soon the old Jewish community was bulldozed to make way for high-rise buildings. For many years, Neighborhood House continued to provide services. Today the building houses a YMCA.

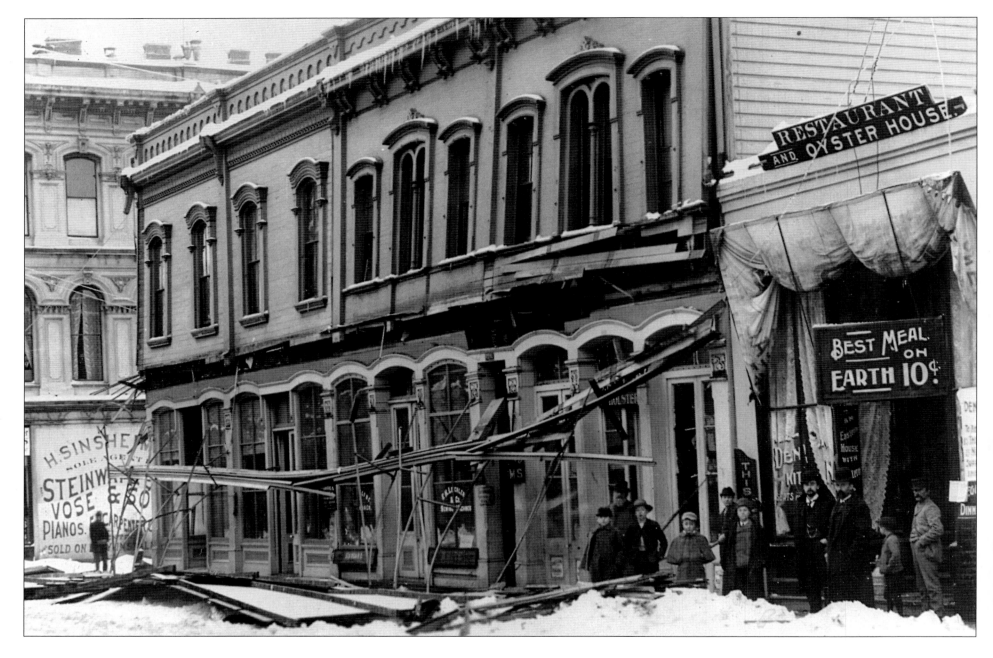

In 1893 the east side of First Street from Salmon to Taylor was hit hard by a snow storm, which knocked its long wooden awning to the ground. Among the businesses pictured here are a music store (*left*), millinery store, and restaurant and oyster house, where the "best meal on earth" could be had for ten cents. *Oregon Historical Society, # OrHi 49957*

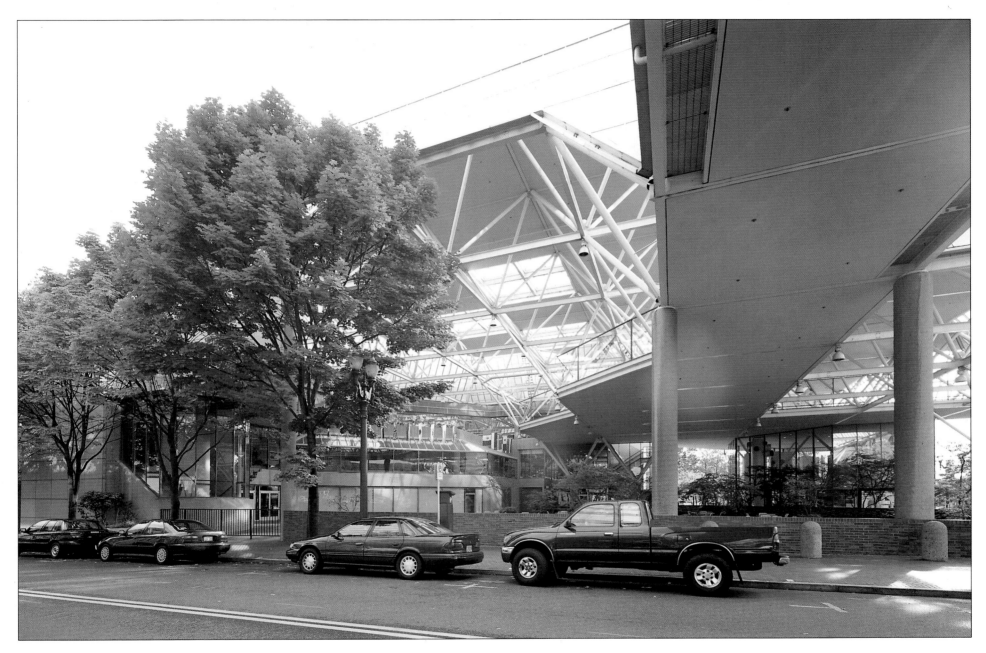

In the 1970s the hyper-modern World Trade Center was built for Portland General Electric on three blocks bordering the Yamhill Historic District, including the block between Salmon and Taylor seen in the photo on the facing page. The complex's three parts are situated near the District's historic buildings and are connected by skybridges.

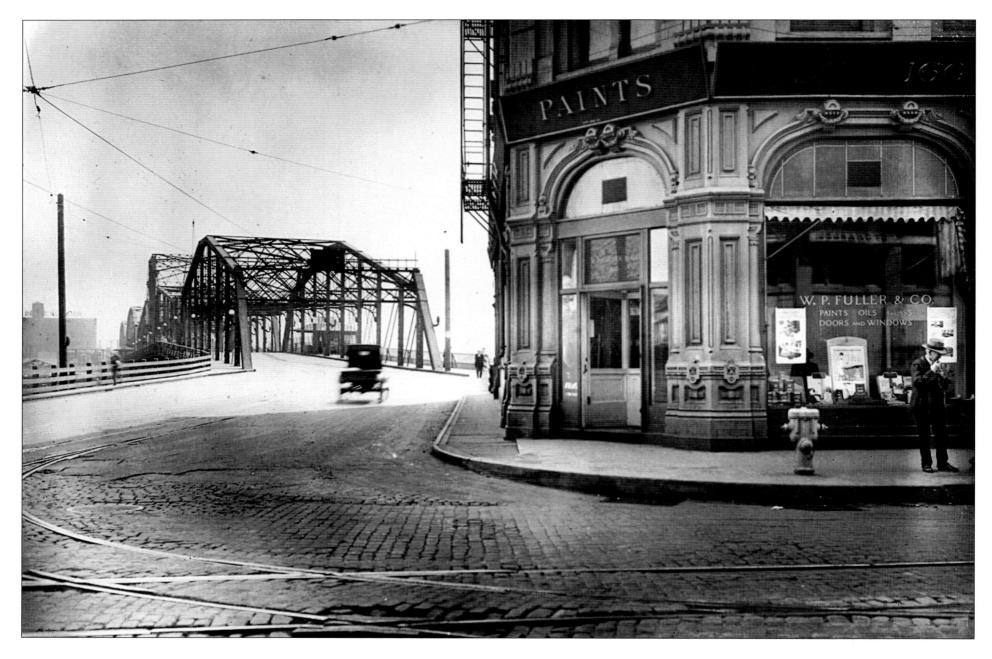

When the old Morrison Bridge opened in 1887 at the foot of Morrison Street, it provided a welcome alternative to ferry transportation across the Willamette River and helped facilitate the 1891 consolidation of Portland with East Portland and Albina, on the east side of the river. A private bridge, it charged tolls ranging from five to twenty cents each for carriages, riders, pedestrians, and livestock. The first bridge was replaced in 1904–05 by the one in this photograph. *Oregon Historical Society, # COP 00297*

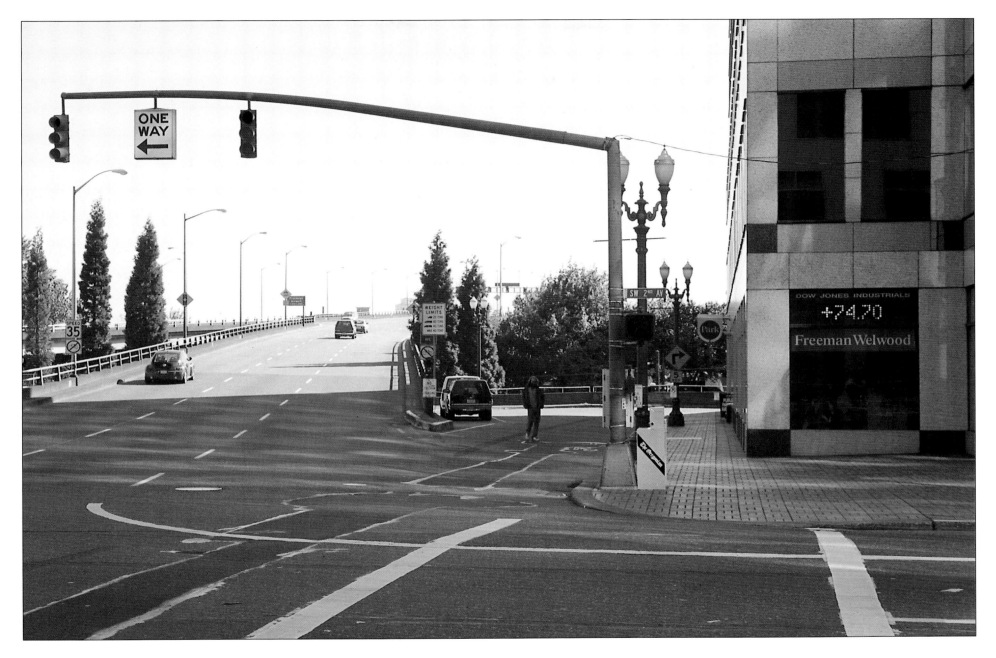

Despite frequent malfunctions of its gears, the second Morrison Bridge limped through the Depression and World War II years. Finally, in 1958 a new three-span steel bridge was built—its approaches relocated one and two blocks north of Morrison Street and two blocks west of the old Front Avenue ramp. In December 1987, the Morrison was the first of Portland's bridges to be illuminated at night. The building in this photograph is the Bank of America Financial Center.

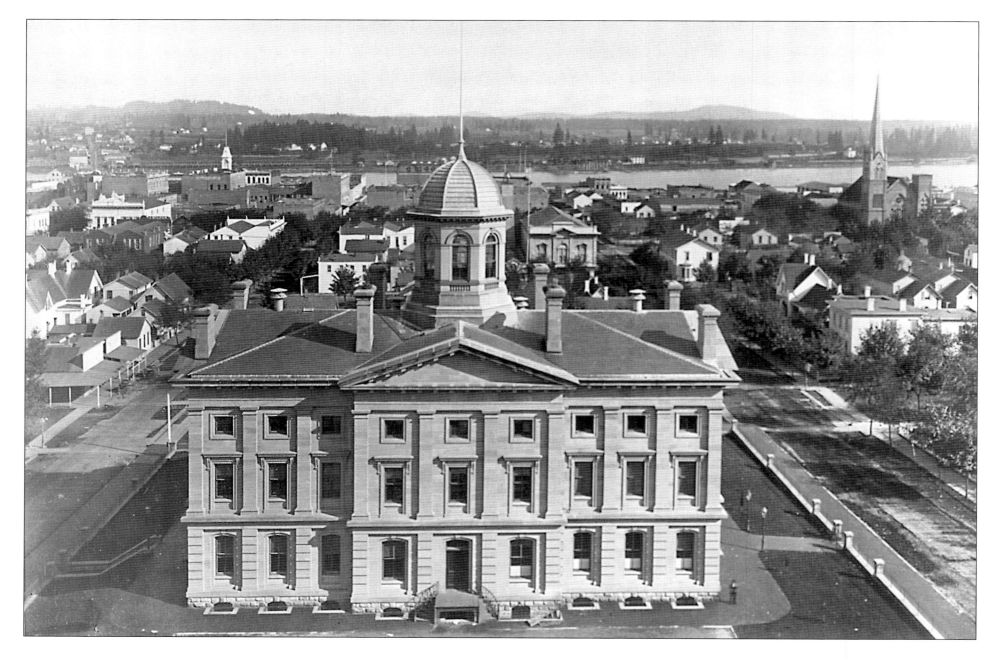

When plans were announced in 1869 to site the new federal courthouse and post office on the block between Southwest Fifth and Sixth and Morrison and Yamhill streets, the federal government was criticized for locating the courthouse so far away from the city's river-edge business center. One pundit suggested that a Pony Express business should be established to serve between the outpost courthouse and the commercial area. *A. H. Wulzen photo, Oregon Historical Society, # OrHi 754a*

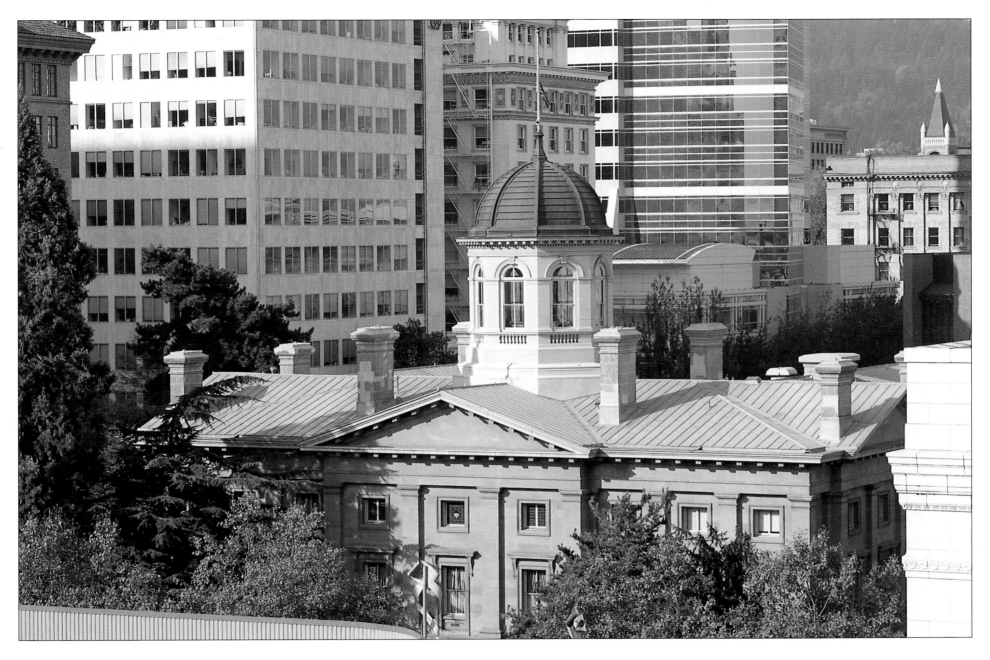

Two wings were added to the federal courthouse in 1905, enabling it to house the courts until 1933. The post office, reactivated here in 1937, became known as "Pioneer Post Office." Following a period of disuse and a Congressional bill that called for its destruction, the building was renamed "Pioneer Courthouse" in 1969. Two years later it was rehabilitated to accommodate the post office and to serve as the new home of the U.S. Ninth Circuit Court.

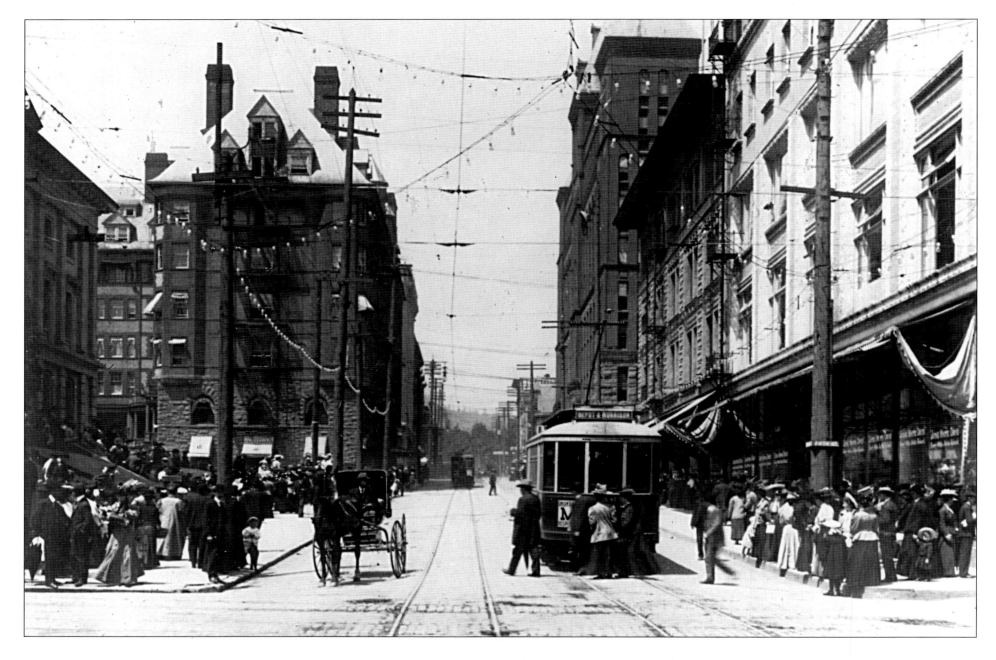

This famous photograph of Southwest Fifth and Morrison depicts the liveliness of crowds and mixed forms of transportation in downtown Portland at the turn of the century. At left is the Pioneer Courthouse, the second oldest federal courthouse west of the Mississippi. Beyond is the stately Portland Hotel, which opened in 1890. And across from the courthouse to the right, is the five-story Meier & Frank Company building, erected in 1898. *Oregon Historical Society, # OrHi 9937*

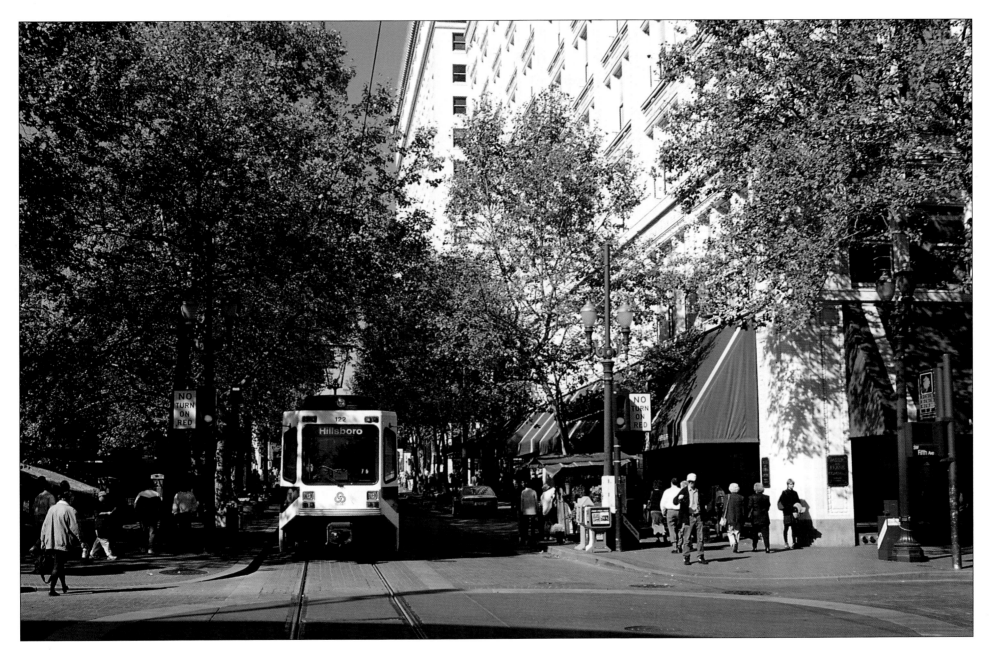

Since the 1890s, the locus of the city has remained near Southwest Fifth and Morrison. The courthouse has flourished, although its neighbor, the once proud Portland Hotel, was reduced to a parking lot in 1951. From its first building at the site, the Meier & Frank Company building evolved into the present one block, fifteen-story building on the right. Succeeding the streetcar lines on Morrison is the Metropolitan Area Express—MAX—light-rail system crossing the heart of downtown.

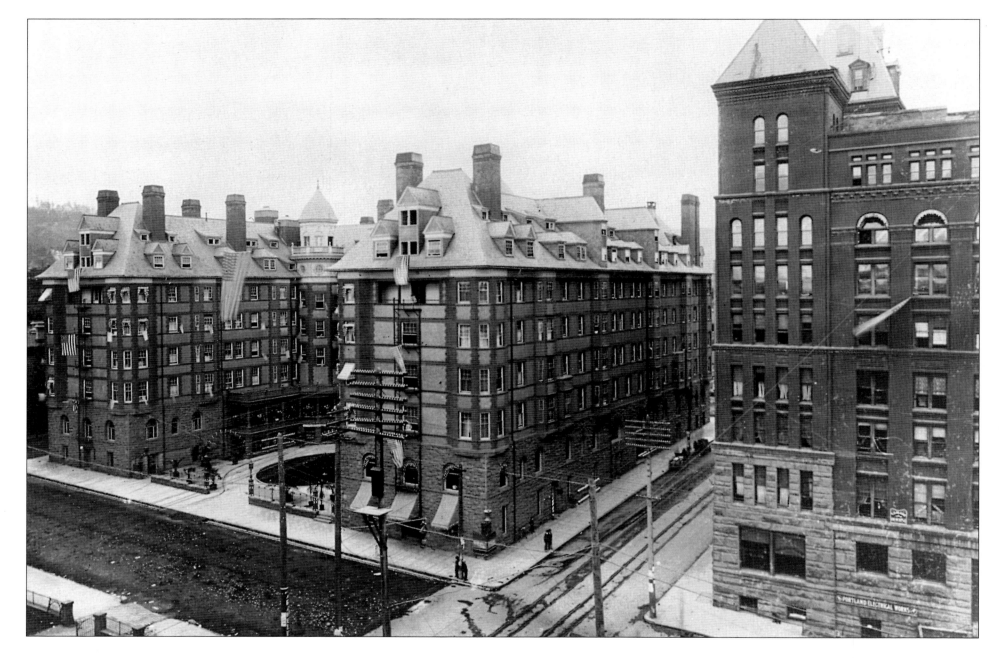

Central School occupied the block where this grand building stood from 1858
until Henry Villard and his Northern Pacific Railroad purchased the property in
1882. Villard intended to build a great railroad hotel, but when his railroad empire
foundered, so did his proposed hotel. Resurrected by Portland businessmen, the
hotel was finished in 1890. The massive building, with its multiple gables and
chimneys, contained 284 rooms on six floors. Among its illustrious patrons were
eleven U.S. presidents. *Oregon Historical Society, # OrHi 11935*

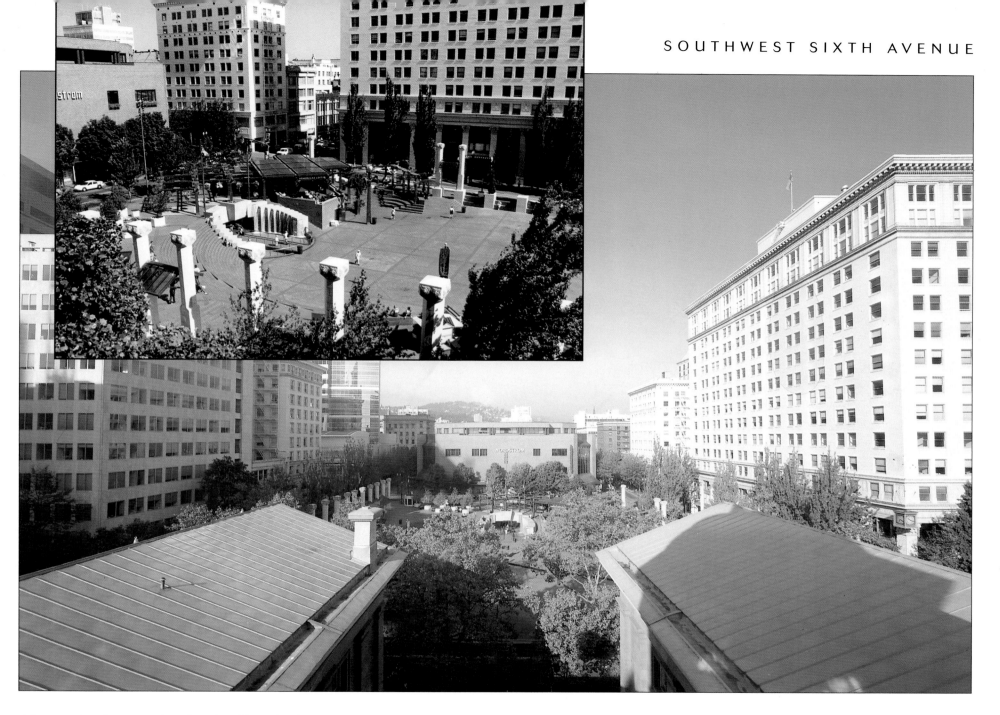

After two decades as a parking lot, the old Portland Hotel block was earmarked by city planners as public space. The experts wanted a city square that conveyed a sense of "timelessness [...] that endures." In a design competition netting 161 proposals, the plan of an interdisciplinary team headed by architect Willard Martin was selected. The square, which opened in 1984, features an amphitheater, waterfall, terra-cotta columns, public art, and—fittingly—an iron gate from the Portland Hotel.

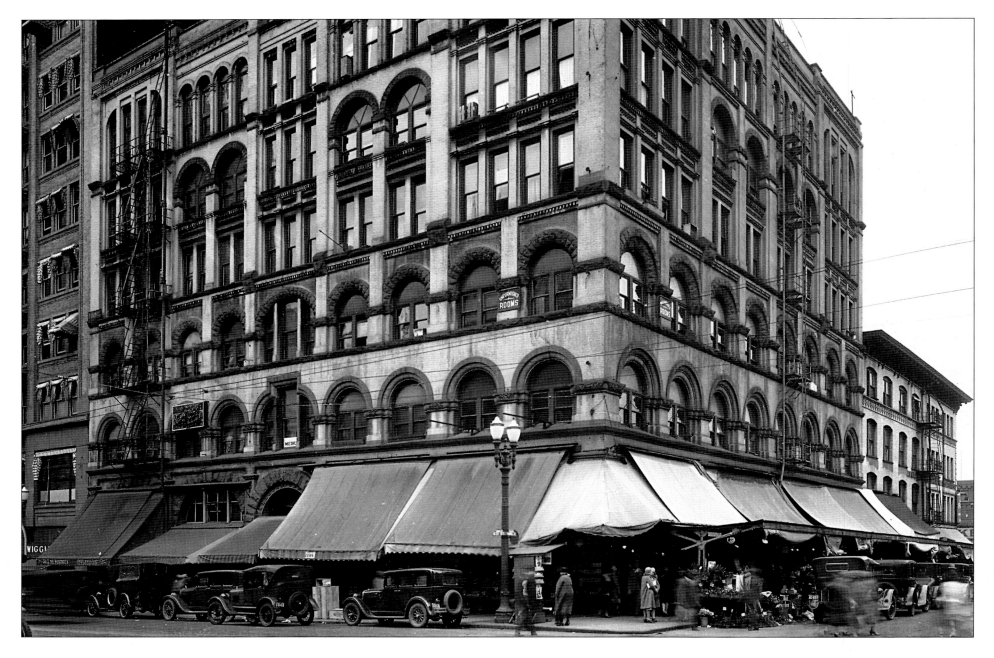

The six-story brick and stone Goodnough Building at the corner of Southwest Fifth and Yamhill was the first home of the *Oregon Journal* when it began publishing in 1902. Constructed by Ira Goodnough in 1891, the Victorian Romanesque building prospered in the city's tight housing periods through World War II. Gradually, however, the upper floors were abandoned, and finally the building was razed to make way for redevelopment. *Oregon Historical Society, # OrHi 26912*

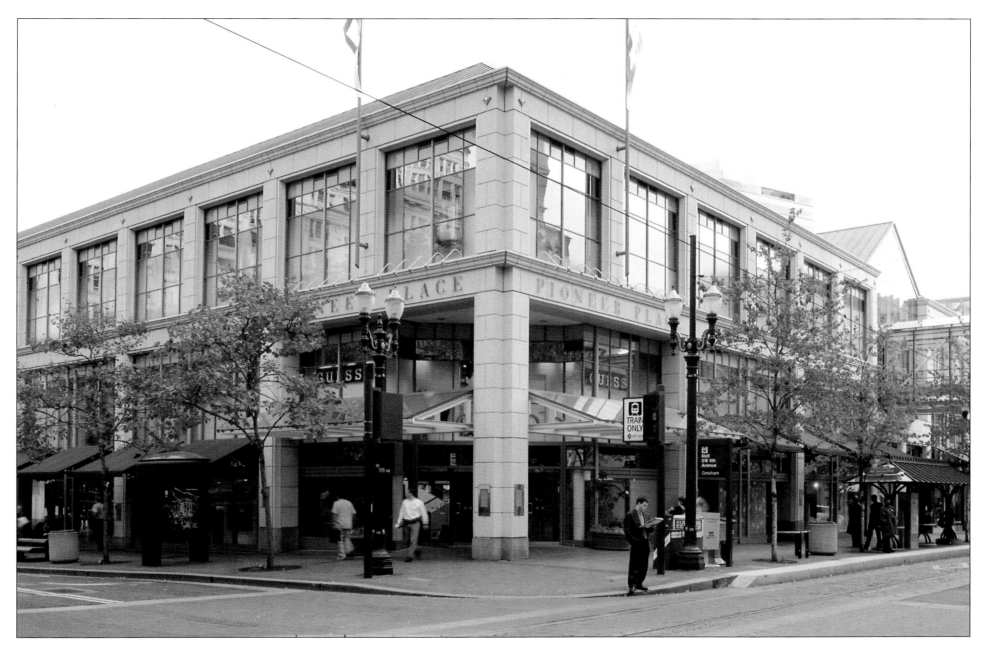

Pioneer Place, one of several downtown urban renewal projects, opened in 1990. The three-block area was developed by the Rouse Company. More than seventy specialty retail stores and a food court were built in a four-level, glass enclosed pavilion adjoining a sixteen-story tower and anchor store Saks Fifth Avenue. The facility was expanded in 2000 to include an additional block of retail space and restaurants.

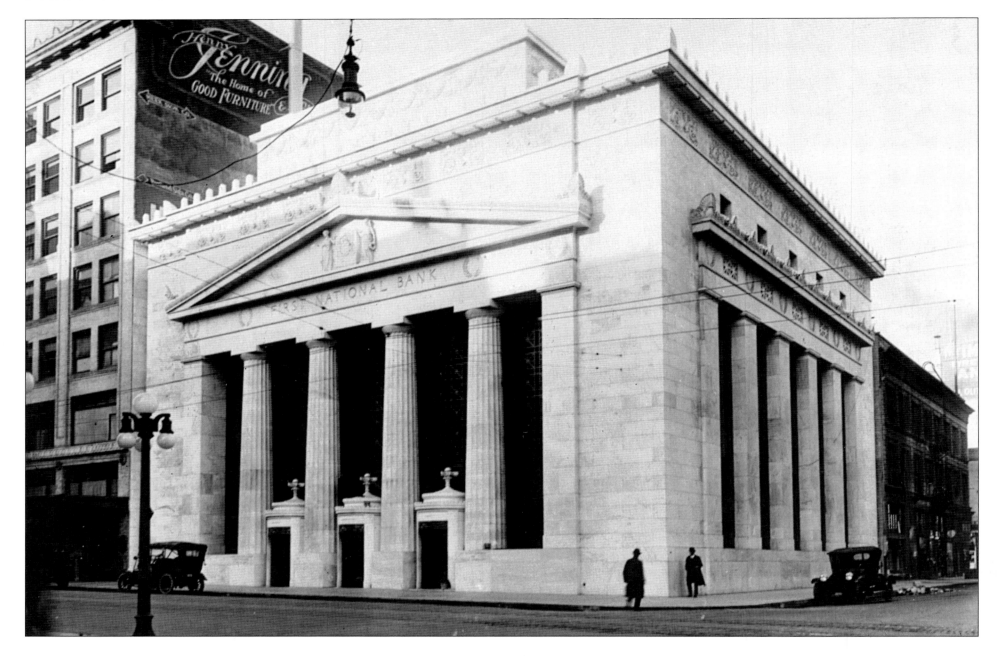

Classic architecture prevails at the corner of Southwest Fifth and Stark in the historic old First National Bank Building, built in 1916 and expanded in 1921. With elements of Greek neo-classicism, the elegant temple-like structure was designed by Boston architect Charles Coolidge for his college friend Abbot Mills, president of the bank. The marble-finished building was completed at a cost of $400,000. Chartered in 1865, it was the first national bank west of the Rocky Mountains. *Oregon Historical Society, # OrHi 35799*

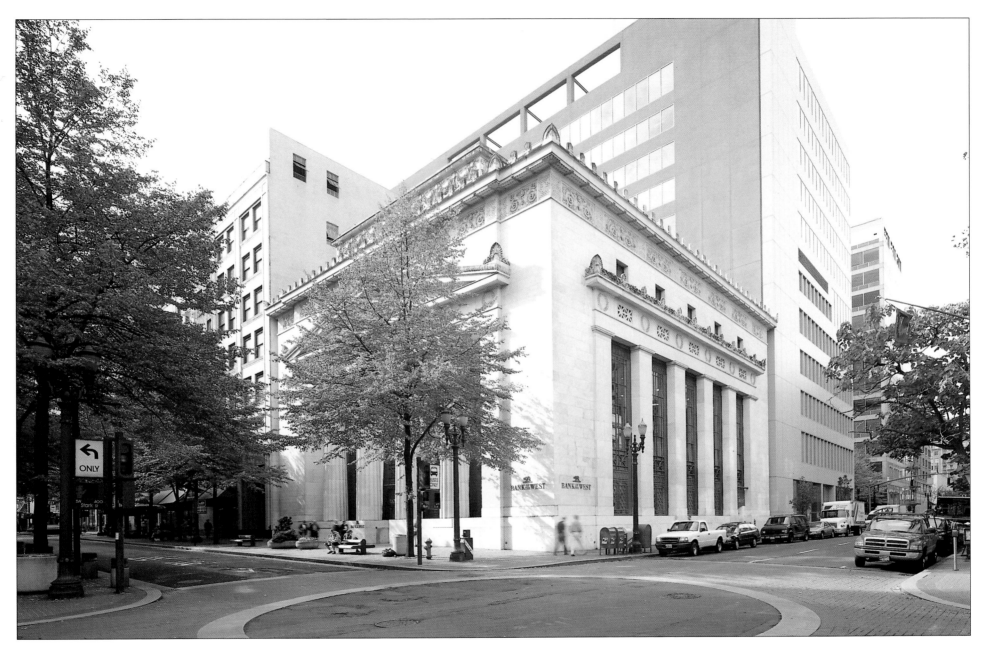

By the 1910s, Portland's financial district had begun to emerge along Southwest Stark Street, largely between Fifth and Sixth streets. Then, as now, the First National Bank Building was at the heart of that financial district. Several institutions, including the present Bank of the West, have been quartered in the front half of the building since First National Bank moved in 1972. But despite changes in occupants, the exterior of the building appears much the same as it did when it was constructed.

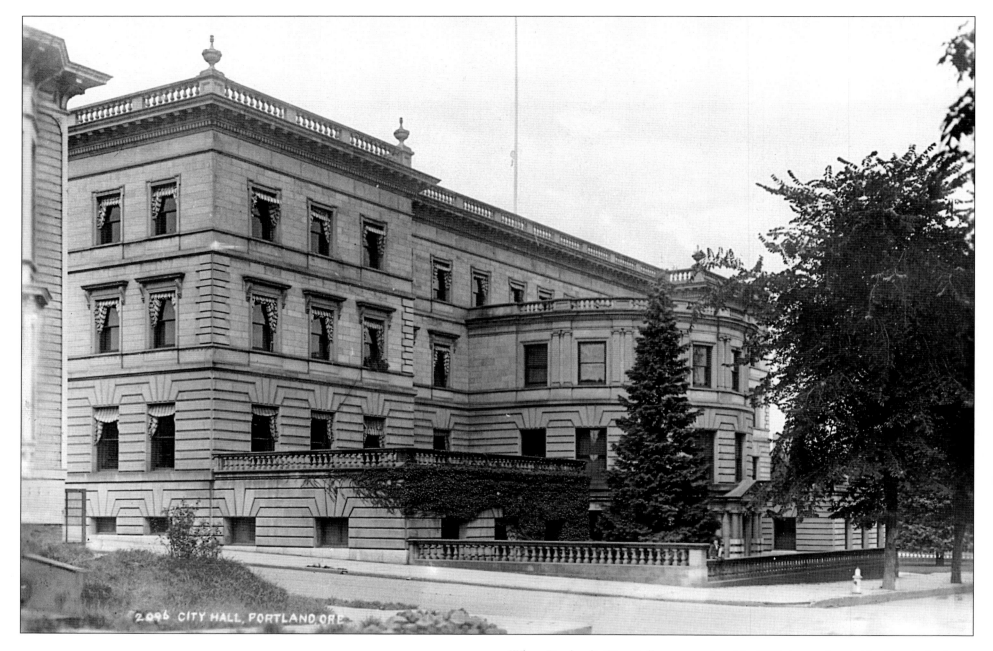

2096 CITY HALL, PORTLAND ORE

When Portland's City Hall was completed in 1895, it was forward looking in both architectural style and engineering. Designed by the well-known local firm of Whidden and Lewis in the classical High Renaissance Revival style, City Hall also embodied the latest engineering innovations: steel frame construction, central heating, fireproofing, and electrical wiring. Once, it also housed Multnomah County offices and the Oregon Historical Society. *Oregon Historical Society, # OrHi 74040*

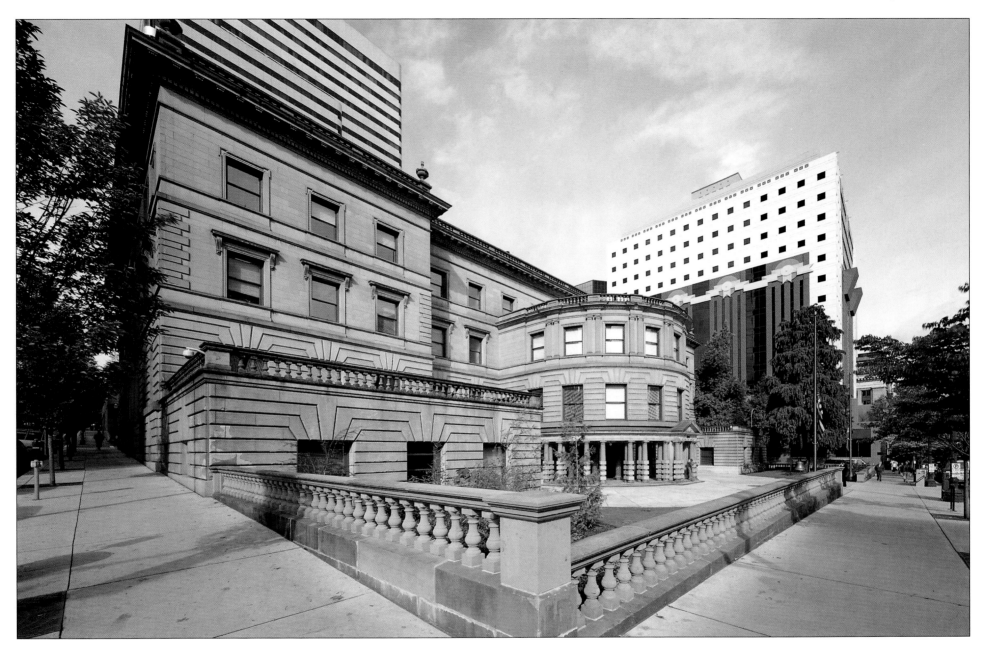

City Hall underwent extensive renovation between 1996 and 1998 to make it safer and more efficient and to restore numerous architectural details lost during past remodeling. Looming up behind City Hall is the Pacwest Center and to the right is the Portland Building, erected in 1982 to house the administrative branch of city government. The fancifully decorated postmodern office building was designed by Princeton architect Michael Graves.

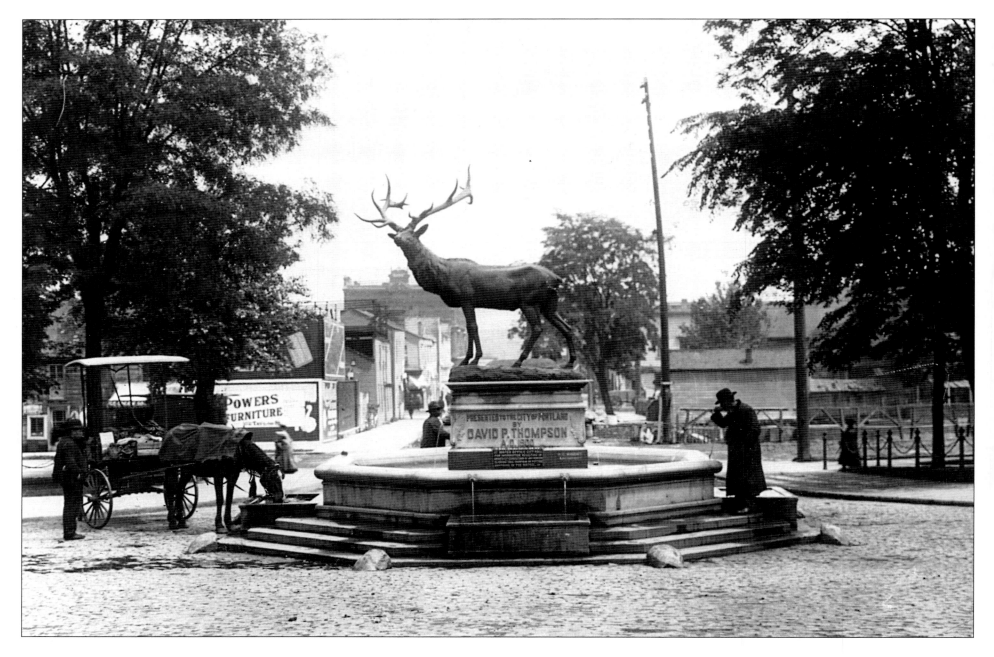

An elk may seem an innocuous subject for a statue, but in 1900, when it was erected in the middle of Main Street between Third and Fourth avenues, it created a furor. When asked to dedicate the statue, the Benevolent Protective Order of Elks refused, charging that it was a "monstrosity of art." In its early years, however, the statue provided welcome refreshment to thirsty pedestrians and quadrupeds. *Oregon Historical Society,* *# OrHi 9550*

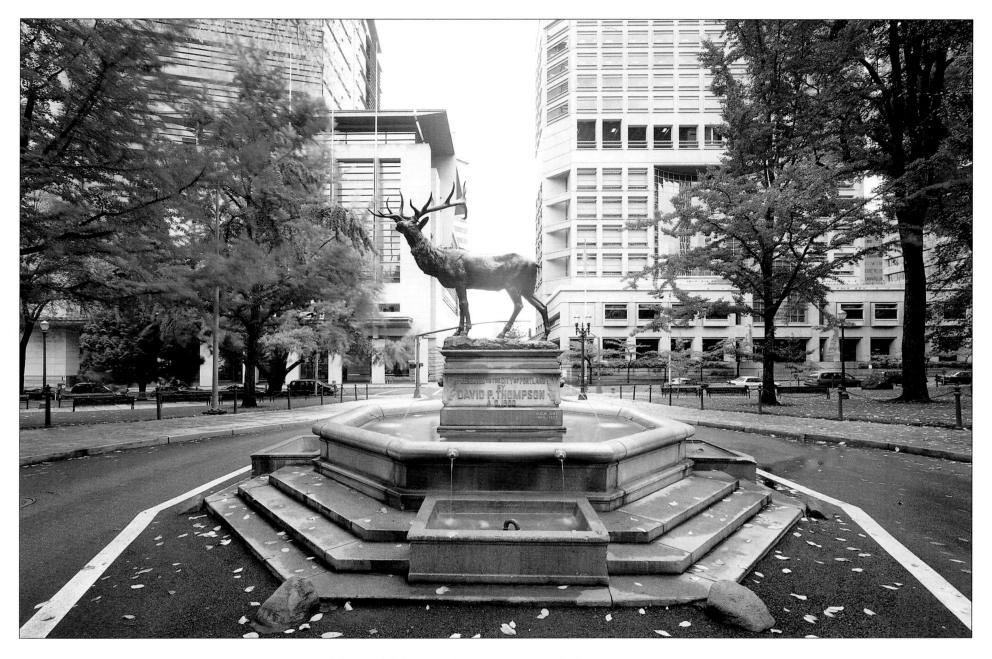

Today the elk watches over an array of civic buildings that surround the Plaza Blocks. To the east are the 1983 postmodern Justice Building by the Zimmer Gunsul Frasca firm (*right*) and the 1997 Mark O. Hatfield United States Courthouse by Portland's BOORA Architects (*left*). To the west—opposite these stunning examples of modern design—are City Hall, the Portland Building, and the Multnomah County Courthouse.

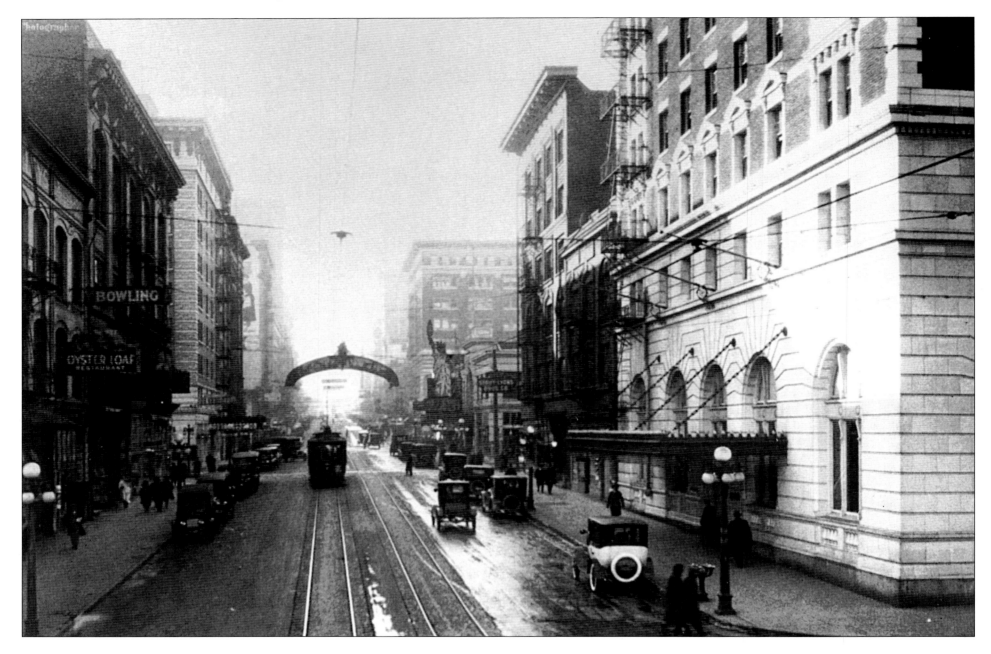

When Norwegian immigrant and lumber baron Simon Benson decided to build Portland a world-class hotel, he hired top architect A. E. Doyle and spared no expense. Inside the twentieth century Baroque building at Southwest Broadway and Oak (*right foreground*), the lobby was finished with Circassian walnut, bronze, and marble, earning it a reputation as the most elegant hotel west of Chicago. *Oregon Historical Society, # OrHi 64819*

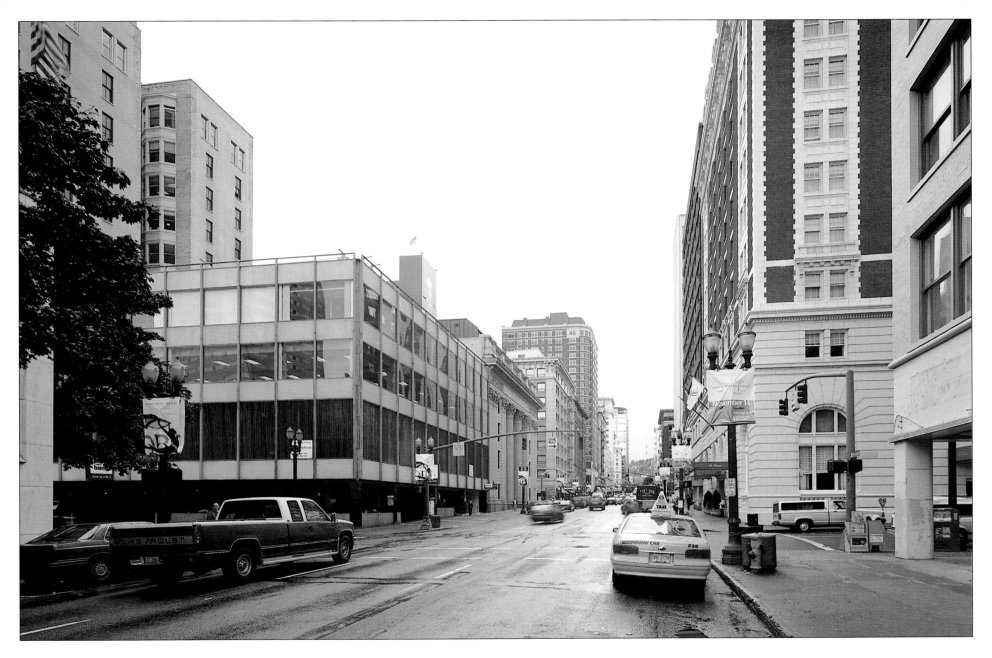

Simon Benson was also known for introducing steam donkey engines in Northwest logging operations and for donating twenty distinctive four-bowl brass fountains to the city so workmen could quench their thirst without entering a saloon. He sold his hotel in 1919 for an even million dollars. Today, it remains a gracious presence on Broadway and a favorite stop for U.S. presidents.

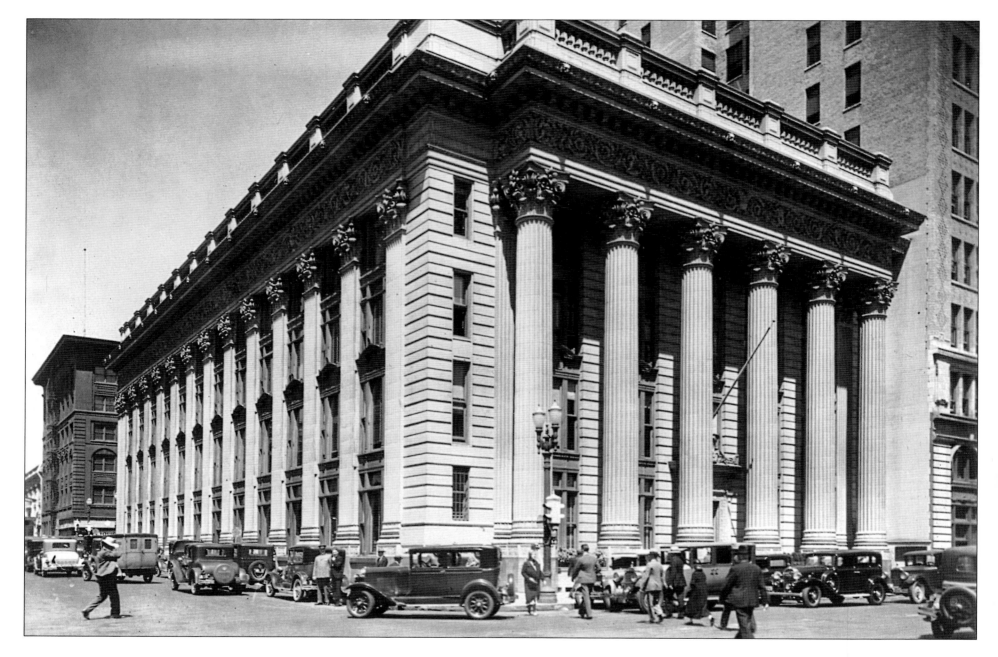

The Neo-classical U.S. National Bank Building on Southwest Stark Street was another triumph of architect A. E. Doyle. Inspired by the design of the Knickerbocker Trust Building in New York City, Doyle chose to feature Roman Corinthian columns and combined steel-reinforced concrete construction with granite, glazed architectural terra cotta, cast iron, and cast bronze. Built in two stages in 1917 and 1925, the imposing structure was home to the Northwest's leading bank.
Oregon Historical Society, # OrHi 54034

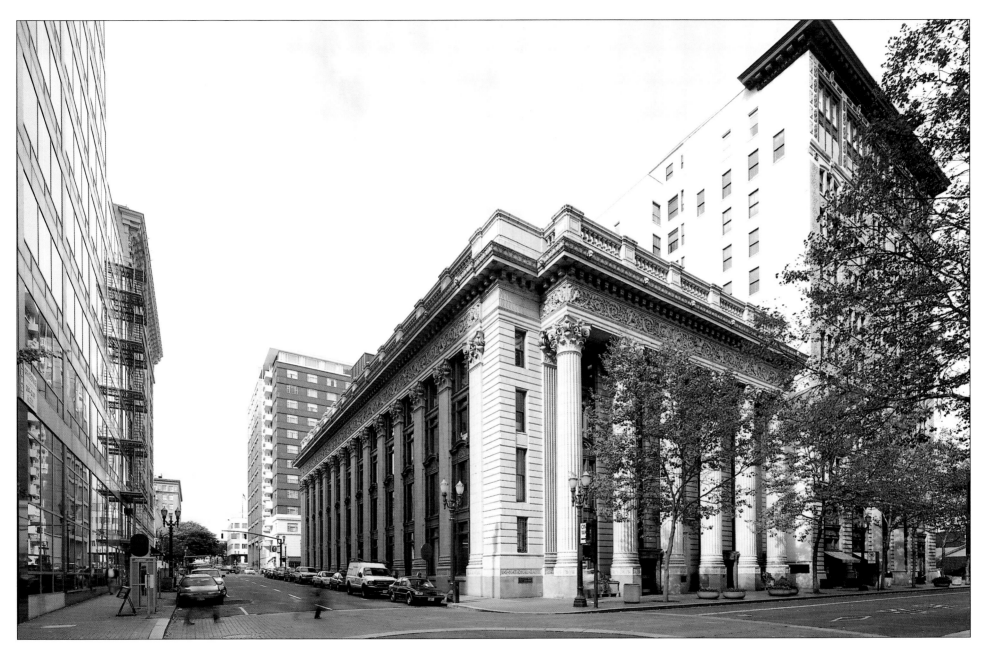

To the right of the U.S. National Bank Building in this photograph is the Wells Fargo Bank Building, erected in 1907 as the city's first skyscraper. On the left is Portland's first International-style building, the Equitable, finished in 1948. All three buildings are listed on the National Register of Historic Places. Behind the U.S. National Bank is the Benson Hotel.

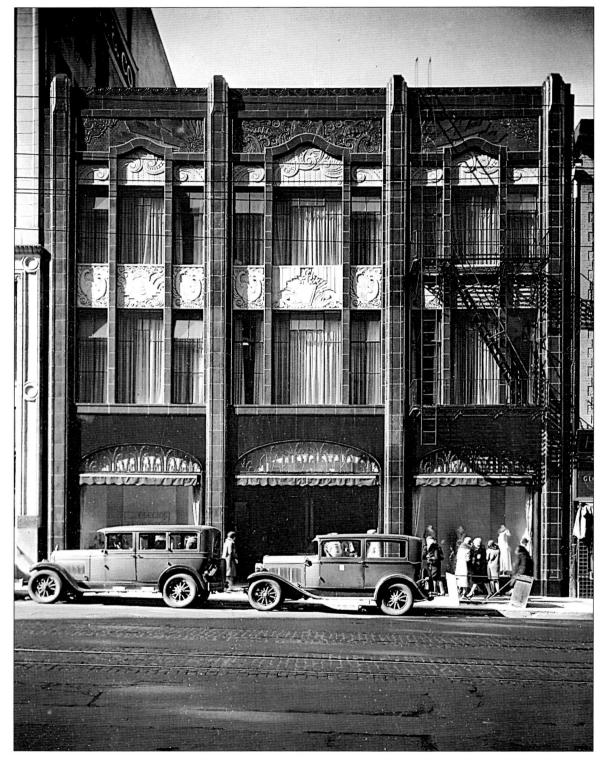

The 1902 Dolph Building at 615 Southwest Broadway marked a complete stylistic departure from its neighbors when it was leased by Charles F. Berg in 1929 and remodeled in the art deco style. Faced in black and cream terra cotta, the Berg Building was finished in 18-karat gold at a time when only two other buildings in the country used such decoration. It also featured an elegant interior with an elevator cab designed by Tiffany. *Oregon Historical Society, # Lot 72-301*

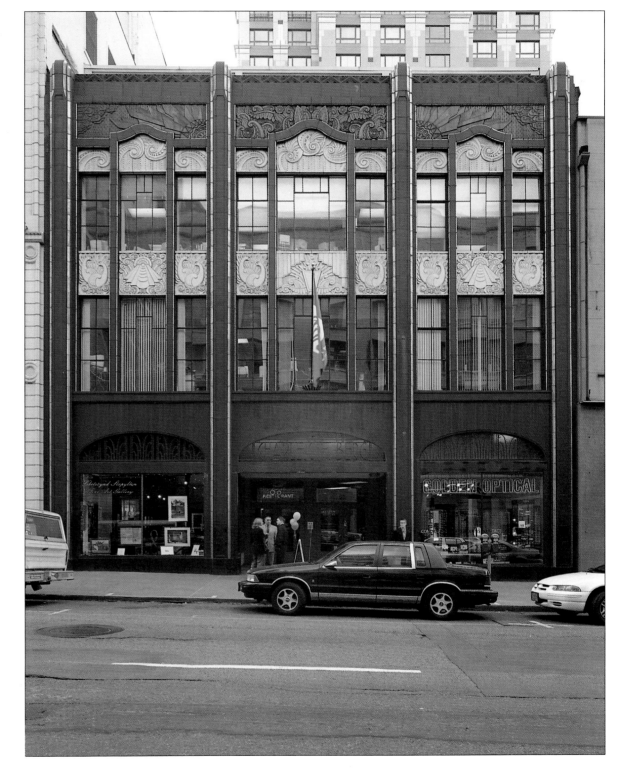

For many years, Charles F. Berg was one of the city's leading women's apparel stores, and local high school girls dreamed of being chosen to sit on its Hi-Board as fashion consultants and models. In 1979 the store was sold to a Canadian firm and in 1982 it closed. Today, the exterior, with its art deco peacocks, sunbursts, and rainclouds has changed little, but the interior has been remodeled to provide office, retail, and restaurant space.

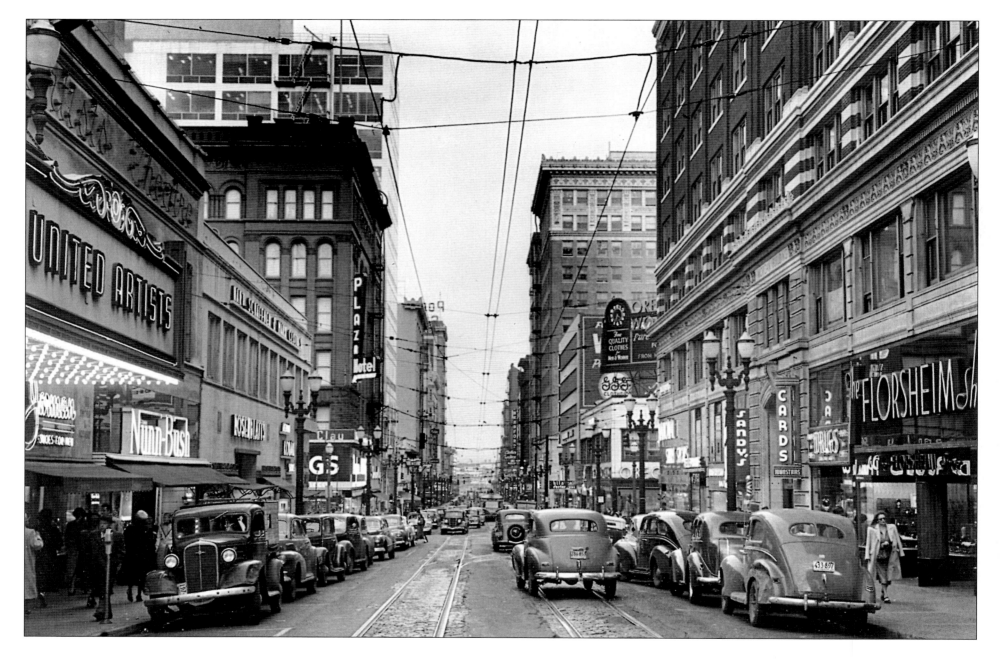

Southwest Washington Street near Broadway was bustling with activity in this 1949 photograph. In the heart of the city's shopping district, the historic 1913 Morgan Building (*right foreground*) contained an array of retail stores, a pool hall, and Jolly Joan's restaurant, a downtown institution. At left on the next block was the Plaza—formerly Imperial—Hotel. *Oregon Historical Society, # OrHi 102310*

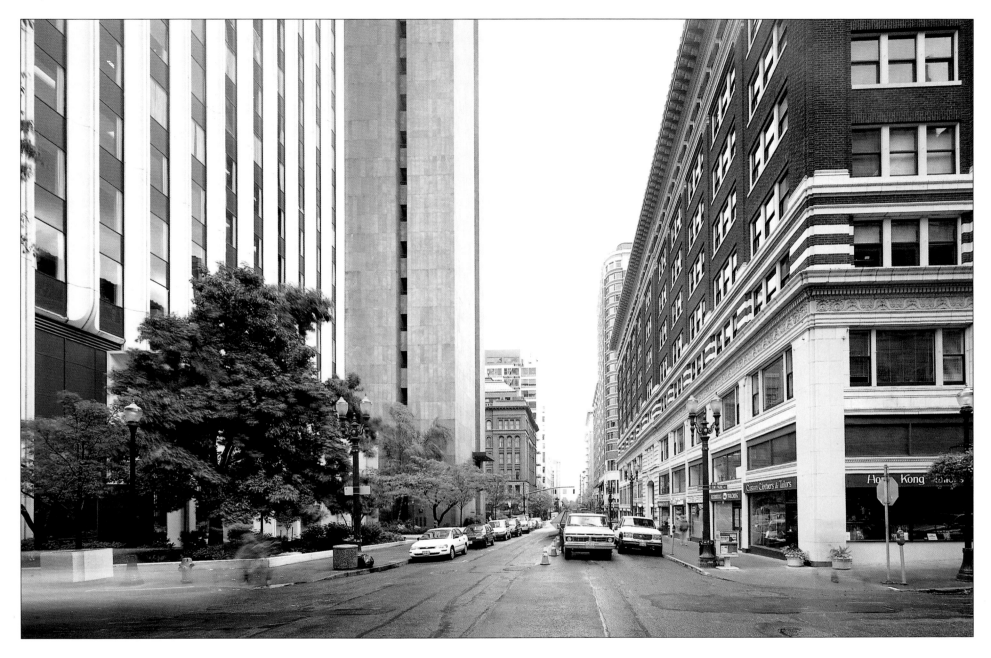

The same streetscape is now a study in sharp contrasts. The Morgan Building has aged well and contains a mixture of businesses on the ground floor and offices above. For a time it housed a thriving mall, until a fire some years ago caused its temporary closure and other businesses lured shoppers elsewhere. Across the street is the modern Bank of California Building (*left foreground*).

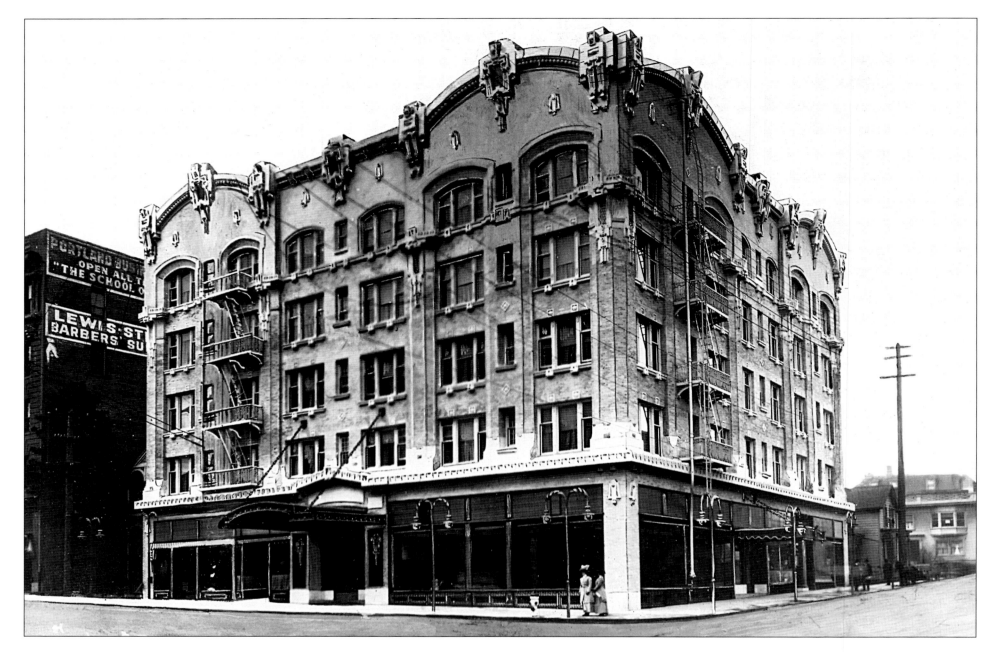

Fanciful as a piece of confection, the Seward Hotel at the corner of Southwest Tenth and Alder added a touch of elegance to the west edge of Portland's retail core when it was built in 1909. Its architect, William Knighton, used terra-cotta trim in a unique way, helping to earn the building a place on the National Register of Historic Places. Inside, the lobby of the "Hotel of Quiet Elegance" featured mahogany and Circassian walnut. *Oregon Historical Society, # OrHi 39256*

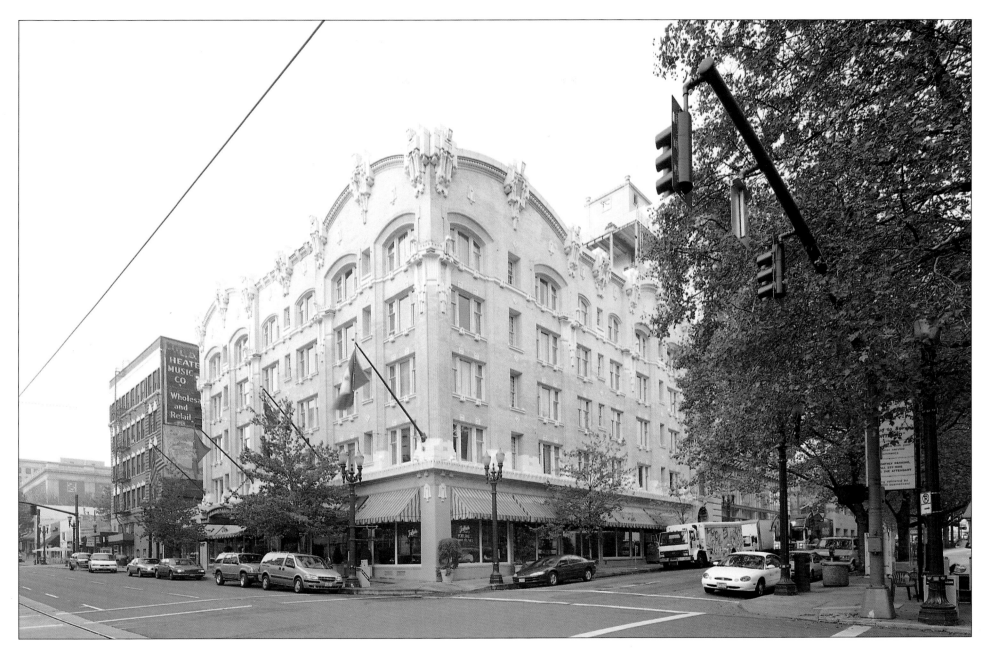

Although the old Seward Hotel (renamed the Governor in 1932) sat empty for some time, it was renovated in the mid-1980s and reopened as one of Portland's most distinctive hostelries. The old Elk's Temple abuts the rear of the hotel and provides guests with first-class meeting, banquet, and guest rooms, as well as a health club. The bell-shaped shields at the street-level corner of the hotel appeared on all of William Knighton's buildings.

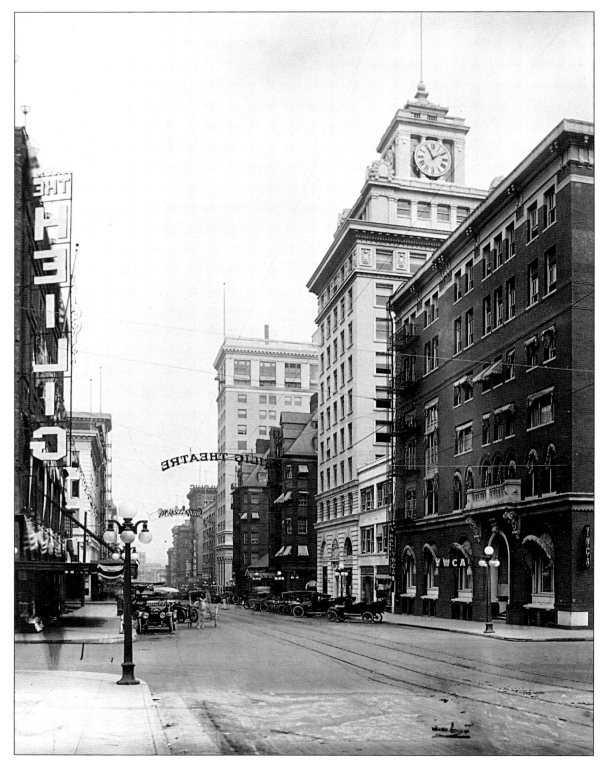

When the Reid Brothers of San Francisco designed the headquarters for the *Oregon Journal*, Portland's evening paper, they conceived of the twelve-story tower as a "wedding cake." Flanked on one side by the YWCA Building and on the other by the Portland Hotel, the 1912 Journal Building offered the city's highest observation point. At night the building was outlined—as it is today—by electric lights. *Oregon Historical Society, # OrHi 102077*

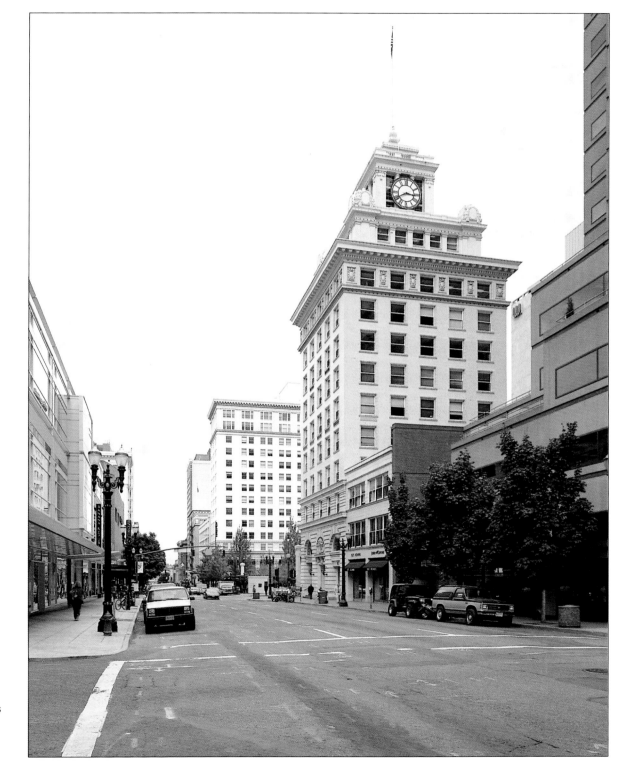

After the newspaper moved to new headquarters near the Willamette River, the old Journal Building was renamed Jackson Tower, after publisher Sam Jackson. Now it and the American Bank Building behind it remain as gracious reminders of Portland's terra-cotta era, while sleeker modern buildings like the Fox Tower (*left*) and the Pacific First Center (*right*) vie for attention.

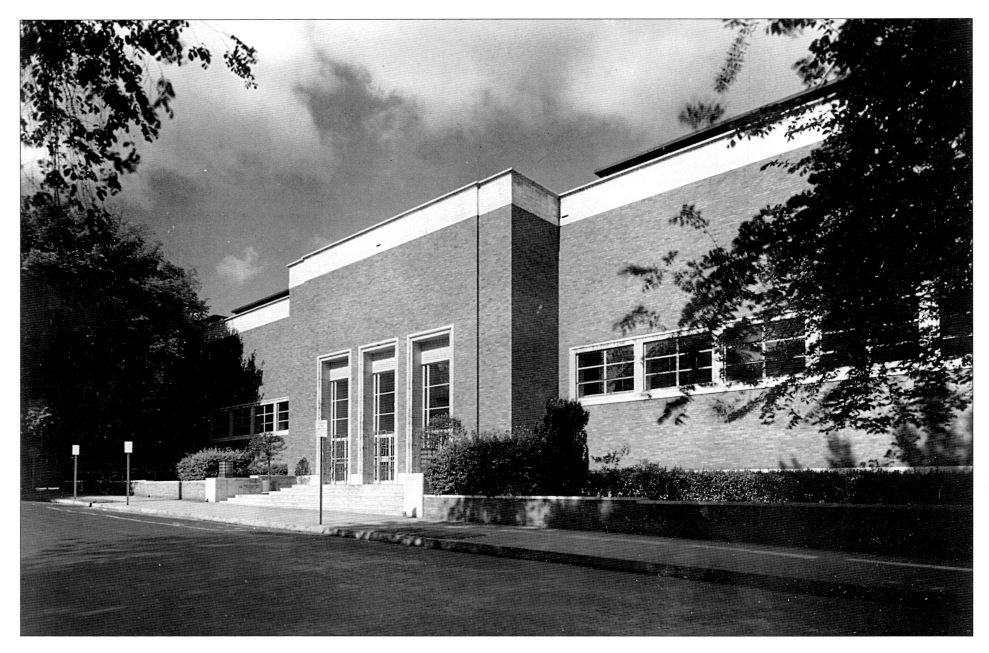

In 1852 farsighted pioneers set aside twenty-five blocks of parkland running north to south through Portland without knowing what their exact use would be. But as the city spread westward, the "South Park Blocks" were chosen as an ideal place to locate some of the city's most important cultural institutions. One of those institutions, the Portland Art Museum, was designed in 1930 by Italian immigrant Pietro Belluschi. *Walter Boychuk photo, Oregon Historical Society, # OrHi 43184*

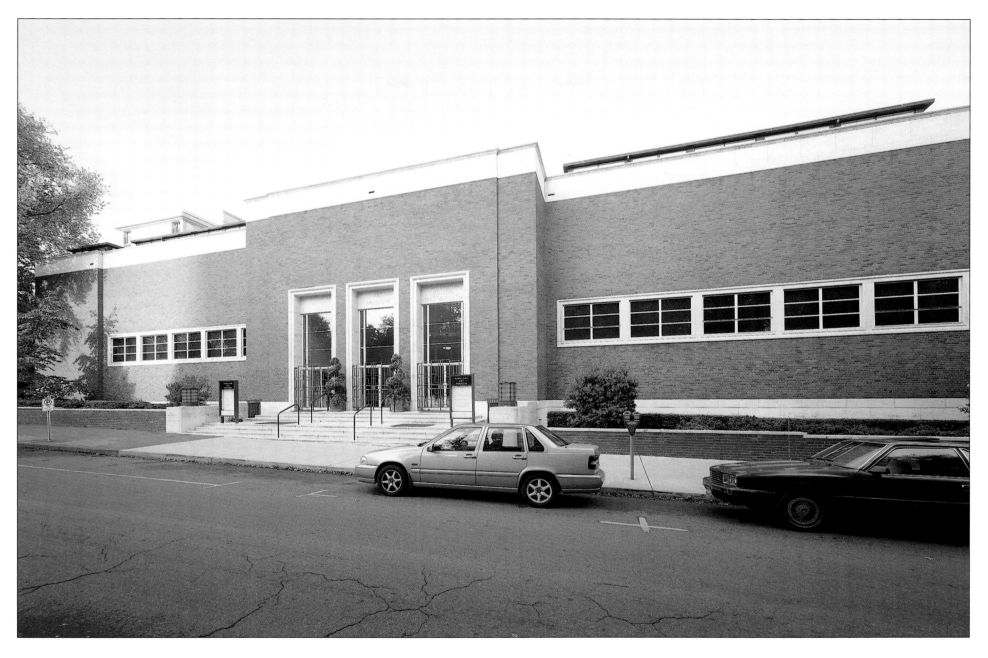

The museum, later listed as one of the 100 best-designed American buildings, is notable for its elegant, clean lines; pleasing combination of orange-red brick and travertine marble; and lack of historical ornamentation. The same unadorned, modern design is carried out in the interior, which recently underwent a forty-five million dollar renovation to provide more gallery space and other amenities.

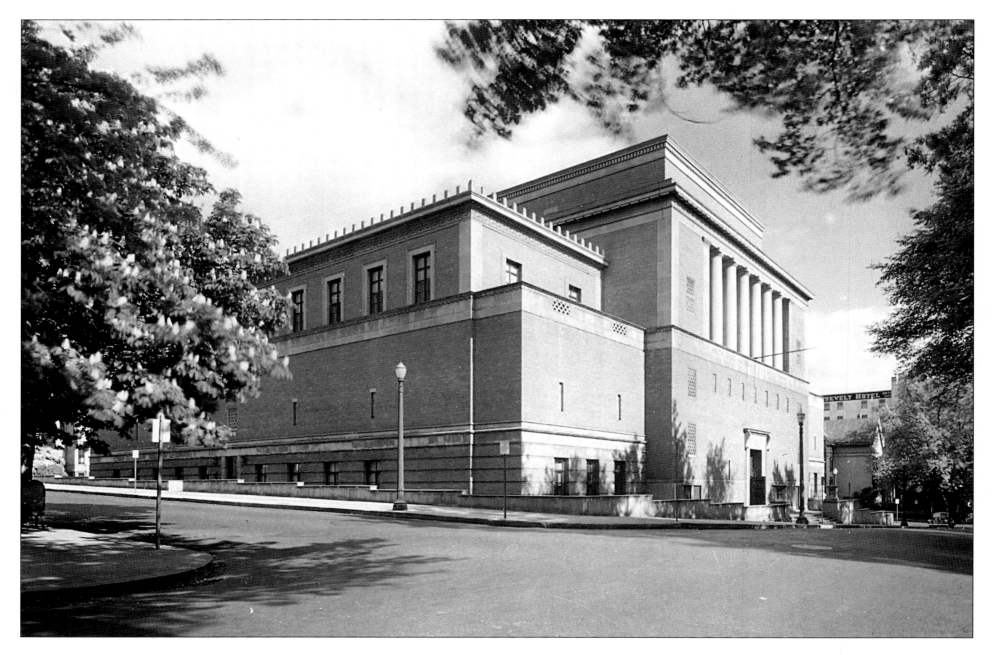

Immediately north of the Portland Art Museum, is the 1924 Masonic Temple, an almost foreboding, tomb-like building with historical associations in its cast-stone colonnade (Greek), window grilles and central door (Byzantine), and interior rooms, including the exotic sunken ballroom. *Walter Boychuk photo, Oregon Historical Society, # OrHi 42449*

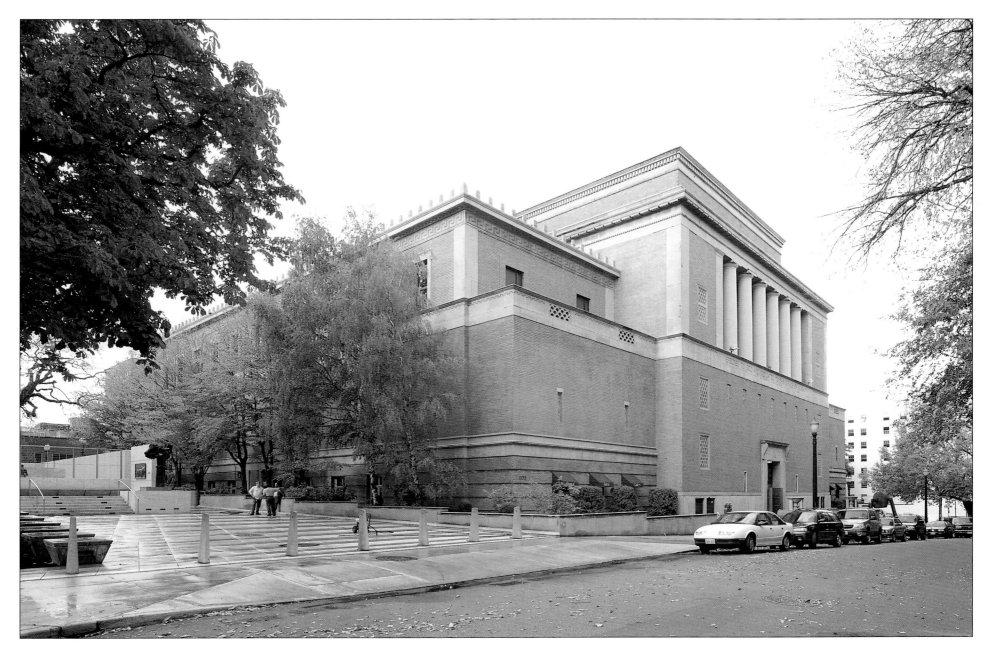

Over the years, the Masonic Temple has been used for lodge events, high school proms, exhibits, performances, and office space for various nonprofit arts groups. In 1994 it was purchased by the Portland Art Museum and today provides a new exhibition gallery, as well as offices and conference space.

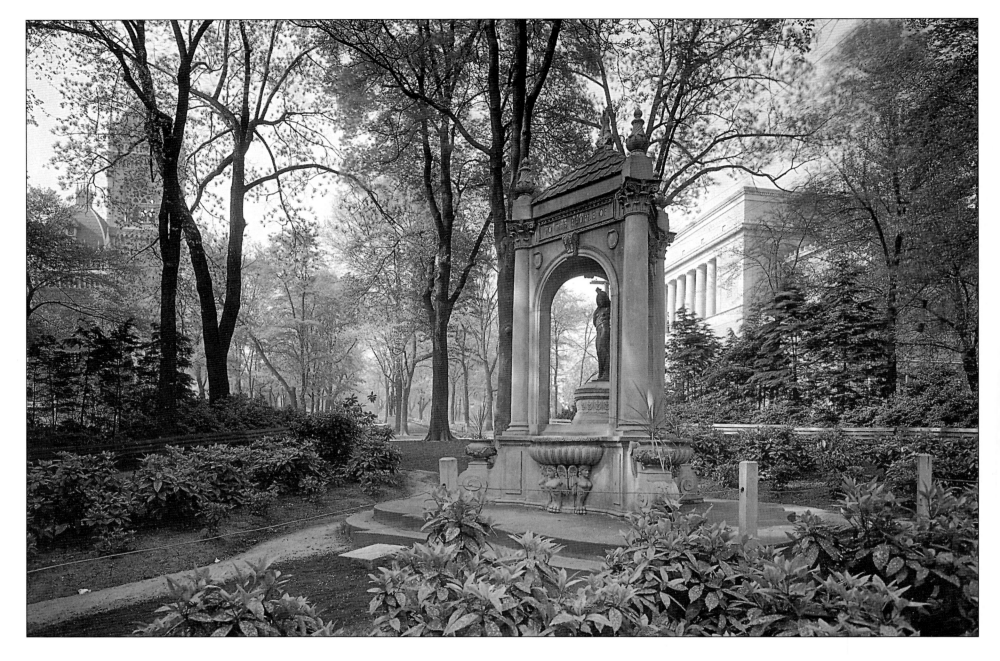

The fountain *Rebecca at the Well* was a symbolic addition to the South Park Blocks when it was unveiled in 1926. It was given to Portland by Polish-born Jewish immigrant Joseph Shemanski in gratitude for the many blessings the city had bestowed on him. Behind it (*far right*) is the Masonic Temple. *Walter Boychuk photo, Oregon Historical Society, # OrHi 43188*

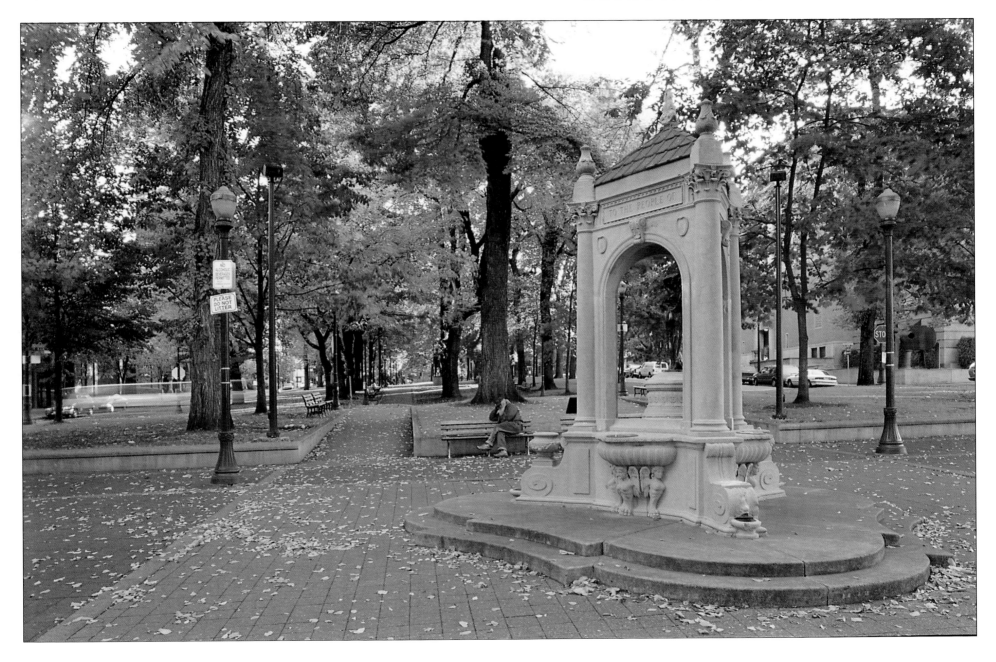

The canopied fountain—often called the Shemanski Fountain—is made of bronze and sandstone, with three inner fountains for people and three outer basins for animals. Sculptor Oliver Barrett and architect Carl Linde collaborated on the biblically inspired design.

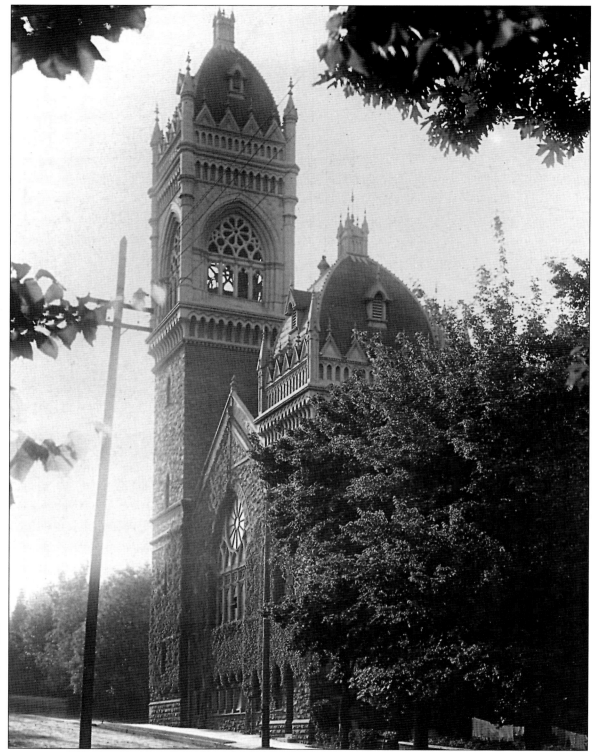

The lovely Venetian Gothic First Congregational Church, 1895, between Madison and Main streets is a serene and stately presence on the South Park Blocks. The original church was designed by a transplanted Swiss architect, Henry Hefty, and had three towers, two of which are visible here. *Oregon Historical Society, # OrHi 52745*

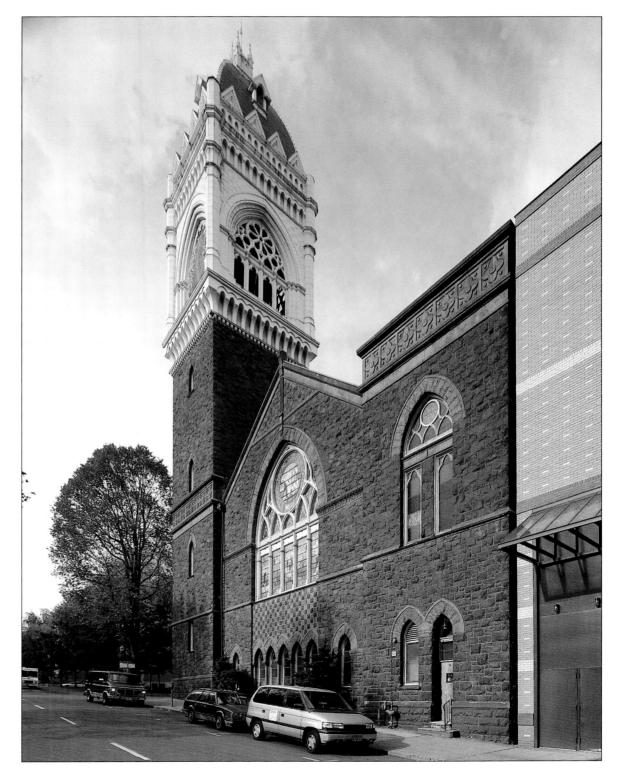

Now on the National Register of Historic Places, the First Congregational Church has lost its two 100-foot towers. They were removed in the 1940s in an unfortunate attempt to modernize, but its tallest tower remains. The building that abuts the church (*right*) is part of the Performing Arts Center complex.

Ivy covered walls and pristine Jacobethan Revival detailing
give an appropriately academic air to the University Club, the
city's third private men's club. The group organized in 1898
with fifty-six charter members—most of whom were alumni of
Eastern colleges and universities. Its clubhouse was designed by
Whitehouse & Fouilhoux and built in 1913. The building later
earned recognition in various architectural competitions.
Oregon Historical Society, # OrHi 78774

Beginning in October 1903 the University Club began admitting wives to some of its functions. Today, women as well as men form the membership. When the club had its seventy-fifth anniversary in 1972, one early member recalled that "We sang at lunch time, the cocktail hour, and dinner. We greeted our guests with song. Whenever any four guys met in the bar or lounge, they huddled together and began harmonizing."

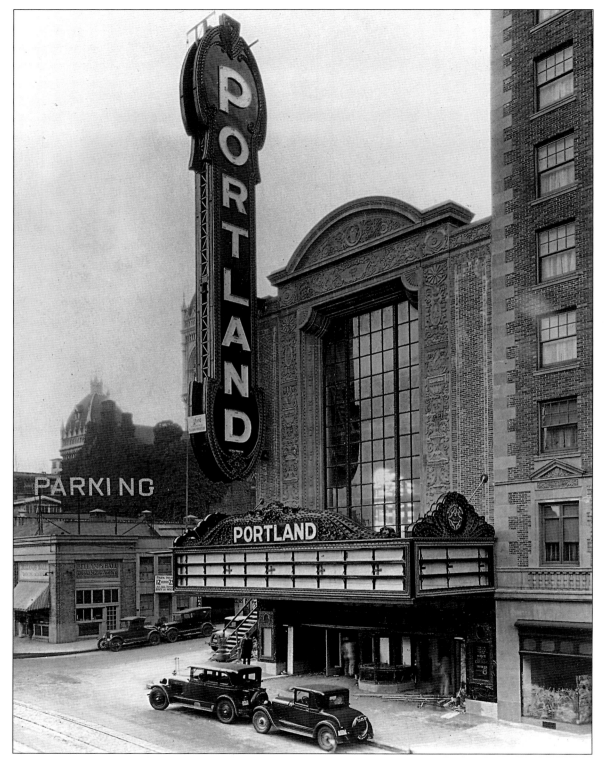

From the 1920s into the 1990s, Portland's Broadway, like its New York City counterpart, was a theater district. The Portland Publix (renamed in 1930 the Paramount) Theatre was the grandest of those grandiose movie palaces, designed by the nation's leading theater architects, Rapp & Rapp, and completed in 1928 in the Northern Italian Rococo Revival style. *Oregon Historical Society, # OrHi 47550*

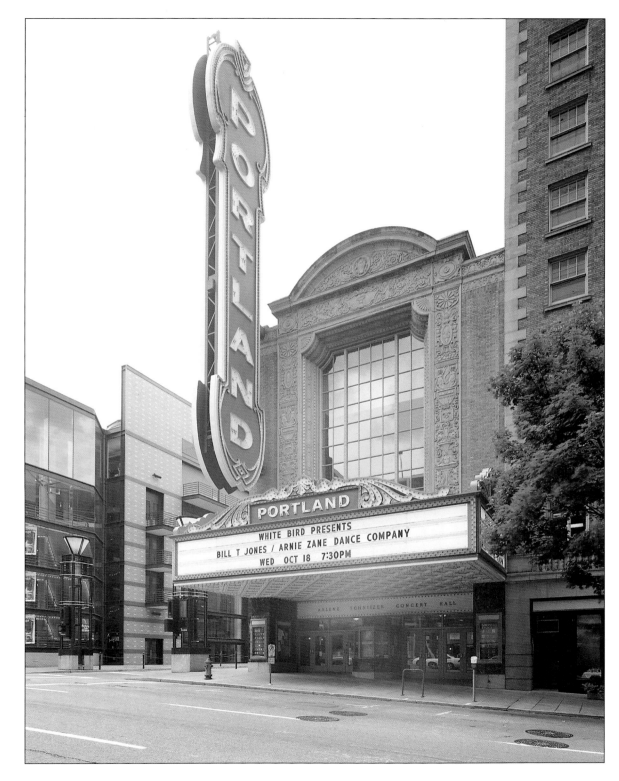

When the Paramount Theatre gained National Historic Landmark status in 1976, it was being leased by a group that put on rock concerts and its future was uncertain. But in 1980 it was acquired by the City of Portland and in 1984 it reopened as the 2,800-seat Arlene Schnitzer Concert Hall, the first performance hall in a three-theater complex that includes the building seen here on the left.

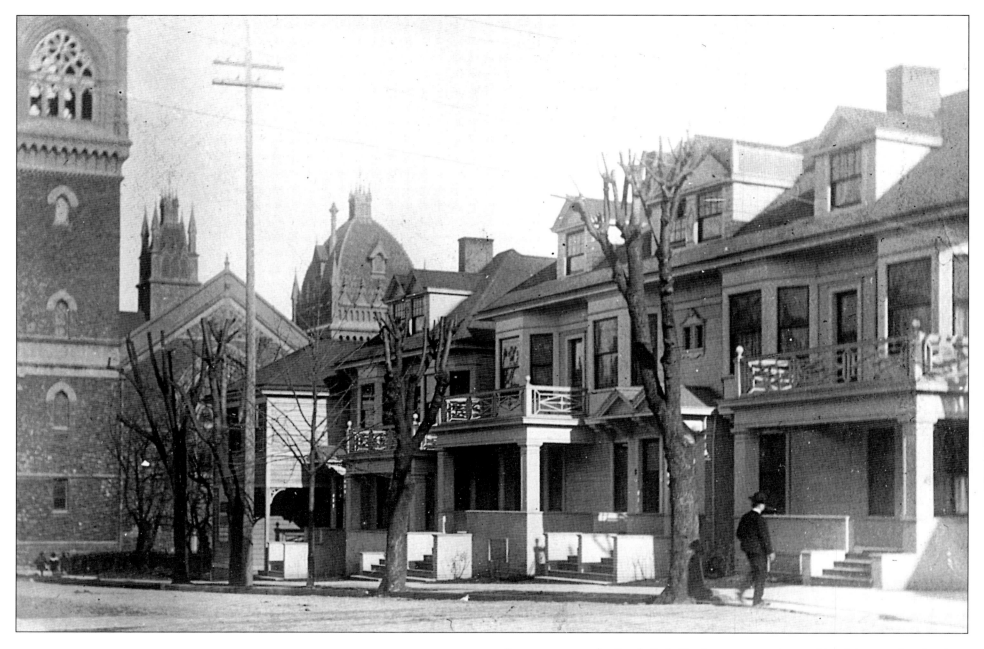

For many years, the South Park Blocks were a gracious residential area—first for the city's wealthy, who built grand mansions, and later for apartment dwellers. In this 1905 photograph, modest apartments line the street in the block south of the First Congregational Church. Later, the land was acquired in stages by the Oregon Historical Society for its museum, bookstore, press, and research library. *Seth Pope photo, Oregon Historical Society, # OrHi 12922*

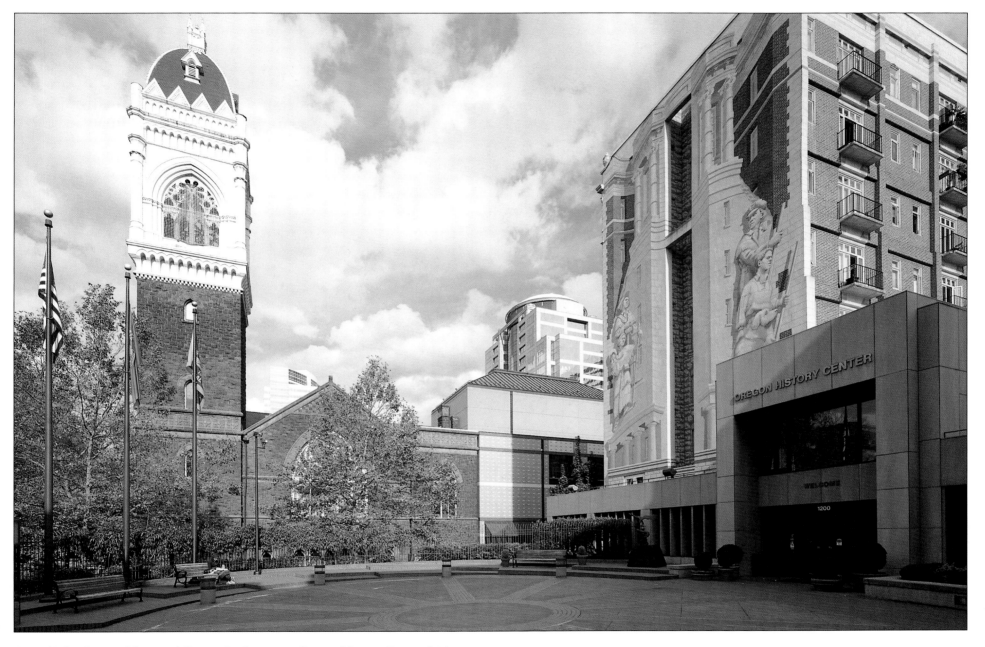

In 1966 the Oregon Historical Society built its new Oregon History Center (*right foreground*) on the south half of this block, and in later years bought the historic Sovereign Hotel (*right center*) to house the Society's offices. In 1989 the Society commissioned two *trompe l'oeil* murals for the hotel's west and south faces. The west mural (seen here) shows members of the 1804–06 Lewis and Clark expedition.

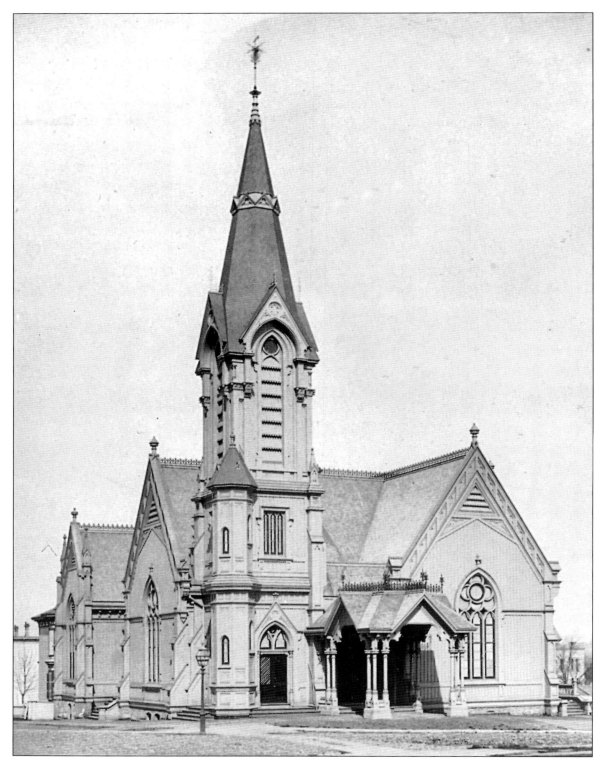

Another lovely church, at Southwest Eleventh and Clay, is the old Calvary Presbyterian. Generally considered to be the best wooden building in the High Victorian Gothic style in Oregon, the church was designed by prominent local architect Warren H. Williams and built in 1882–83 on land donated by William S. Ladd, a pioneer of 1851 and a leading local businessman. *Oregon Historical Society, # OrHi 23683*

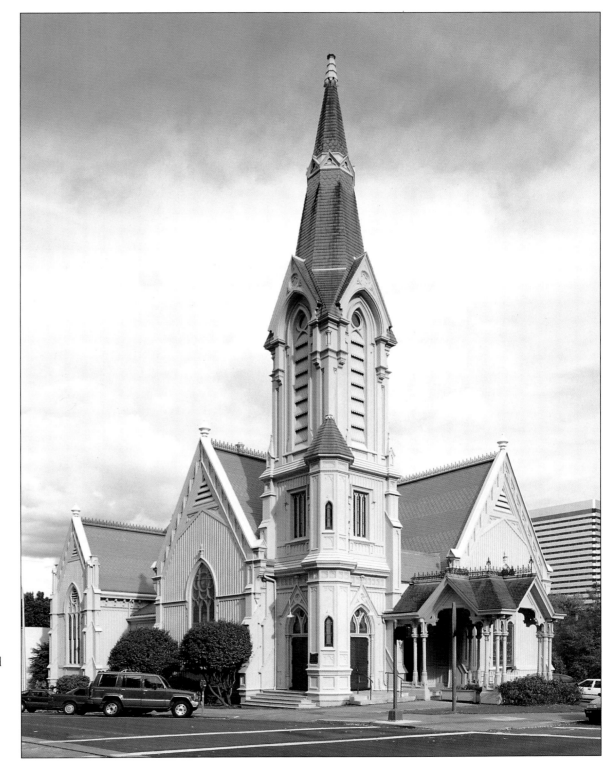

Now known as "The Old Church," the building has been restored by the Old Church Society—which acquired it in 1969—and is used for meetings, lectures, and recitals. Among the elements restored during renovation in the early 1980s is the porte-cochere, which was removed some two decades earlier. The church has been placed on the National Register of Historic Places.

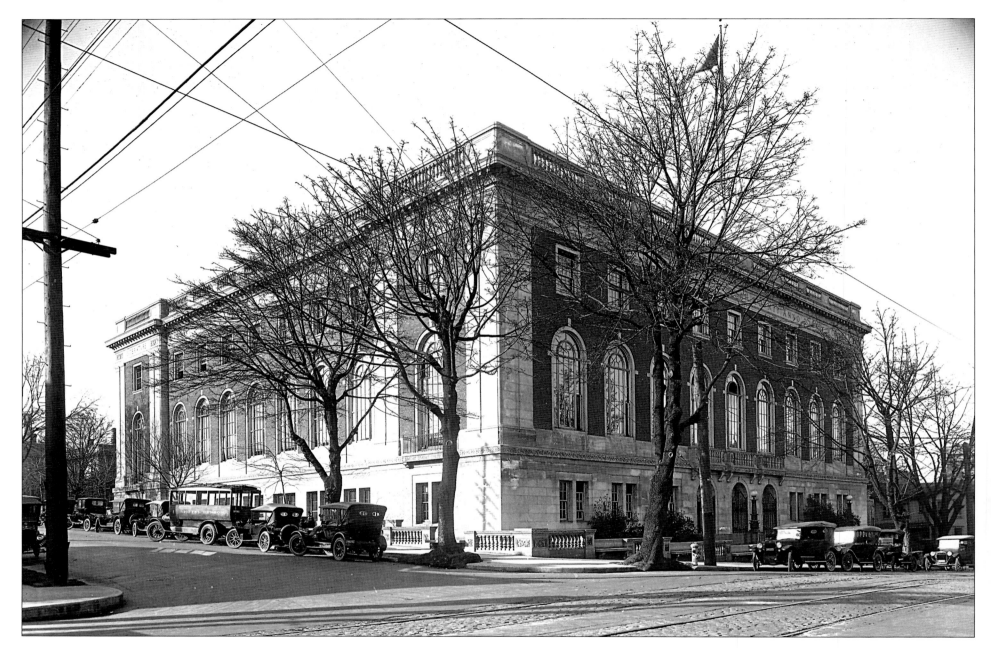

When Central Library was completed in August 1913, the event marked the high point in Portland's love affair with one of its earliest cultural amenities. The library occupied an entire block and was designed by architect A. E. Doyle in an expression of the Georgian Revival style. Its stately interior featured a central lobby and stacks surrounded by reading, exhibit, and lecture rooms. *Benjamin Gifford photo, Oregon Historical Society, # Gi 10106*

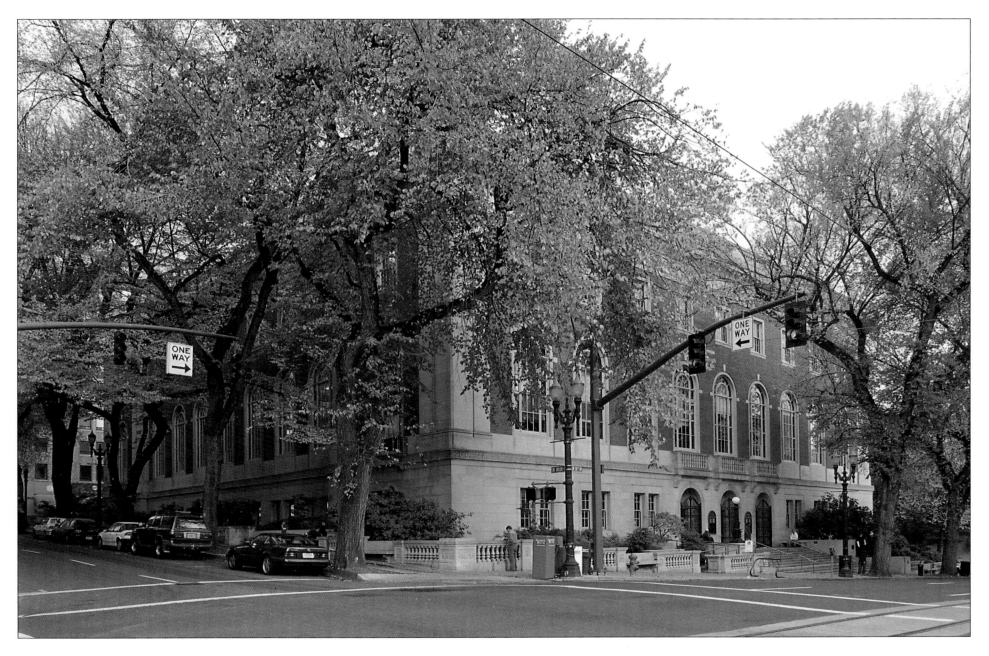

Over the years, the Central Library's interior was the victim of several well-meaning
attempts to modernize. In 1991 structural defects were detected that could cause
partitions in the reading rooms to collapse, and temporary scaffolding was erected
to protect patrons. Renovation began in 1994, and three years later a splendid "new"
Central Library opened to wide public acclaim. Portland's love affair with the
library continues.

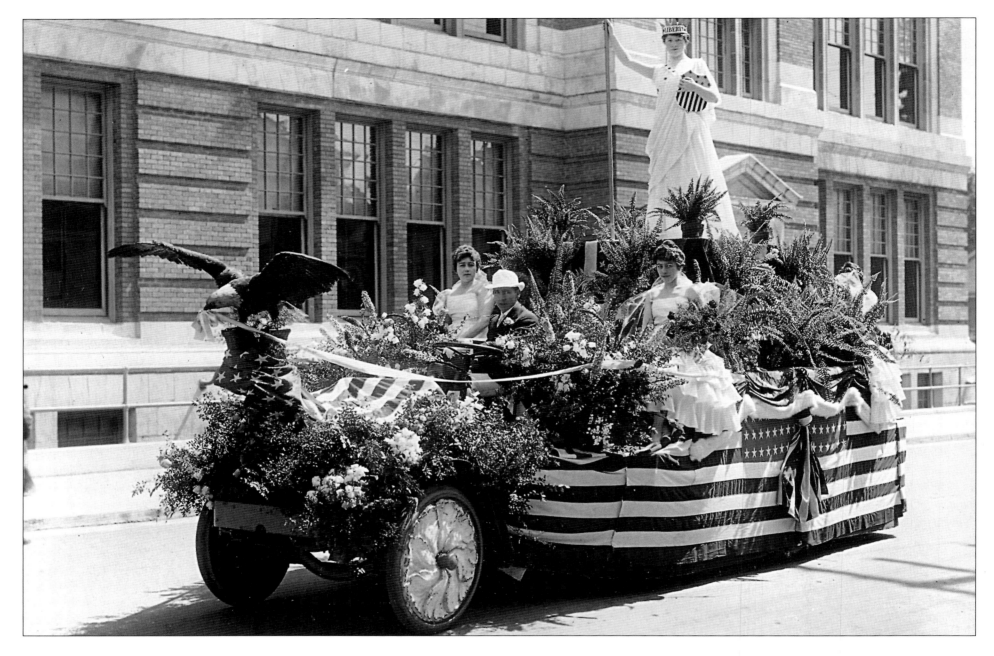

On July 4, 1916, a float featuring the "Goddess of Liberty" pauses for its portrait in front of Lincoln High School, which had been built four years earlier. The American Renaissance Revival building, second home of the city's first high school, was the work of Portlander Morris Whitehouse and Frenchman Jacques André Fouilhoux, who later helped design Rockefeller Center in New York City. The high school closed its doors in the spring of 1951. *Benjamin Gifford photo, Oregon Historical Society, # Gi 6615a*

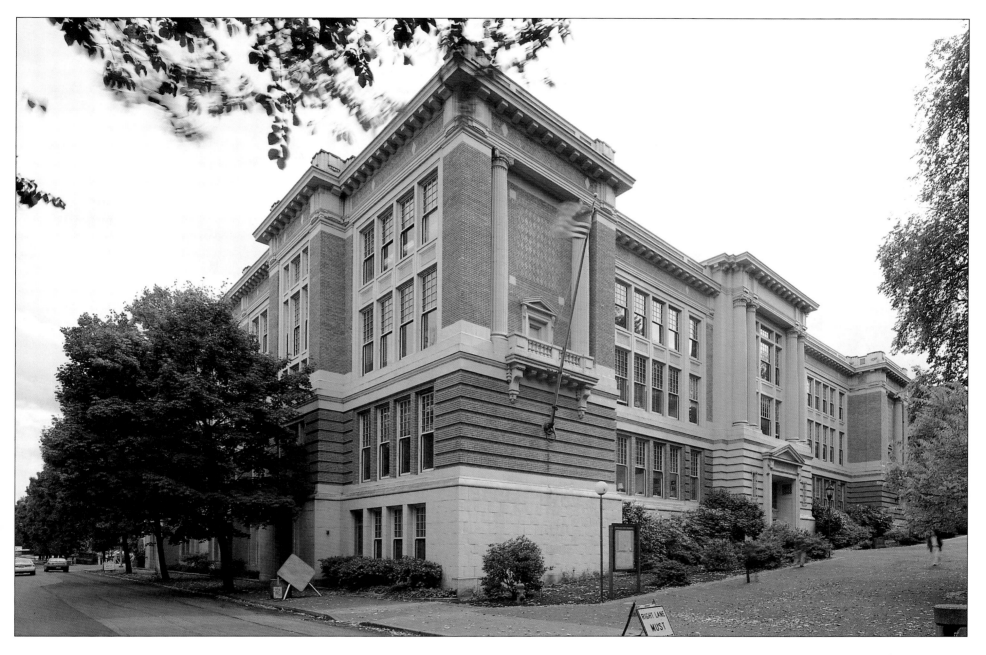

By September 1952 Lincoln High School had been transformed into Lincoln Hall, the first building on the Park Blocks campus of Portland State University. The university dates from the Vanport Extension Center, founded in 1946 and destroyed by a 1948 Columbia River flood. After an interim stay in St. Johns, the institution moved downtown as Portland State Extension Center. In 1955 it became Portland State College and in 1969 it acquired university status.

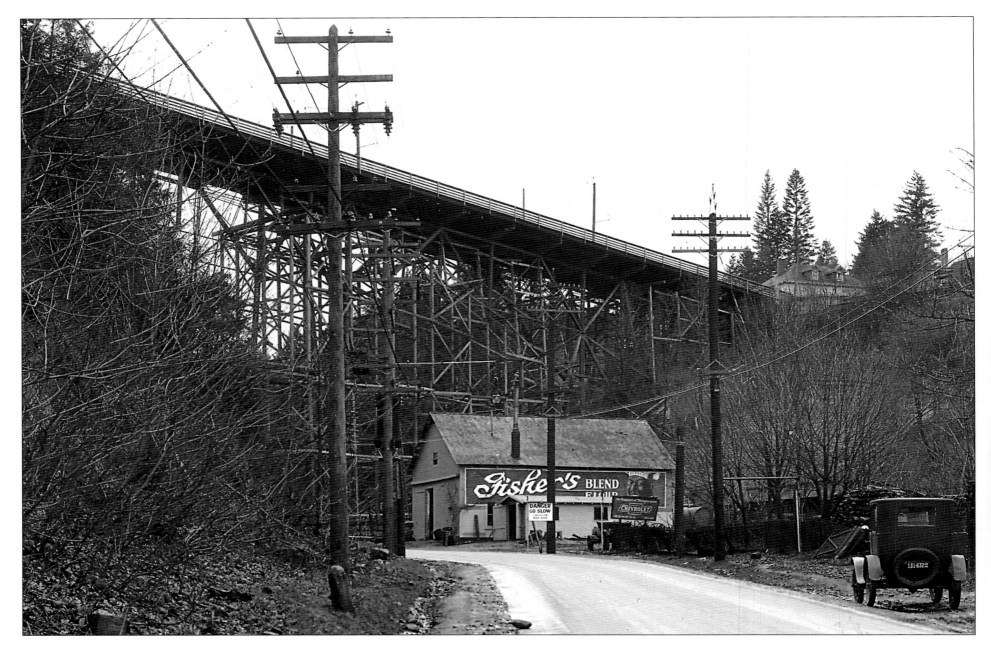

"Down in the Hollow, Up in the Heights" was one way early twentieth-century Portland neighborhoods thought of themselves. When this photograph was taken at the edge of Goose Hollow, the wooden Ford Street Bridge had become too dilapidated to continue carrying streetcars and foot traffic up to Portland Heights, and residents of that affluent neighborhood were agitating for a replacement. *Oregon Historical Society, # COP 02184*

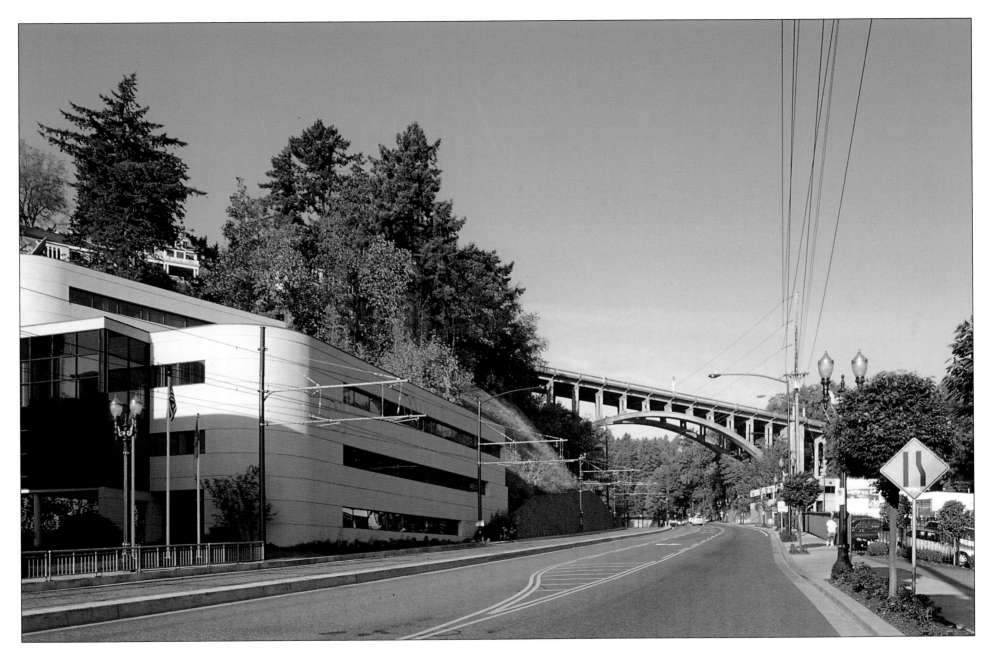

The new Vista Avenue Viaduct, built in 1926, is typical of the arched bridges that were popular in America during the 1920s and 30s. It is constructed of reinforced concrete and has supports detailed to resemble classical columns with stylized bases and capitals. The new bridge carried the now-defunct Council Crest streetcar line and in later years acquired the grim nickname "Suicide Bridge."

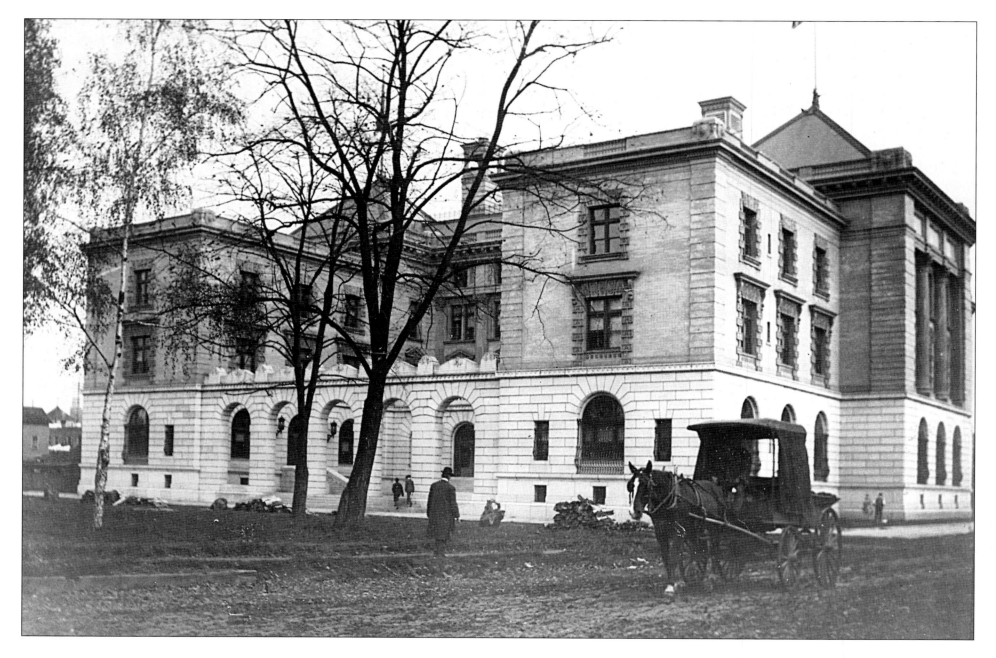

Portland's status as the Northwest's chief port created so much activity that by 1897 a new Customs House was needed. When the U.S. Treasury Department built on the North Park Blocks the next year, it spared no expense—outfitting the imposing new edifice with a grand staircase, cast-iron balustrades, brass fittings, and oak paneling. In its tower (*center*), a ball dropped each noon signaling the hour to ships on the river. *Oregon Historical Society, # OrHi 68518*

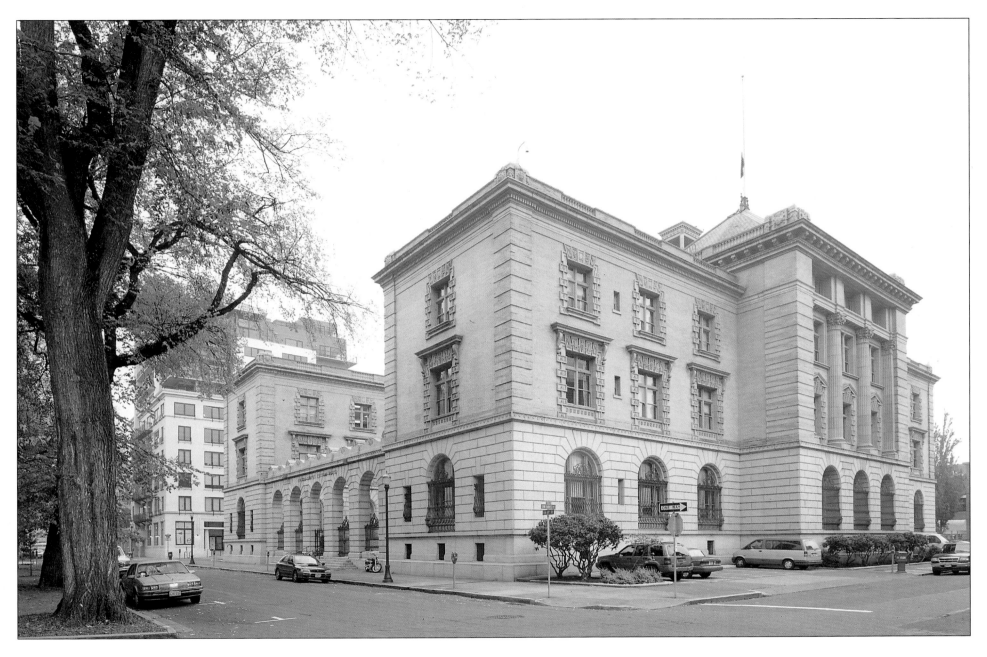

When the Customs House was built, lavish courtrooms were added for use by the federal court. But at the time, the facility was considered to be "too far out of town" and the courtrooms were never used. In later years, the building suffered from ill-advised remodeling as other federal tenants were accommodated. In 1974 it was placed on the National Register of Historic Places and today remains one of Portland's finest buildings.

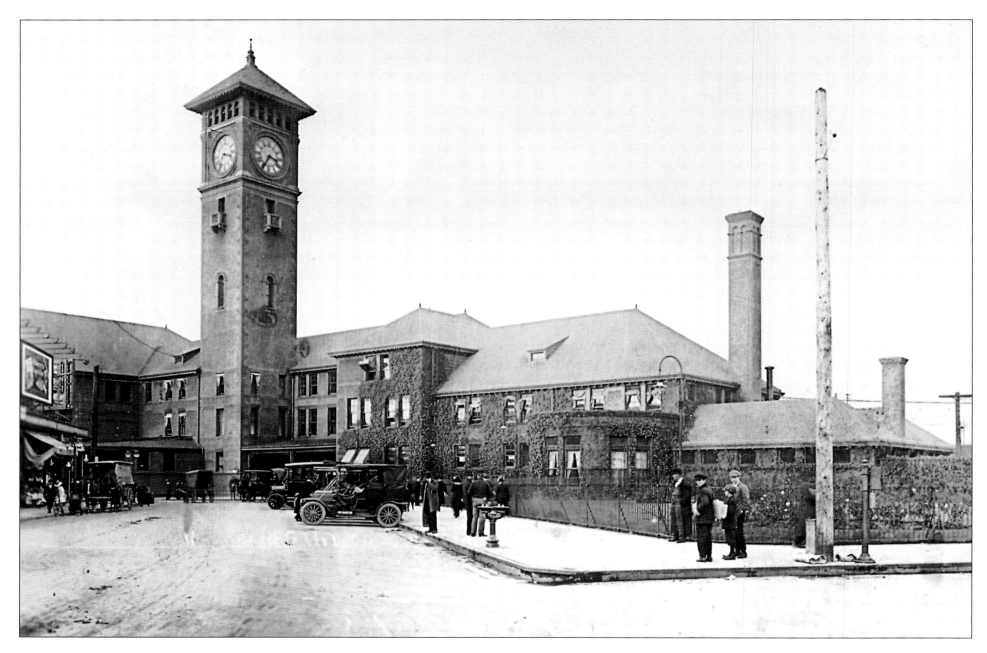

Begun in 1890 as the Grand Union Depot and completed six years later, Union Station provided new rail accessibility to Portlanders. The finished station's massive 496-foot-long brick exterior featured a 140-foot clock tower, tiled roof, ornamental stone, terra cotta, art molded bricks, and carved stone details. Eventually, five passenger lines—Southern Pacific, Northern Pacific, Great Northern, Union Pacific, and Spokane, Portland & Seattle—connected to the depot. *Oregon Historical Society, # OrHi 17571a*

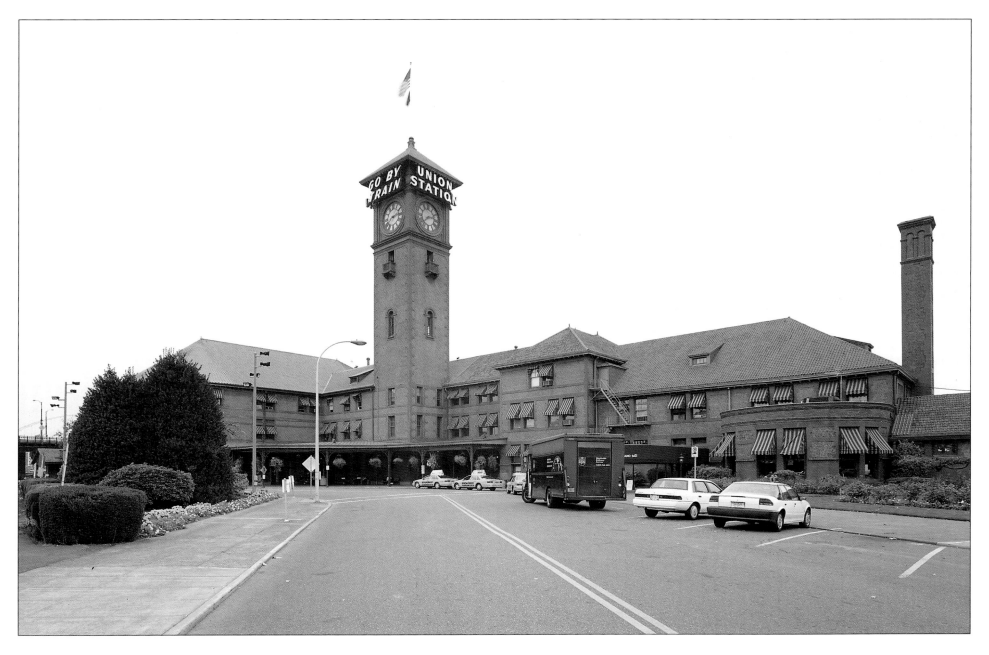

Long recognized as a Portland landmark, Union Station retains many of its original
exterior features, although in the 1930s the station's interior was remodeled under the
direction of distinguished Northwest architect Pietro Belluschi. In its halcyon days
the depot served seventy-four trains daily, and during World War II the station was
used by more than 4.8 million people. By 1971 Amtrak replaced the private passenger
lines servicing the station.

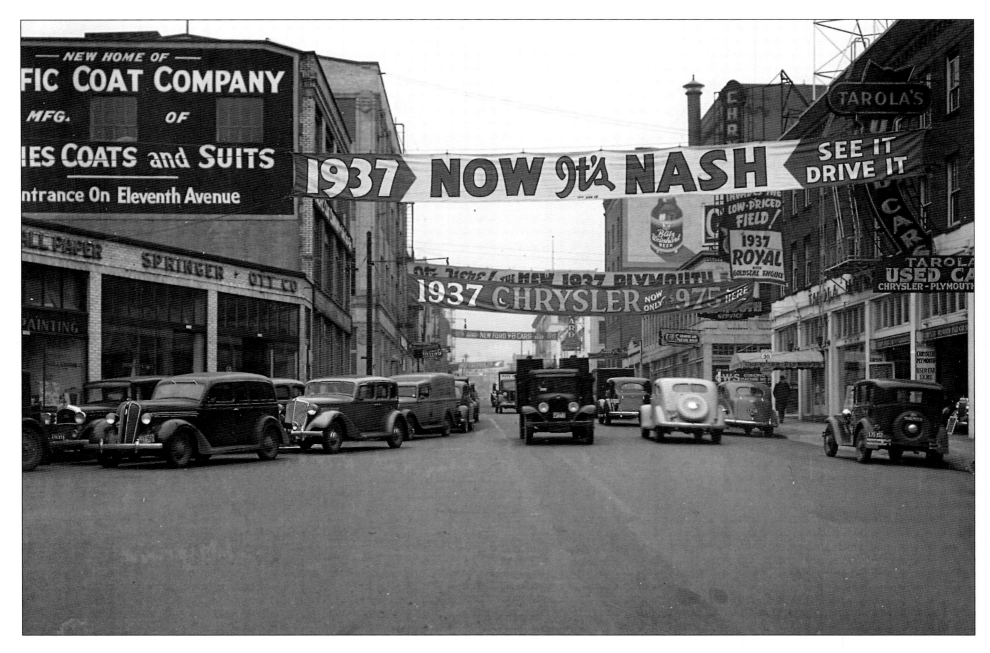

At the intersection of Southwest Tenth and Burnside on New Year's Eve 1936, auto dealers proudly announced new models of Nash, Chrysler, Plymouth, and Ford. Beyond the Chrysler banner on the right is the Blitz-Weinhard Brewery, built in 1908. The brewery operated here from 1864 to 1999 and was known as the West's oldest continuously operating brewery. *Oregon Historical Society, # COP 01708*

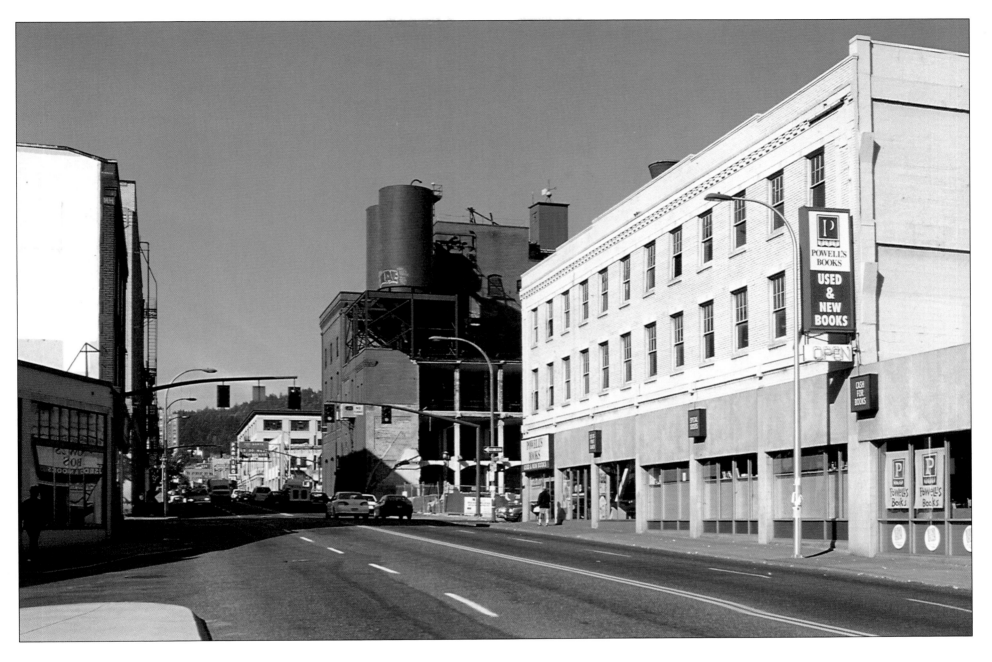

Powell's Books, on this block since 1971, eventually acquired the three-story building housing Tarola's Used Cars (see photo on facing page). Today Powell's has several buildings and stocks more than one million books. Beyond Powell's, a major portion of the Blitz-Weinhard Brewery—the brewhouse and hop and malt building—awaits transformation to the multiuse Brewery Blocks development planned in the former warehouse district known as "The Pearl."

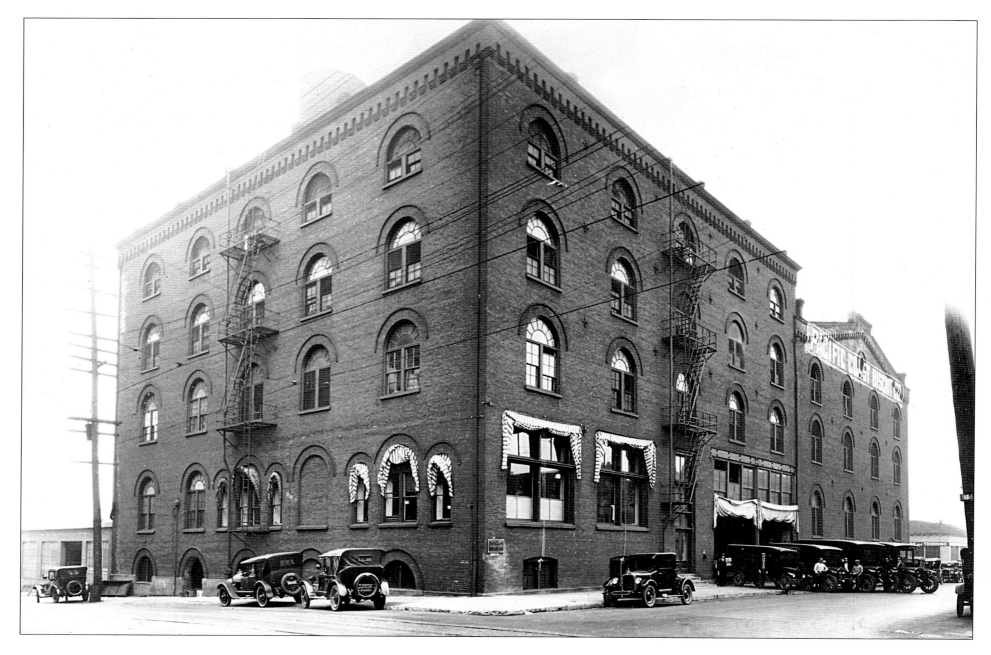

The historic Pacific Coast Biscuit Company at Northwest Davis and Eleventh Street was built in 1891 and expanded in 1905. This masonry structure, with especially fine brickwork, reflects the manufacturing history of Northwest Portland. It was built for Herman Wittenberg, whose wholesale bakery, Portland Cracker Company, evolved into the Pacific Coast Biscuit Company. With its many regional offices and factories, Wittenberg's business employed over 100 salesmen and 2,000 workers.
Oregon Historical Society, # OrHi 76592

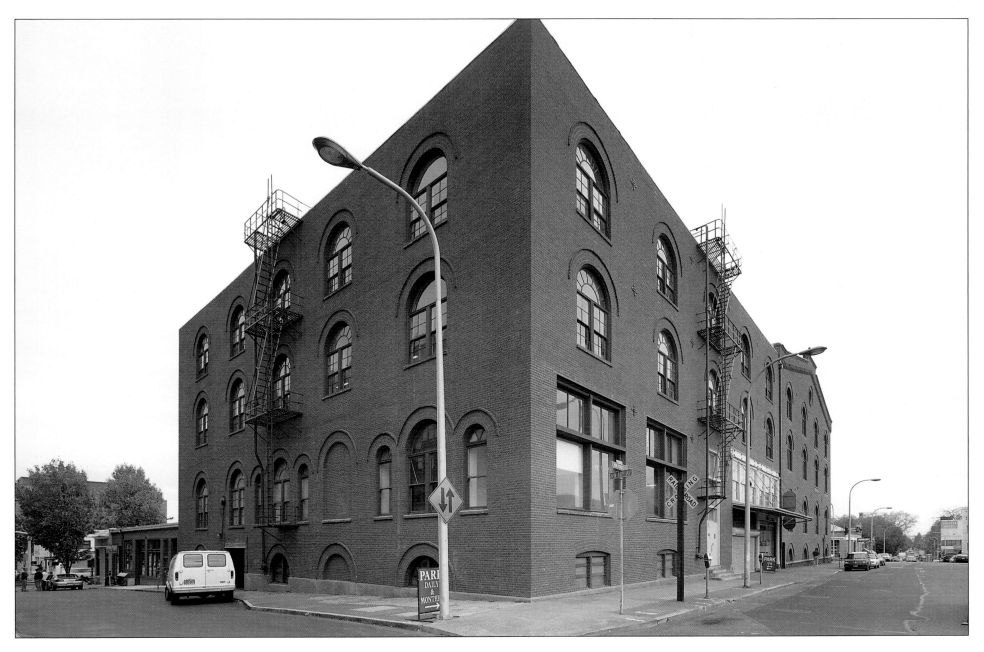

The Pacific Biscuit Company Building remained a cracker manufacturing center until 1930, when the National Biscuit Company, Nabisco, bought it. Nabisco carried on operations at the site until 1954, but later the building was stripped to become a parking structure. It continues to serve that function today, while all around it warehouses and dilapidated storefronts are being remodeled to meet the demand for boutique and office space in the newly gentrified Pearl District.

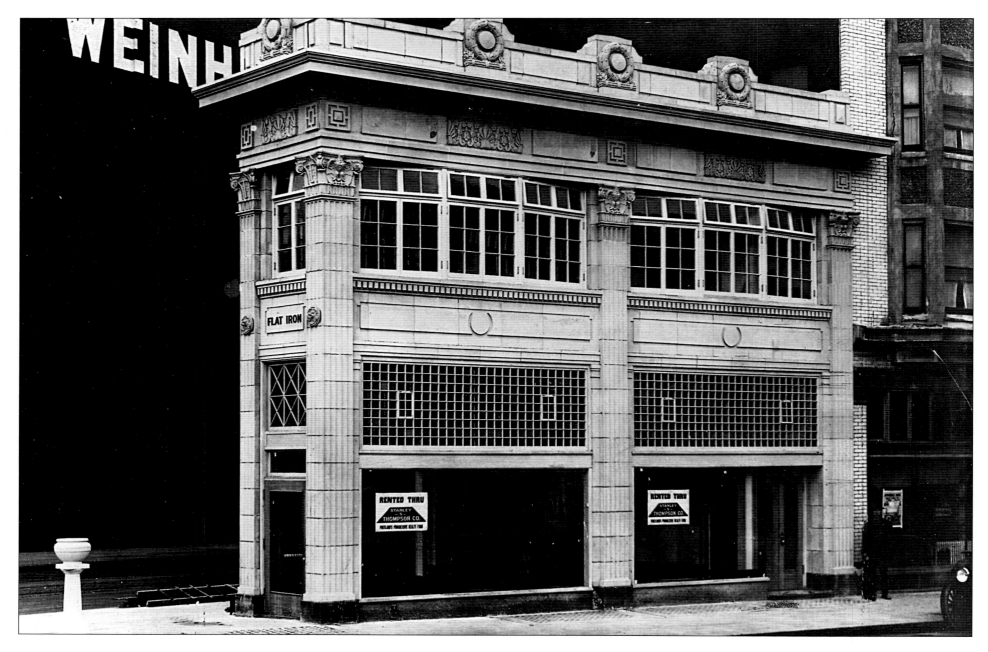

A particularly interesting building, at Southwest Stark and West Burnside streets, is the diminutive Flatiron Building of 1917. While most Portland buildings are suited to the city's rectangular blocks, the Flatiron was a response to the non-grid, diagonal lines of West Burnside, which created triangular lots. The unusual trapezoidal-shaped, cast stone structure drew praise for the fine symmetry of its two long sides.
Oregon Historical Society, # OrHi 90082

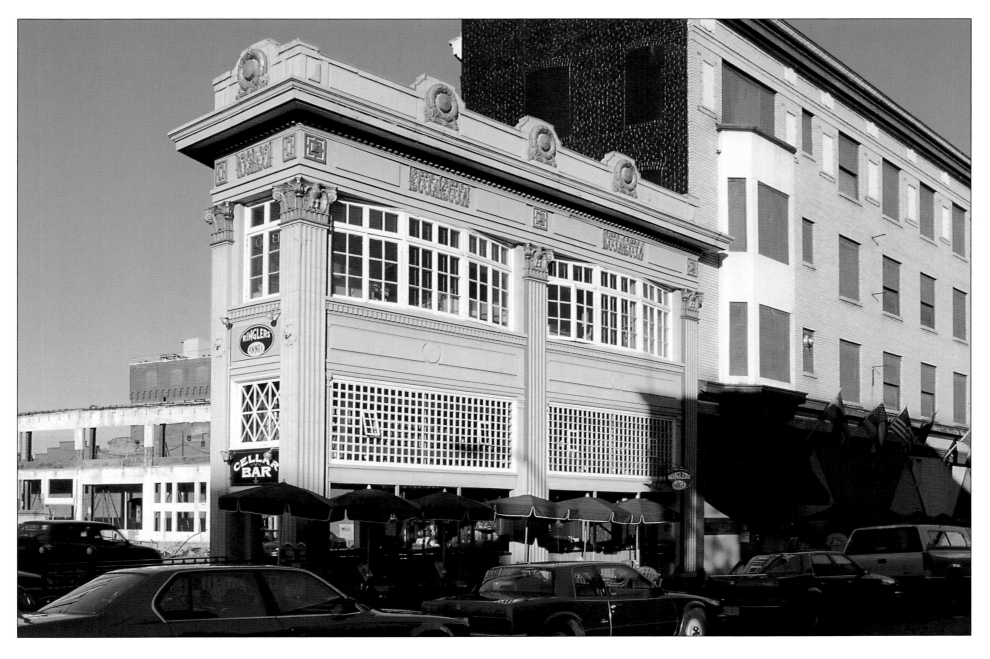

For much of its history, the Flatiron Building served the automotive industry in the West Burnside area, which by the 1920s was lined with all manner of auto dealerships, gas stations, and garages. From 1949 to 1962 the building housed a cafeteria. Later, it became a radio station, and now it is Ringler's, a restaurant and bar operated by the McMenamin brothers, who specialize in reclaiming interesting historic buildings.

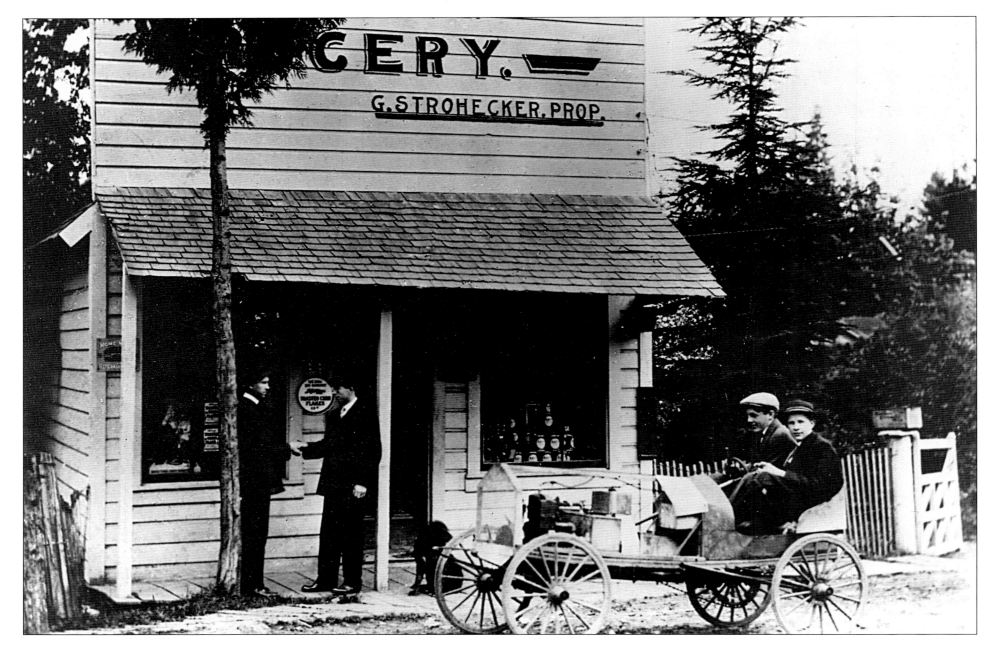

In 1902, when Portland's south hills were known as Mt. Zion, Gottlieb Strohecker and his sons started the Mt. Zion Grocery. At the time, one of them later remarked, "it was the size of a modern two-car garage" but carried "all the things people used in those days." The car in this photo was the invention of a customer and had a marine engine, visible through the transparent hood. Many customers also relied on the store's free horse and buggy delivery service. *Oregon Historical Society, # OrHi 66946*

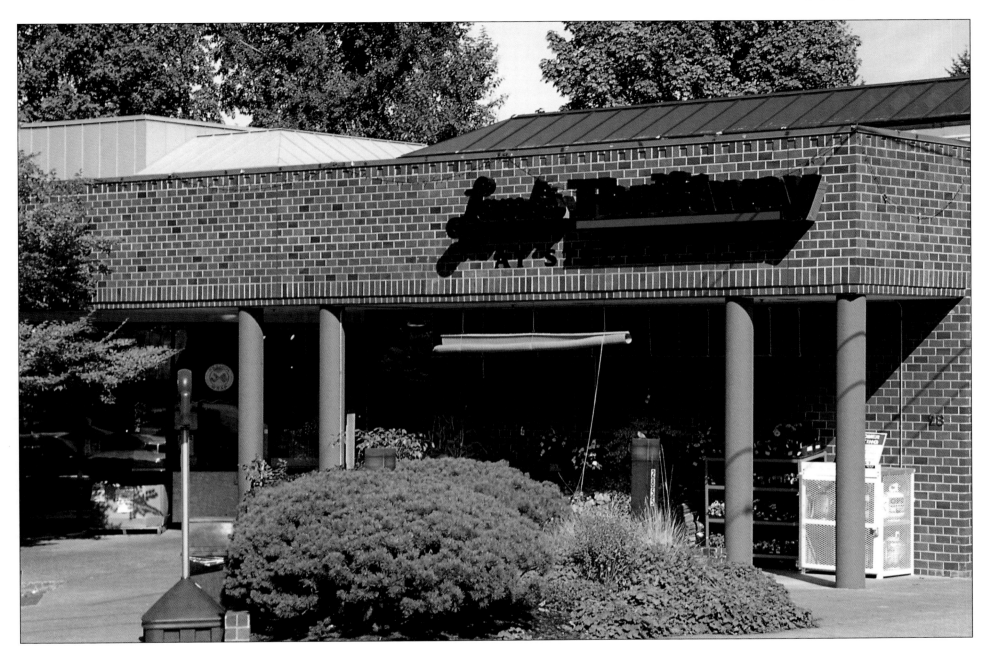

Over the years, Strohecker's gained a reputation for stocking hard-to-find gourmet items as well as more traditional groceries for its well-heeled West Hills patrons. The store has been remodeled many times and is now quite large behind its deceptively modest storefront on Southwest Patton Road. For many years the store was staffed by family members, but in 1997 it became a Lamb's Thriftway and most have retired.

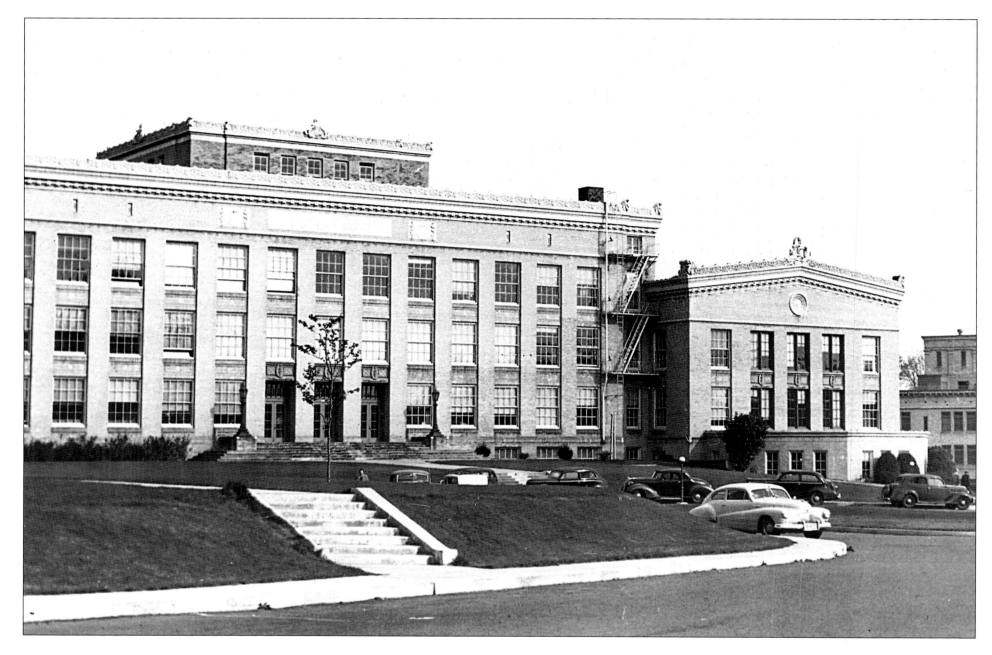

Oregon Health Science University, founded by the University of Oregon, dates to 1887 when it was the only medical school in the Pacific Northwest. Following a merger of several medical and dental schools, the present Marquam Hill campus was established with a twenty-acre donation from Oregon-Washington Railroad and Navigation Company, and an eighty-eight-acre donation from *Oregon Journal* publisher C. S. Jackson. The first building there was Mackenzie Hall, opened in 1919 and named for distinguished local physician and second dean of the school, Dr. K. J. A. Mackenzie. *Oregon Historical Society, # CN 006258*

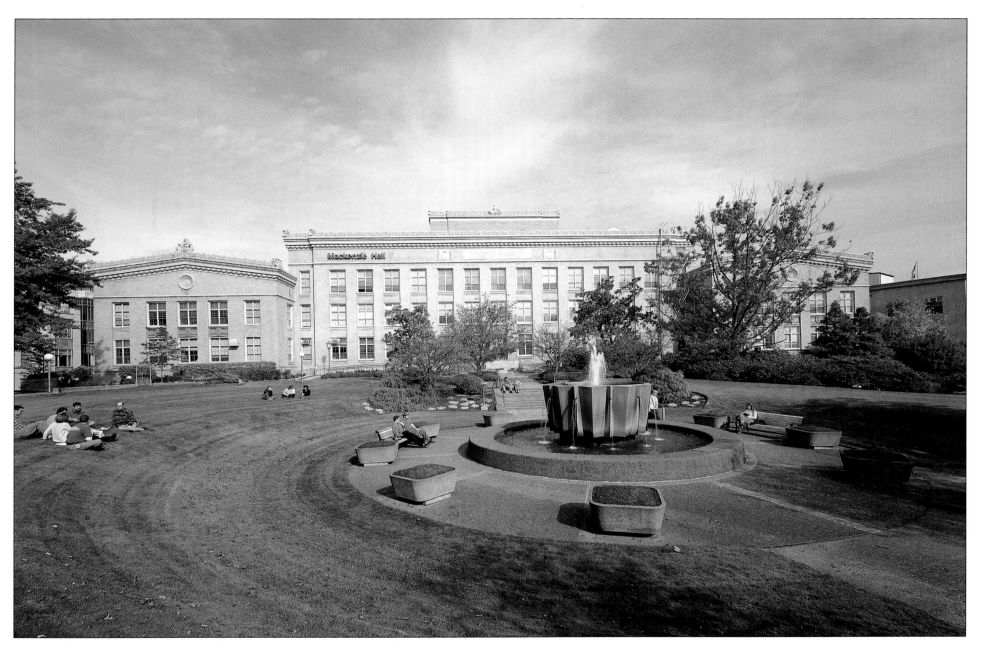

Today Oregon Health Science University, known to locals as "Pill Hill," is a 116-acre campus that includes the schools of Dentistry, Medicine, and Nursing; OHSU and Doernbecher Children's hospitals; dozens of primary care and specialty clinics; research institutes and centers; and community service programs. In addition to thirty-three major buildings, the complex also contains the longest suspended skybridge on the continent—a 660-foot-long enclosed footbridge connecting OHSU with the adjacent Veterans Administration Medical Center.

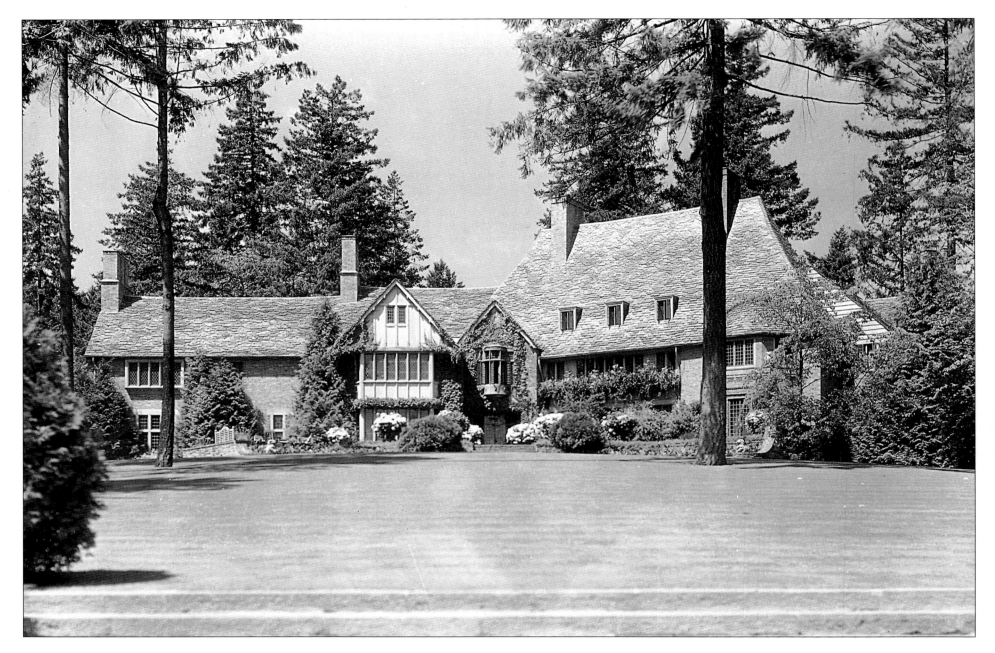

On Palatine Hill Road, high above the city of Portland, Mr. and Mrs. M. Lloyd Frank built their estate in the mid-1920s in the grand English manner. Frank's ancestors had been partners in one of Portland's earliest retail stores, which became Meier & Frank Department Store. The Manor House (*seen here*) was designed by a prominent architect, Herman Brookman, who hired special craftsmen and designers to create wrought iron work, wood carvings, and lighting fixtures of the highest quality. *Walter Boychuk photo, Oregon Historical Society, # OrHi 42750*

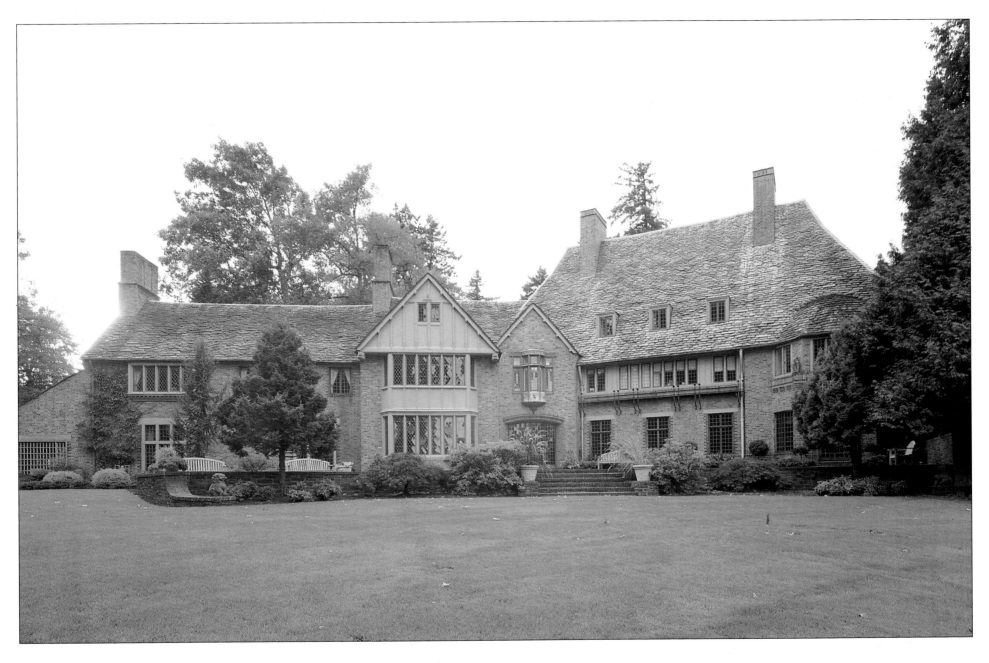

After the Franks moved, their estate—with its gate lodge, stables, formal gardens, reflection pools, gazebos, and outbuildings—stood vacant for seven years. In 1942 it was purchased by a small liberal arts institution, Albany College, for $46,000 and renamed Lewis & Clark College. The Manor House has been used as a women's dormitory, business office, home economics department, cafeteria, and student union, but through the years it has retained its original beauty and craftsmanship.

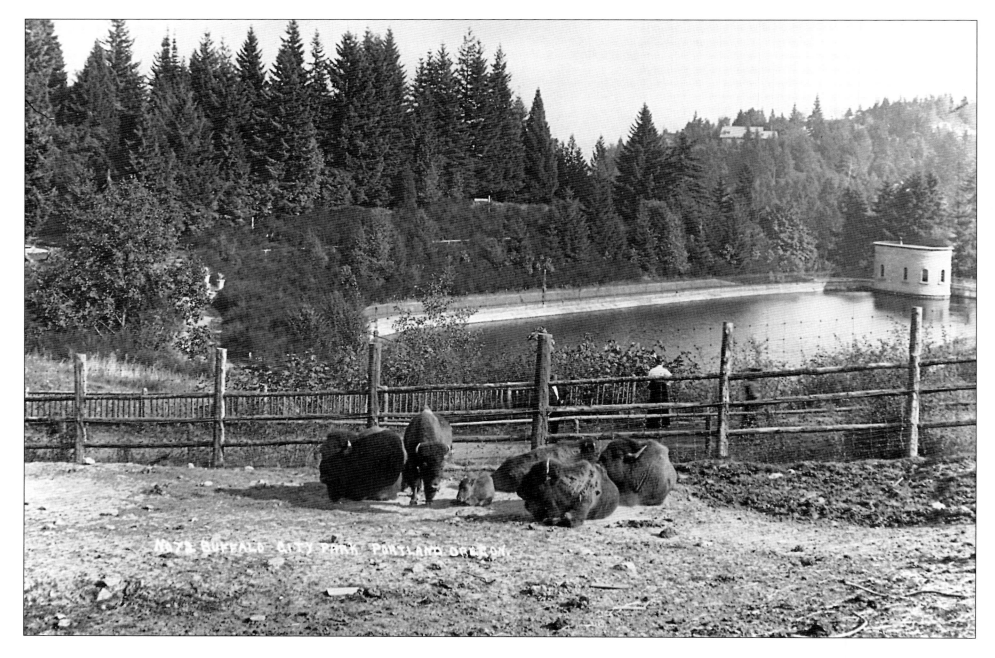

This picturesque reservoir lies in Washington Park, a large area of woodland and open space laid out in Portland's West Hills in 1871. The reservoir was the first site of Portland's zoo, established in 1887 when an eccentric pharmacist and former seaman presented his collection of animals to the city. (Before that, he had kept them in the back of his pharmacy!) The buffalo in this photograph were not caged but allowed to roam in the park. *Oregon Historical Society, # OrHi 73022*

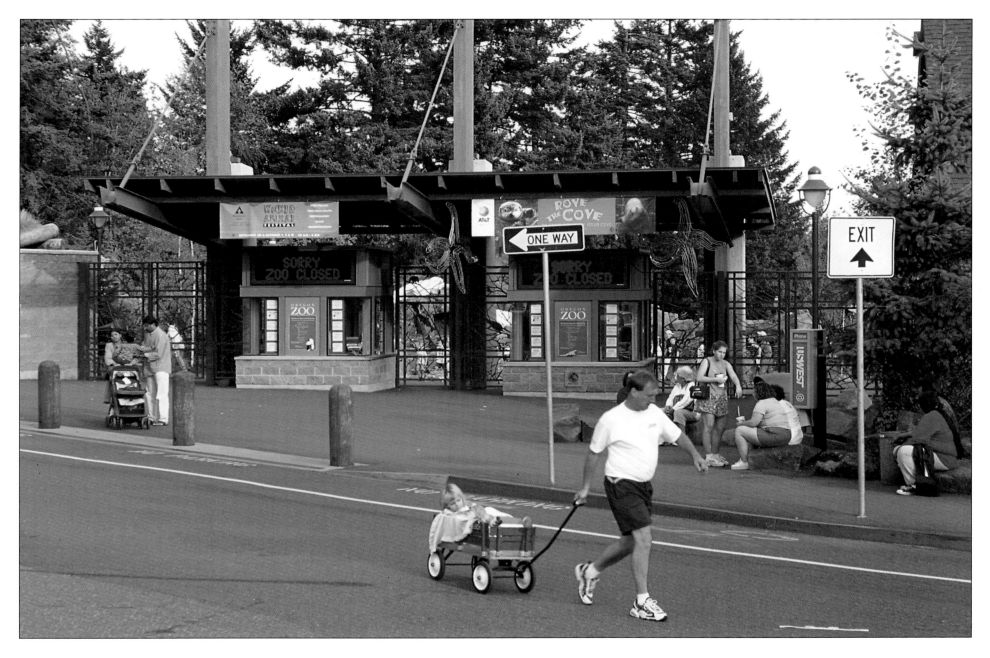

The present Oregon Zoo has well over 1,000 animals—representing 200 species—and attracts more visitors than any other paid tourist attraction in the state. It also boasts the most successful elephant breeding program in the world, a breeding and research facility for endangered animals, one of the largest volunteer groups of any zoo, a zoo railway, a summer concert series, a holiday ZooLights Festival, and an outstanding year-round education program.

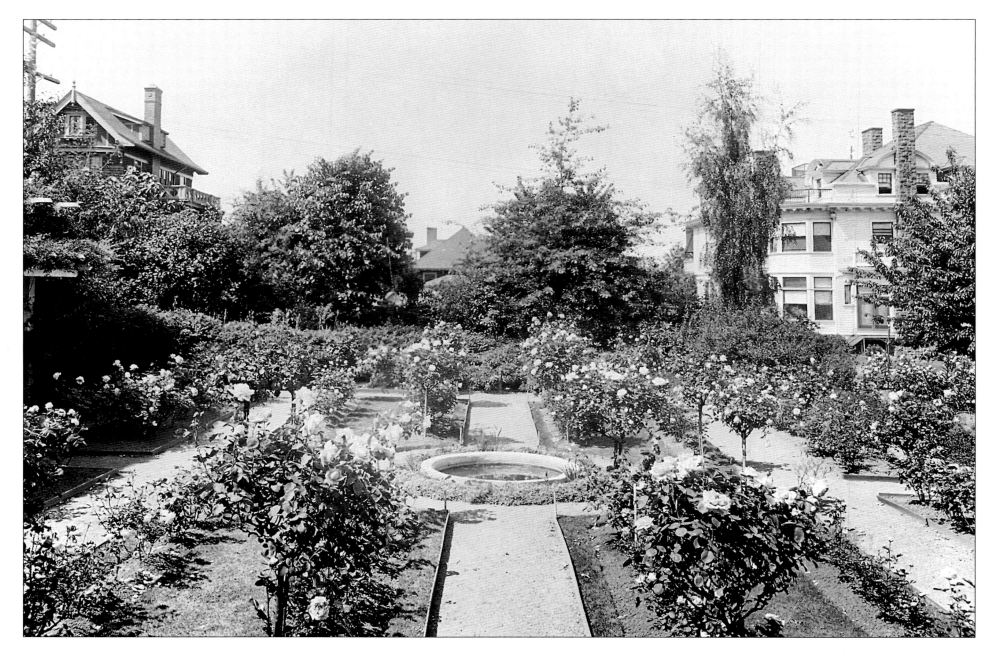

Portland has reason to be proud of its International Rose Test Garden, located in Washington Park since 1917. The garden was established through the tireless efforts of Jesse Curry, whose group, the "Kickers," prodded Portland into calling itself "The City of Roses." Curry was also a founding member of the Royal Rosarians, the group most closely associated with the city's annual Rose Festival since it was established in 1907. *Oregon Historical Society, # CN 006291*

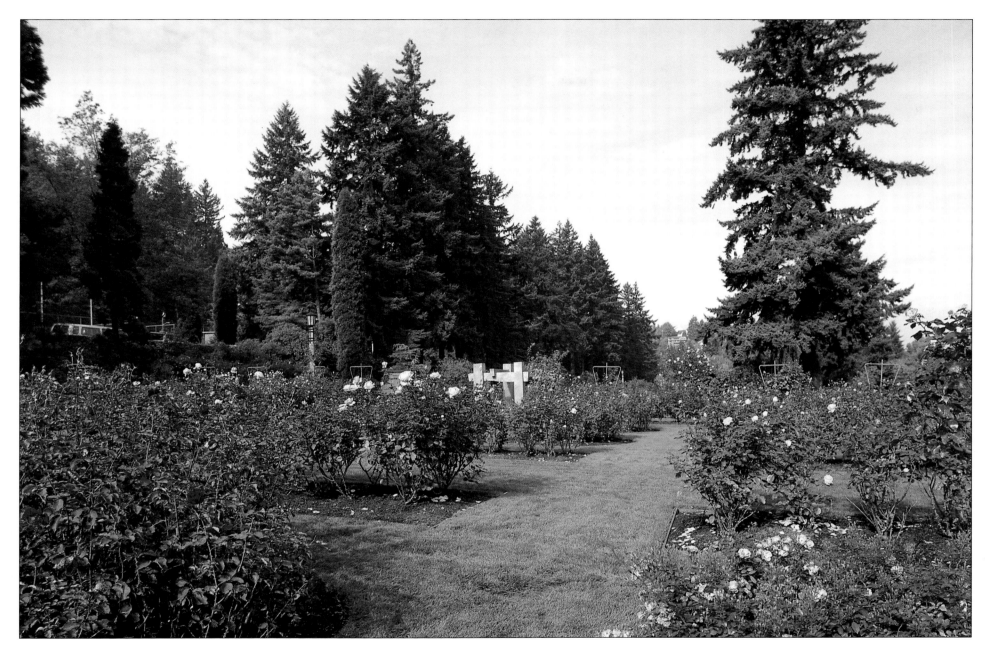

Portland's Rose Garden covers four and a half acres and contains 10,000 plants representing some 500 rose varieties. Here, tourists and locals admire the profusion of blooms, enjoy spectacular views of downtown Portland and the snow-capped peaks of the Cascades, and hold weddings. Set among tall trees and low stone walls, the area also includes a Shakespeare Garden, a walk bearing plaques for all the Rose Festival queens, and an outdoor amphitheater.

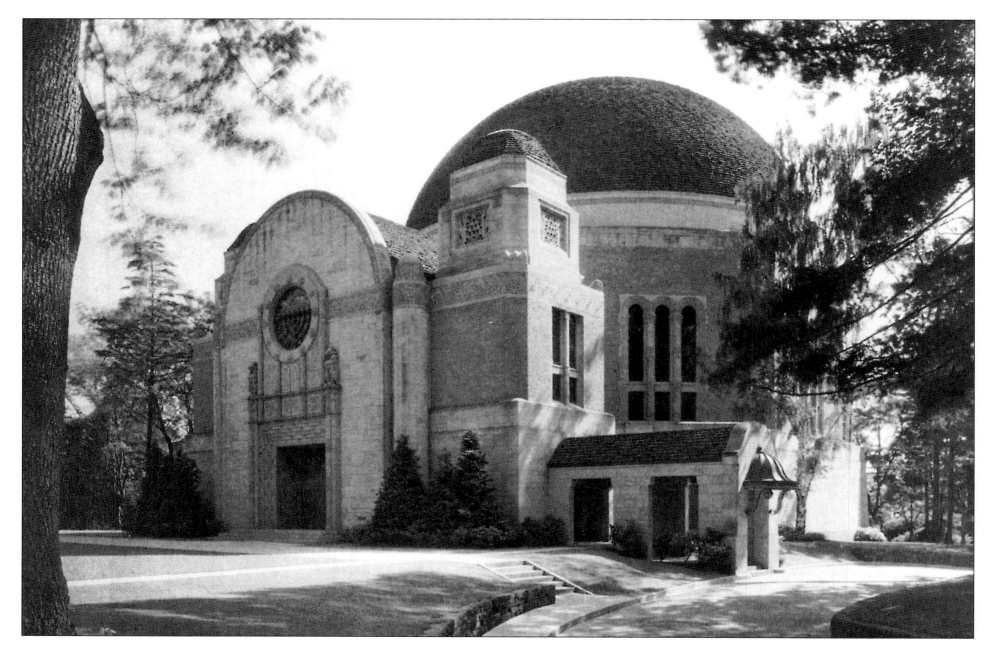

Temple Beth Israel at 1972 Northwest Flanders Street is the third temple of Oregon's oldest Jewish congregation. Congregation Beth Israel was founded in June 1858, when Portland had only about thirty Jewish families. When its second temple fell—probably to an arsonist's fire—the congregation built this magnificent new home in the Byzantine style. Members of the congregation became the nucleus of Jewish social and charitable organizations in Portland. *Oregon Historical Society, # CN 015551*

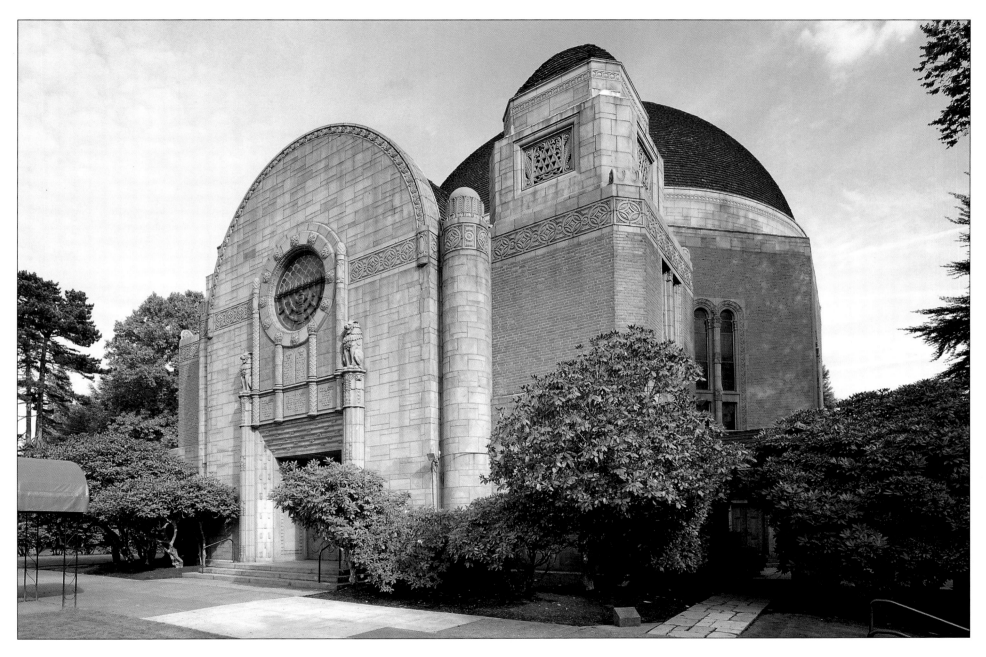

Sitting atop a hill among tall trees, Temple Beth Israel is now listed on the National Register of Historic Places. Among the congregation's best-known rabbis were Stephen Wise, who developed the philosophy of "liberal Judaism" and fought for Oregon's first child labor law, and Jonah Wise, who was a leader in the fight against the Ku Klux Klan in Oregon.

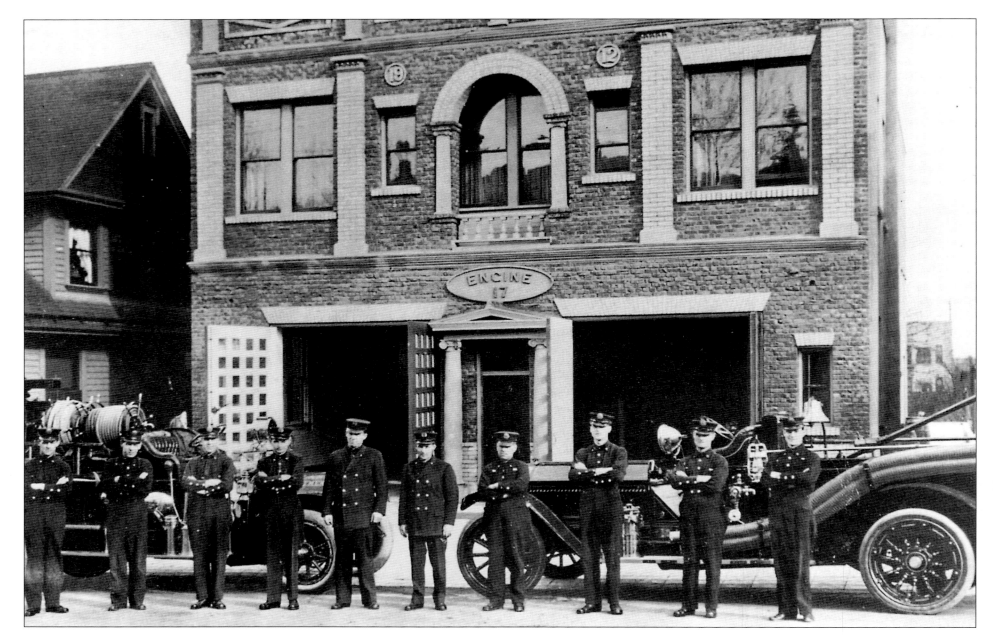

Horse-drawn ladder trucks and steam pumpers were the order of the day when Portland Fire Station 17 was built in 1912. But within four years the station had to be remodeled to accommodate motorized equipment and eliminate the stalls, feed bins, and racks associated with horses. "Engine 17" was one of twenty-four firehouses designed and built—not by an architect but by a battalion chief, Lee Gray Holden, who later became Portland's fire chief. *Photo courtesy of City of Portland Stanley Parr Archives and Records Center*

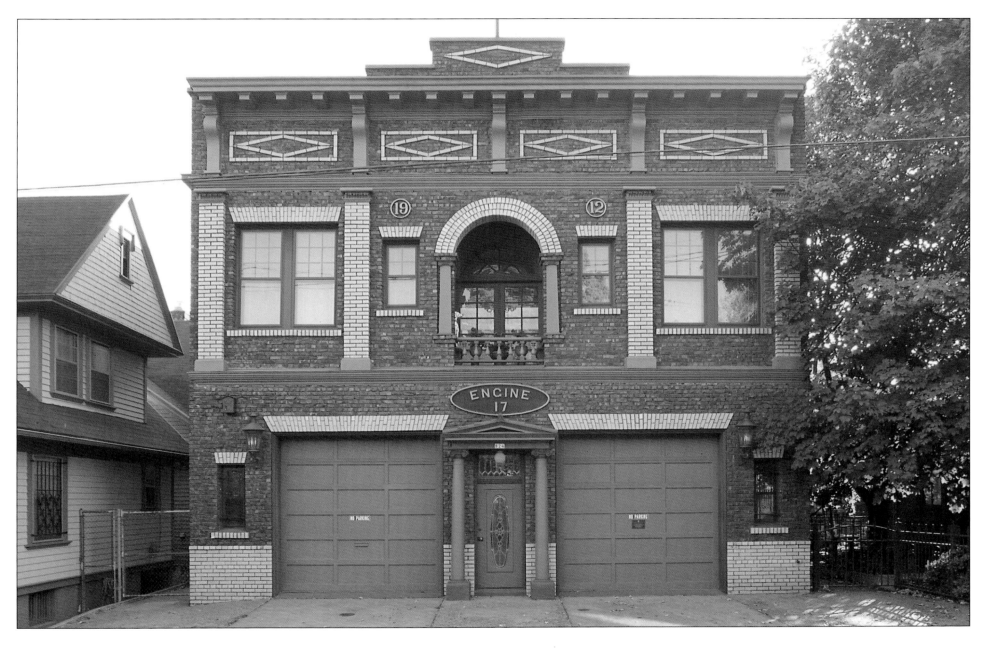

Engine 17, now on the National Register of Historic Places, is located on Northwest Twenty-fourth Avenue among large, carefully restored older homes. Interior traces of its original use are now partly obliterated, but the exterior—although somewhat altered—is still an excellent example of its designer's unobtrusive firehouses, which fit seamlessly into residential neighborhoods. Note the Dalmatian in the second-story alcove.

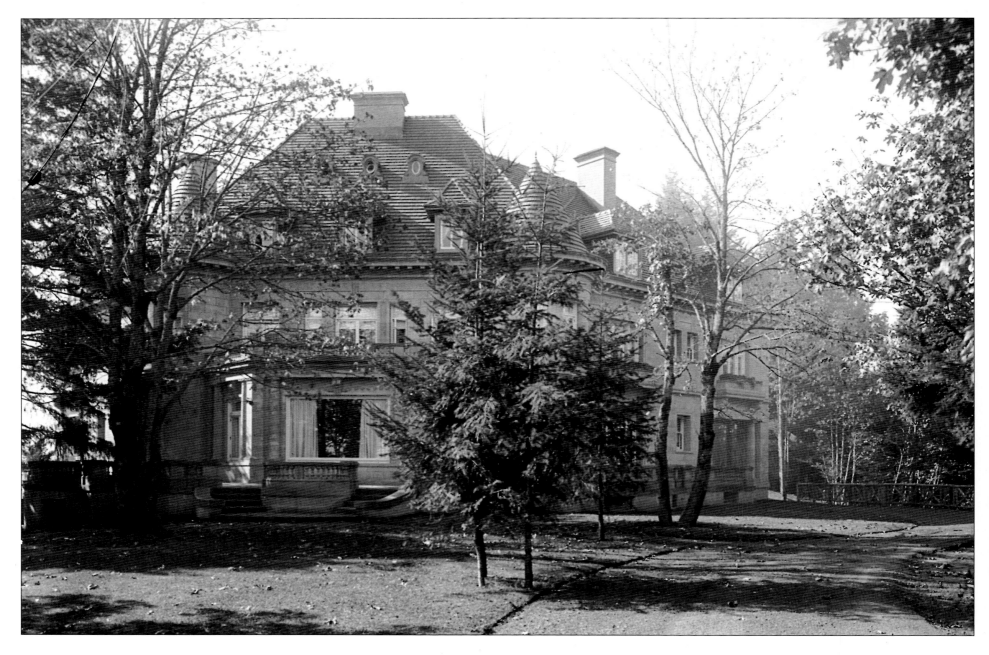

High in Portland's West Hills, above the hustle and bustle of commerce, Henry and Georgiana Pittock built this chauteau-like mansion when they were in their seventies. Henry owned *The Oregonian* and had built an empire in real estate, banking, transportation, and other ventures. When the house was completed in 1914, it featured stunning architecture, fine craftsmanship, and such modern conveniences as a central vacuum system and intercoms. *Oregon Historical Society, # Oreg 4380*

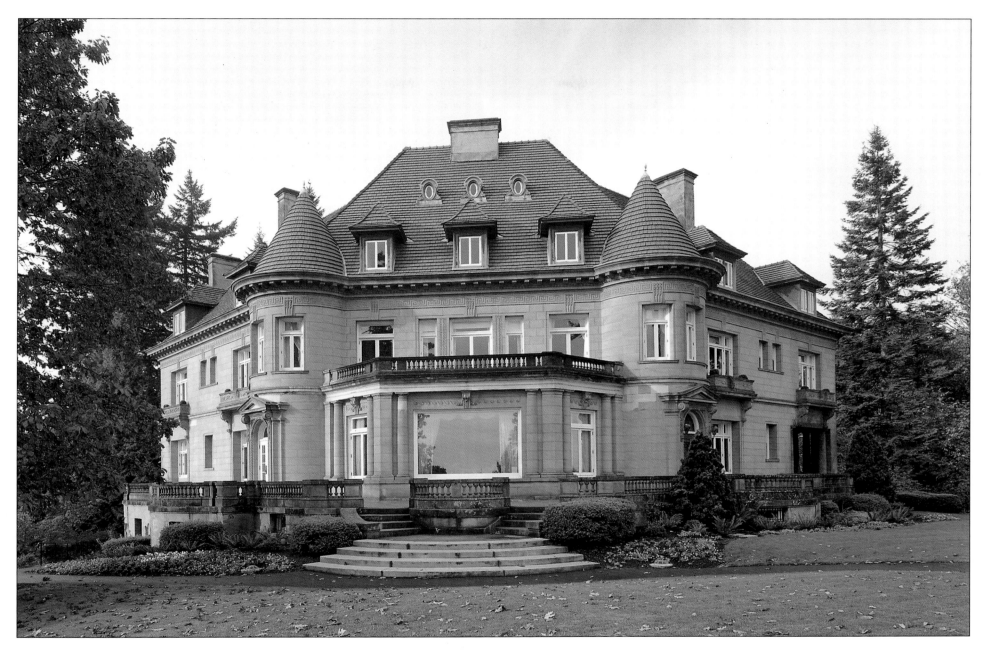

In 1964 the City of Portland acquired the Pittock Mansion to save it from threats of demolition by land developers. Today, it is a popular tourist stop, where visitors can experience the opulence of a bygone era, marvel at spectacular views of Mt. Hood, and stroll on the forty-six-acre grounds. During the winter holidays, the house is lavishly decorated and open for special tours.

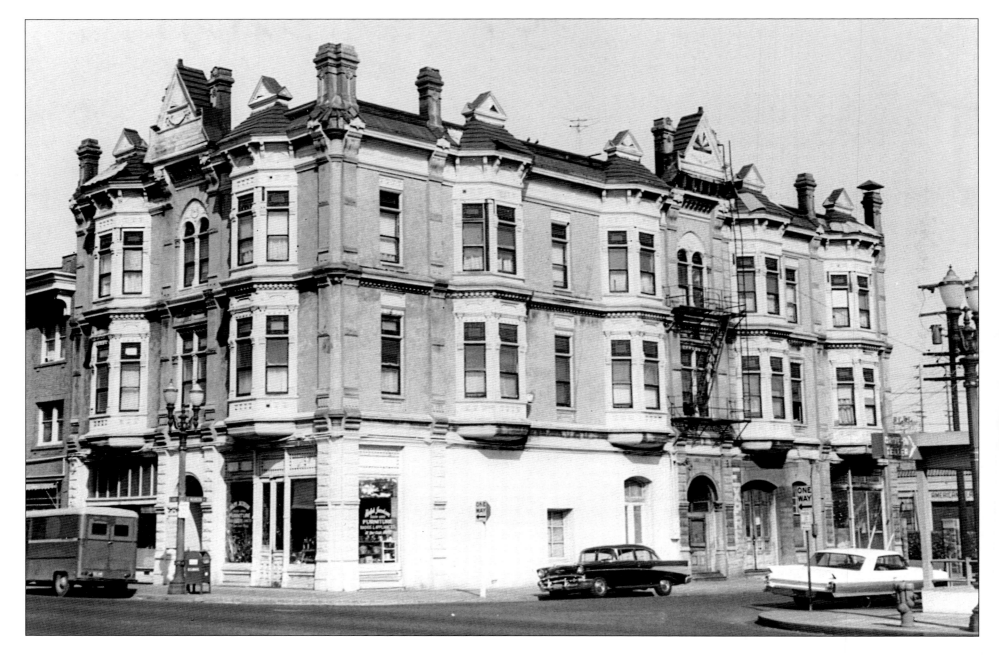

The showplace of Southeast Grand Avenue is the Barber Block, one of the earliest commercial buildings in the town of East Portland. Built in 1890, the ornate Victorian business block was named for Henry Barber, owner of a mortuary firm that was located here for nearly three decades. Pioneer historian H. K. Hines said Barber had "the finest undertaking rooms in the Northwest if not all the Coast." *Oregon Historical Society, # OrHi 102311*

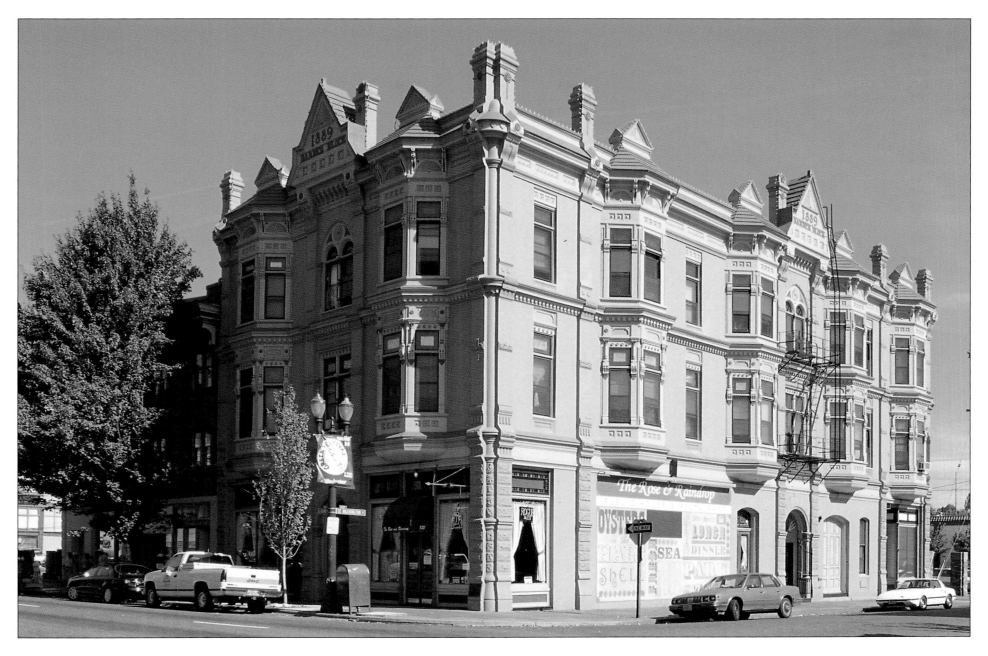

Among the businesses that occupied the Barber Block at various times were a drug store, banking house, "nickel theater," restaurant, laundry, furniture store, hardware store, and junk store. In the late 1970s, the building was restored and placed on the National Register of Historic Places. For many years, Digger O'Dell's Restaurant was on the ground floor. Now that space is occupied by The Rose & Raindrop.

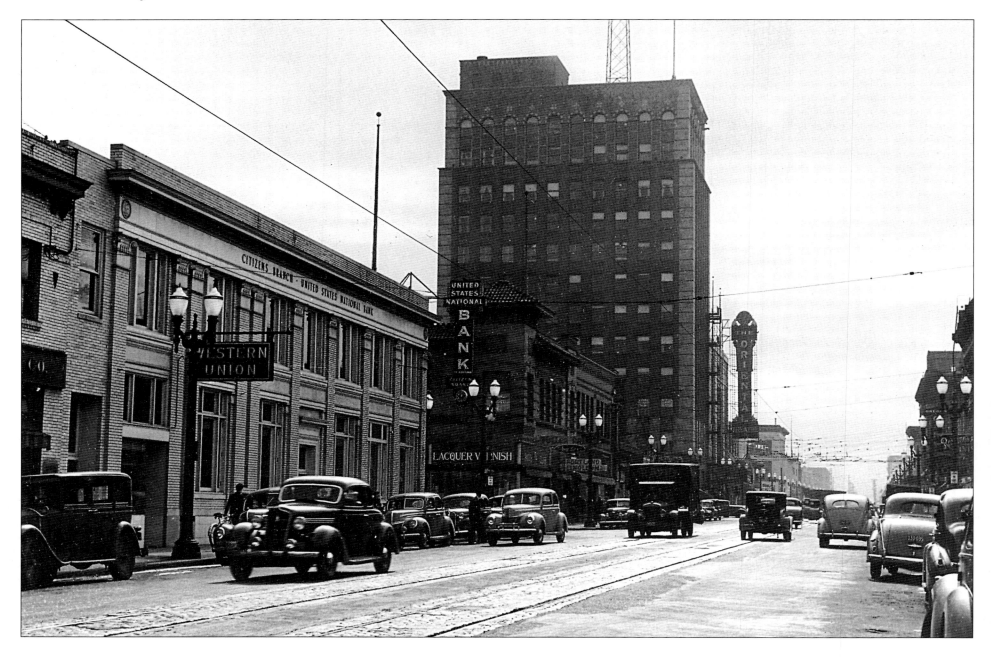

When ice cream king George Weatherly decided to build a twelve-story office and theater complex on Southeast Grand Avenue, east-side businessmen thought their first skyscraper would make the west side sit up and take notice. At the groundbreaking ceremony, where high spirits prevailed, Mayor George Baker sank his shovel into the ground and brought up a cake of ice and a carton of ice cream! *Oregon Historical Society, # CN 000187*

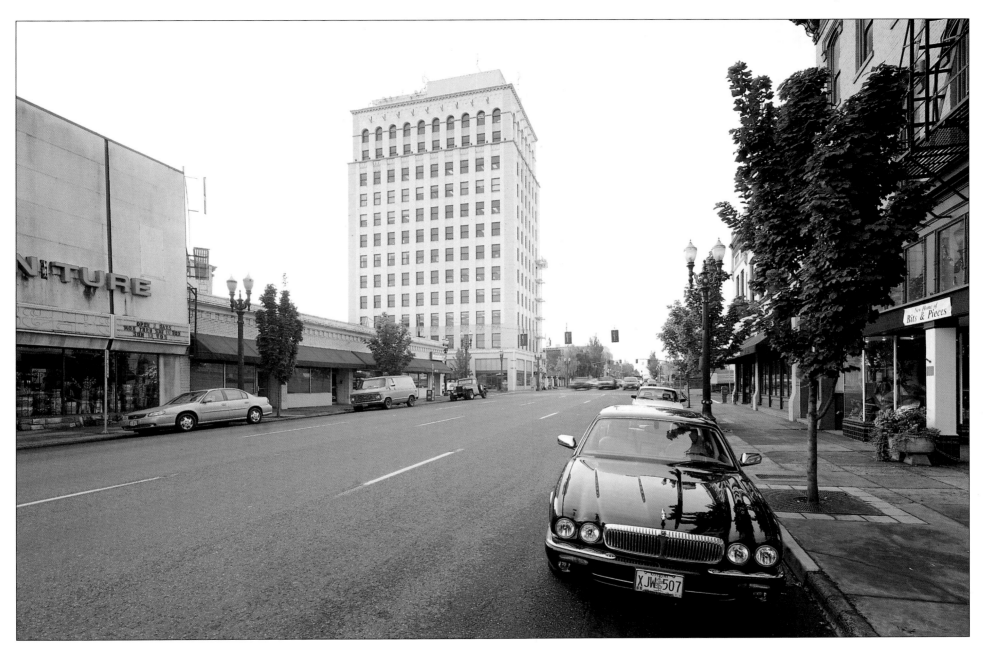

When the Weatherly Building was completed in 1927, it was considered to be very modern, with three fast elevators that would whisk office workers to the upper floors and offices that were specially designed for dentists. Today the Weatherly Building, a National Register property, continues to dominate the southern end of the east-side skyscape, which for the most part is filled with more modest structures.

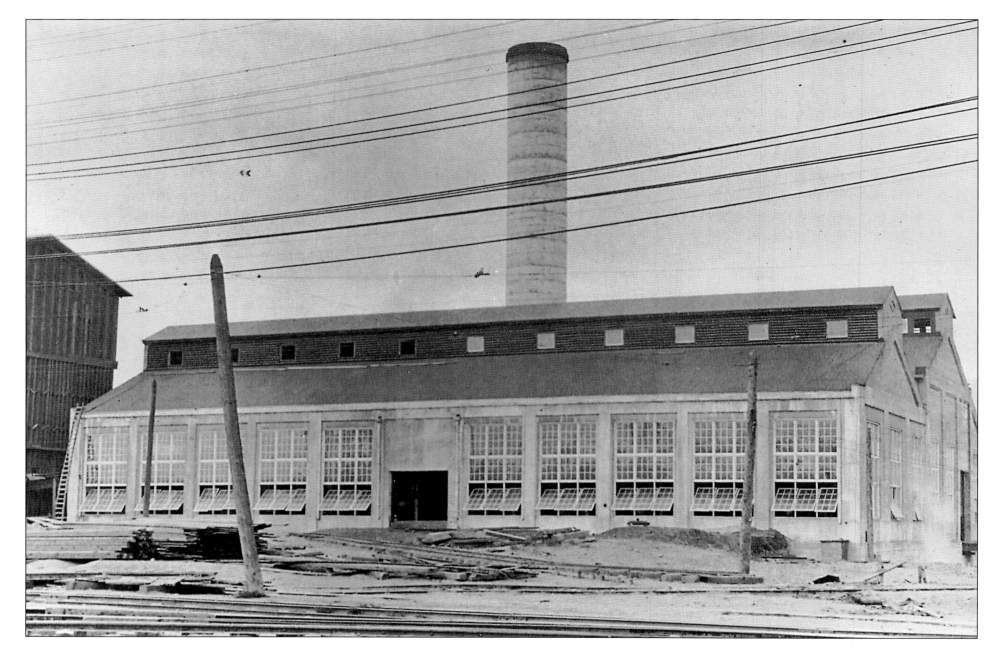

Historic Station "L" was built by Portland General Electric Company between
1910 and 1929 on land that once belonged to James Stephens—the man who laid
out East Portland in 1861. Station "L" was one of several substations built to power
the burgeoning new streetcar lines and to meet an increasing demand for electricity
in businesses and homes. The plant used mill-wood waste from the adjacent Inman
Poulsen Lumber Company to run its steam plant. *Oregon Historical Society,*
CN 003664

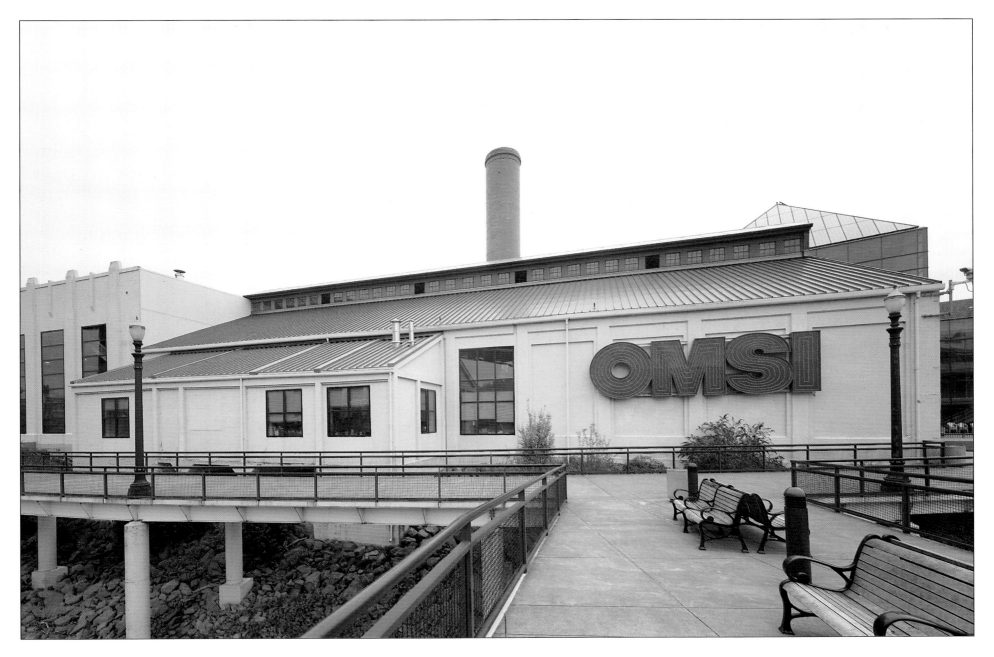

The old Oregon Museum of Science and Industry in Washington Park was bursting at the seams when Portland General Electric Co. donated land on the east bank of the Willamette River for a new, larger museum. That 18.5 acre site included the historic Station "L" power plant, part of which was incorporated into the new facility as its Physical Science Hall (*seen here*). Inside the old 1910 plant, visitors can examine restored plant equipment.

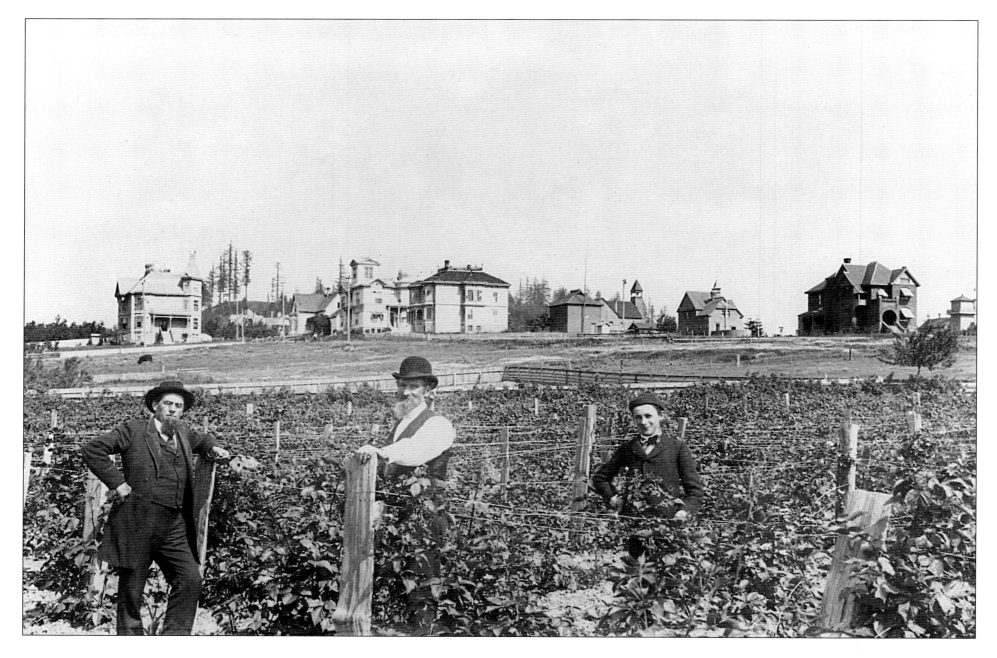

The coming of the railway to the east side beginning in the late 1880s made it possible to develop new neighborhoods far from Portland's city center. At the turn of the century, the Mt. Tabor area was a mixture of rural and urban uses. Nursery gardens, like the one pictured here, stretched from present-day Stark to Morrison and Fiftieth to Fifty-second avenue, but a few substantial homes had begun to appear. *Oregon Historical Society, # OrHi 52397*

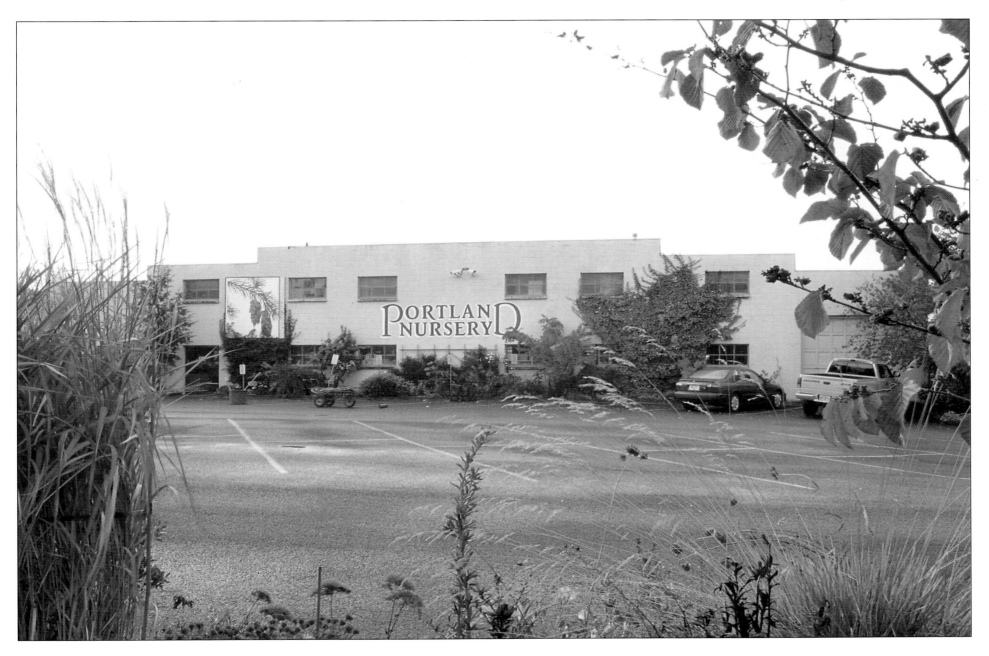

When Portland Wholesale Nursery opened on the same site in 1907, it shipped
hundreds of thousands of plants to the East Coast in unrefrigerated cars packed
with ice. Now a retail business, Portland Nursery is well-known around the Pacific
Northwest for its large selection and its willingness to give expert advice about plants
and gardening.

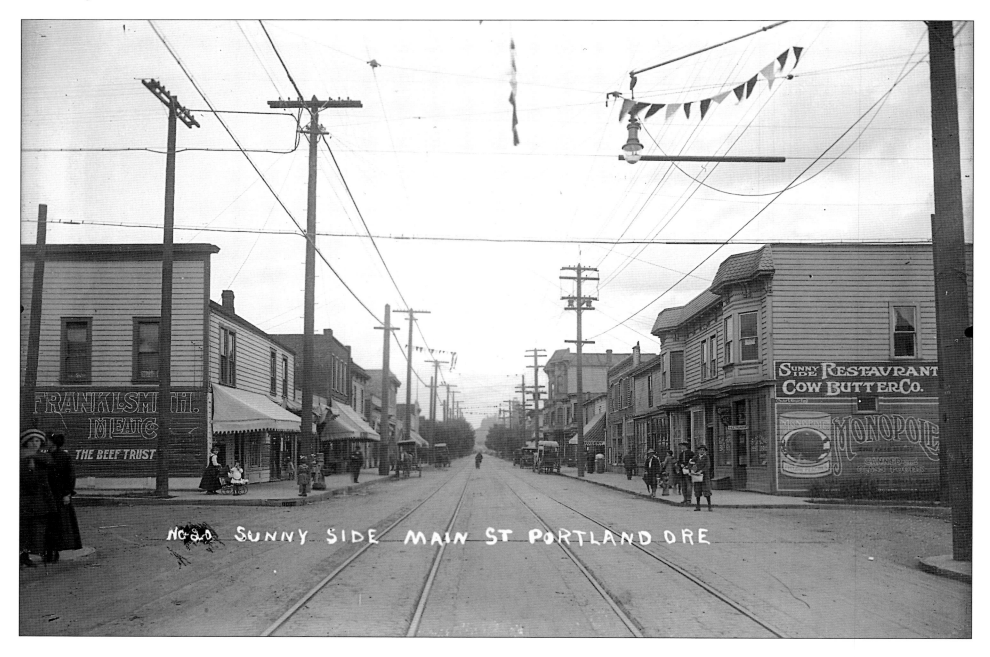

No.20 SUNNY SIDE MAIN ST PORTLAND ORE

On the east edge of the city, the area known as Sunnyside developed as a working-class enclave served by streetcars. This cluster of shops near Southeast Thirty-third and Belmont streets included a restaurant (*right foreground*) and next to it a grocery store. Later, on the north side of the street (*far left in this photograph*) the Carnation Dairy built its plant. *Wesley Andrews photo, Oregon Historical Society, # OrHi 17423a*

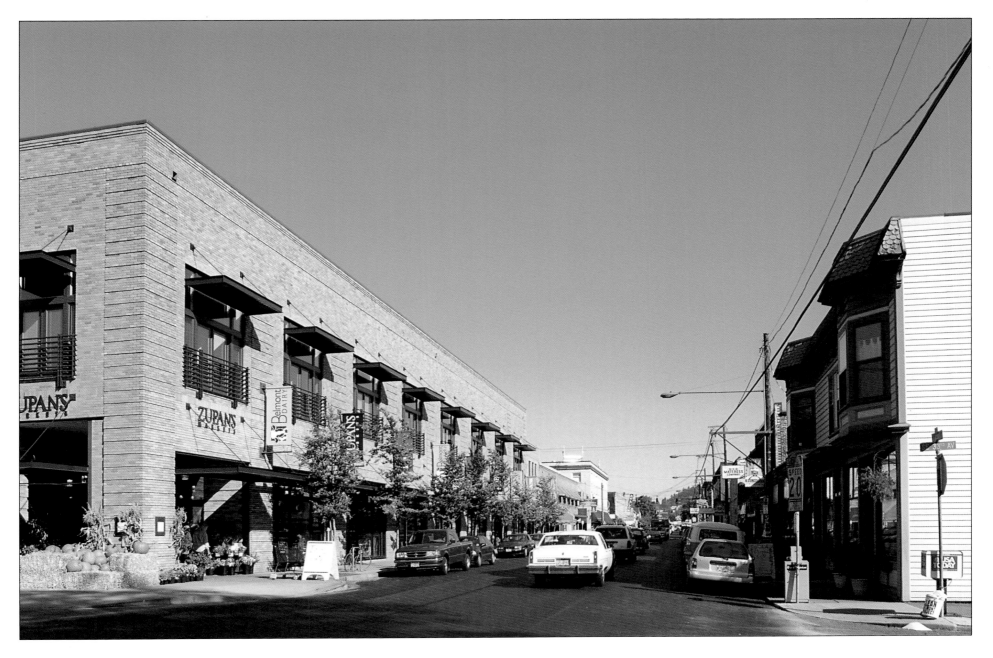

In the 1990s Belmont Street began to reinvent itself as a hip new area of trendy and working-class businesses. The revamped Carnation Dairy building in the left foreground is now the Belmont Dairy, a mixed-use complex that features condominiums, a grocery store, and a Caribbean restaurant. In 1997 the Belmont Dairy won the Governor's Livability Award.

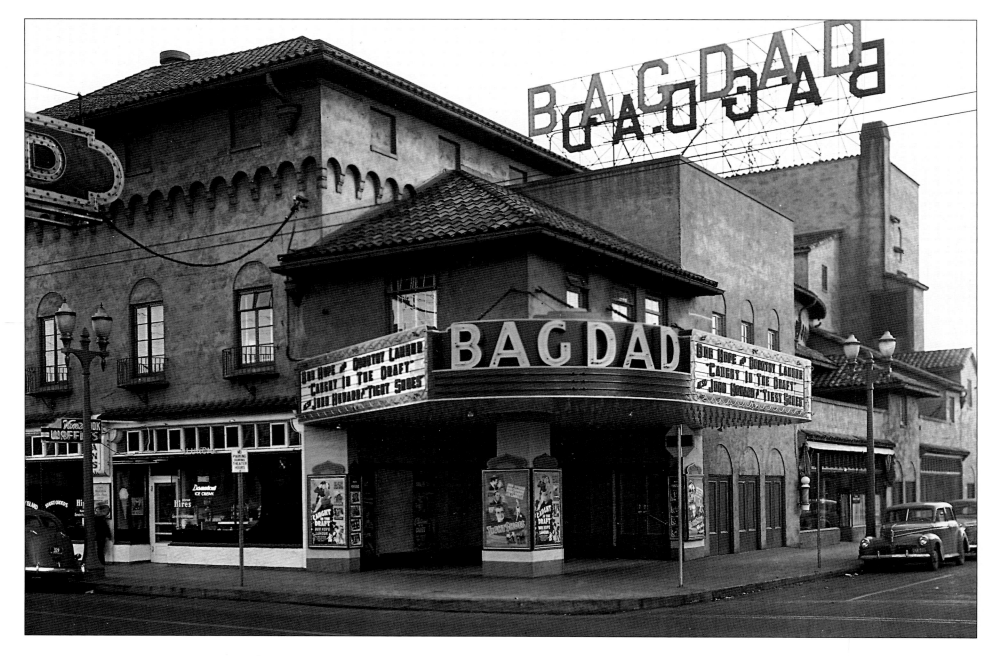

The massive Bagdad Theater was an exotic addition to working-class Hawthorne Street when it opened in 1927. In an era when Hollywood studios were building new theaters across the country, Universal Pictures spent $100,000 creating the Bagdad, which boasted a large stage, Middle Eastern decor, and usherettes in Arabian-style uniforms. Through the 1940s the theater offered live vaudeville shows. *Photo Art Neg. #R13379K13*

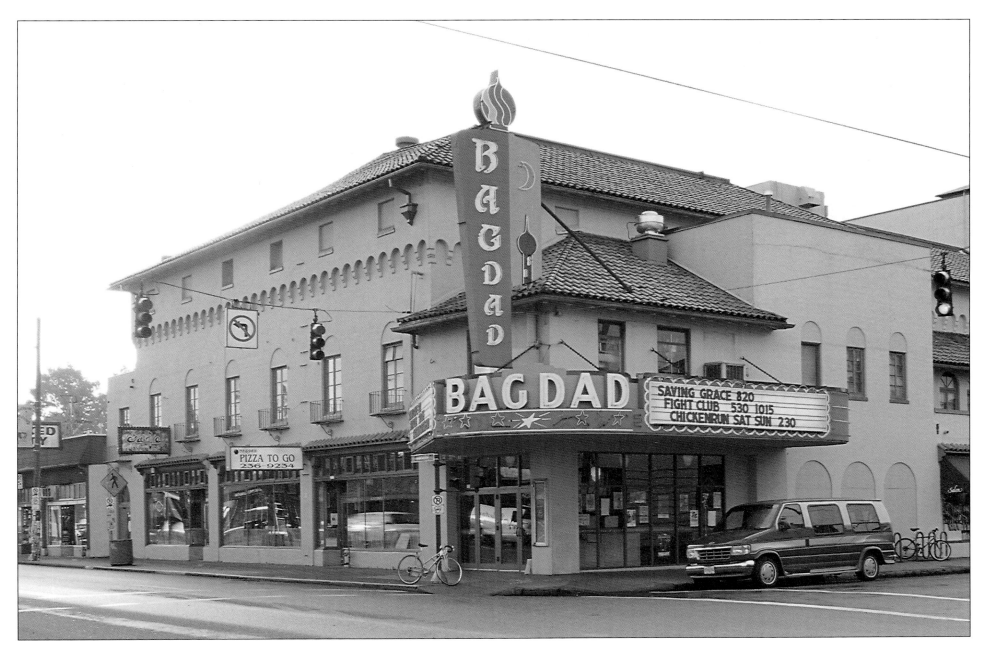

In later years Portland's largest residential theater hosted two gala Hollywood premieres—for *One Flew Over the Cuckoo's Nest* in 1975 and *My Own Private Idaho* sixteen years later. A decade ago the theater was acquired by McMenamins Pubs & Breweries and renovated for use as a combination cinema and pub. Today, it is a favorite spot to enjoy a brew and a slice of pizza while watching a first-run Hollywood flick.

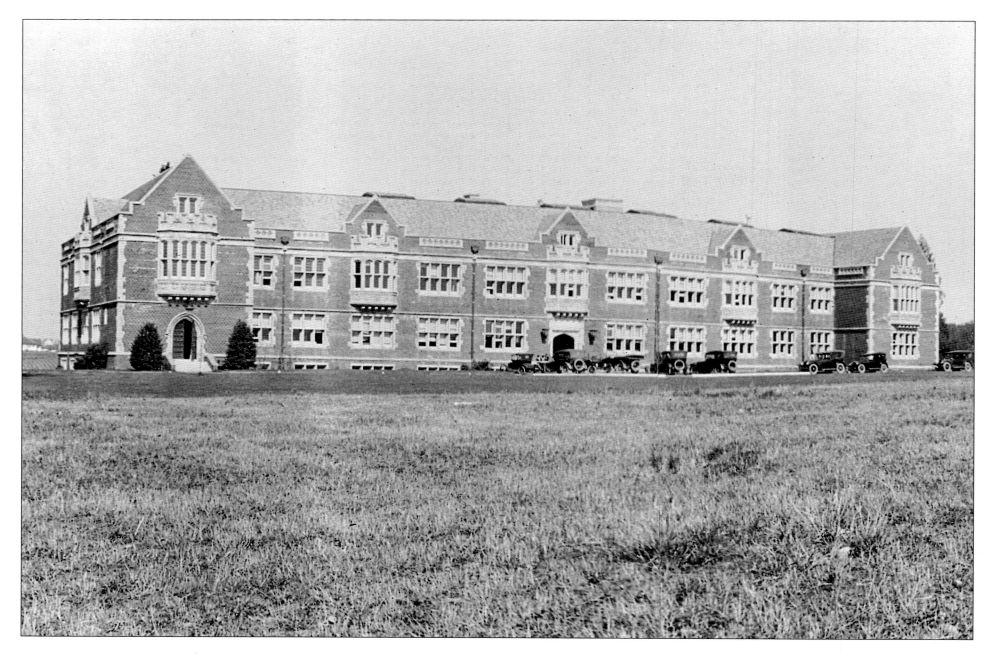

Eliot Hall, built in 1912, was one of the first two buildings on the Reed College campus in Southeast Portland. The Tudor Gothic building was named for Portland civic leader Thomas Lamb Eliot, a Unitarian minister and the first chairman of Reed's board of trustees. Originally known as the Arts and Sciences Building, Eliot Hall was designed by A. E. Doyle in the style of Oxford University's St. John's College and the University of Chicago. *Photo courtesy of Reed College*

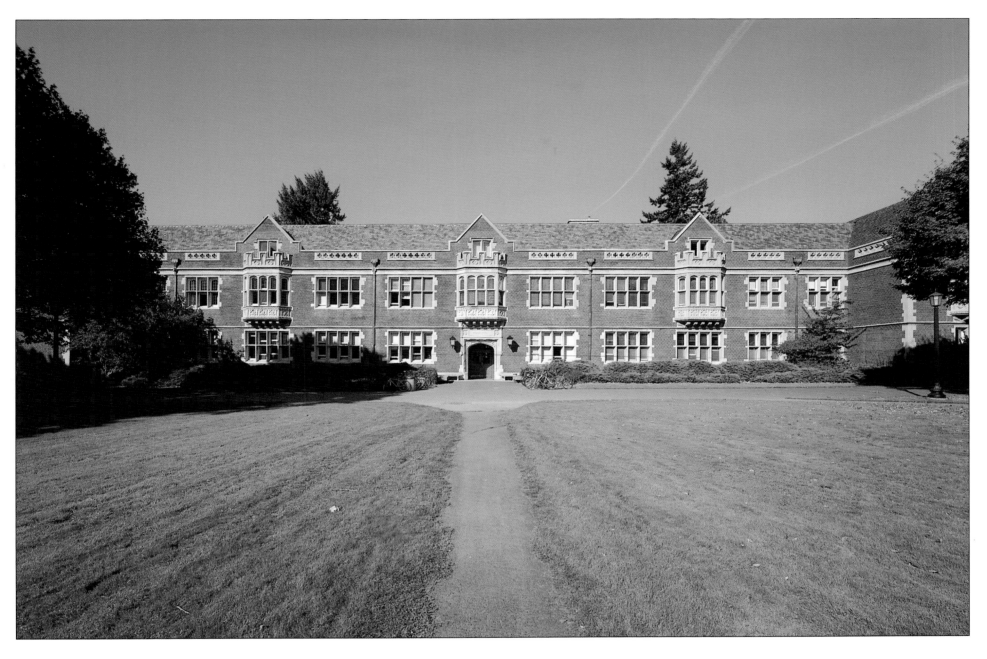

Today, Eliot Hall remains an architectural icon of the Reed College campus. Reed was recently hailed as the most intellectual college in the country and has consistently garnered accolades for its high undergraduate standards in American higher education. Alumni have distinguished themselves in all fields, and as a group, have the second highest number of Rhodes Scholars from a small college of the liberal arts and sciences.

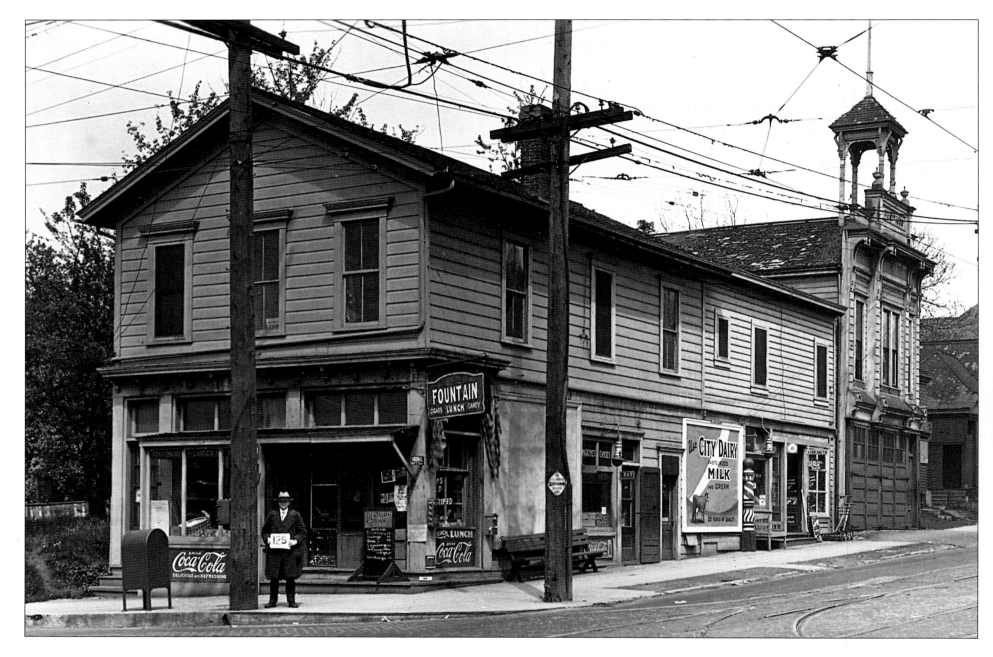

At the beginning of the Great Depression, this block on Northeast Union Avenue at Holladay Street was occupied by a rambling wooden building housing a mom-and-pop grocery and confectionery, a barber shop, and a locksmith service. In later years, Union Avenue became a major thoroughfare and some of the old buildings were demolished, to be replaced by businesses that catered to the automobile.
Oregon Historical Society, # COP 02450a

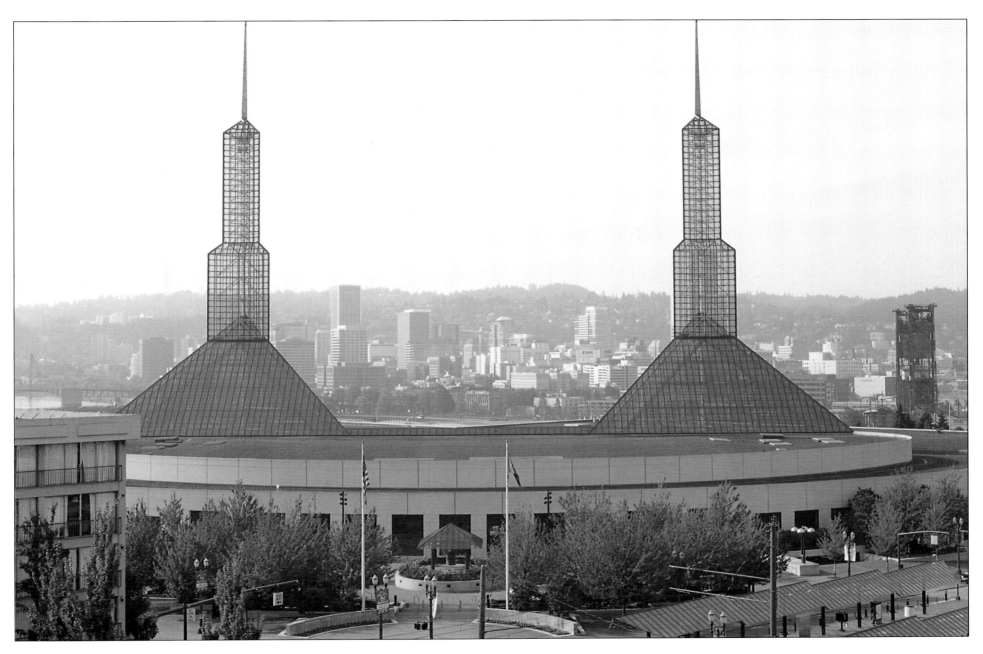

In 1988 the same part of Union Avenue was once again slated for transformation, as construction on the new $91.5 million Oregon Convention Center began. When the Center had its $600,000 grand opening celebration two years later, officials hoped it would boost the region's economy. But the question that plagued John Q. Public was, "How will you wash all those windows?"

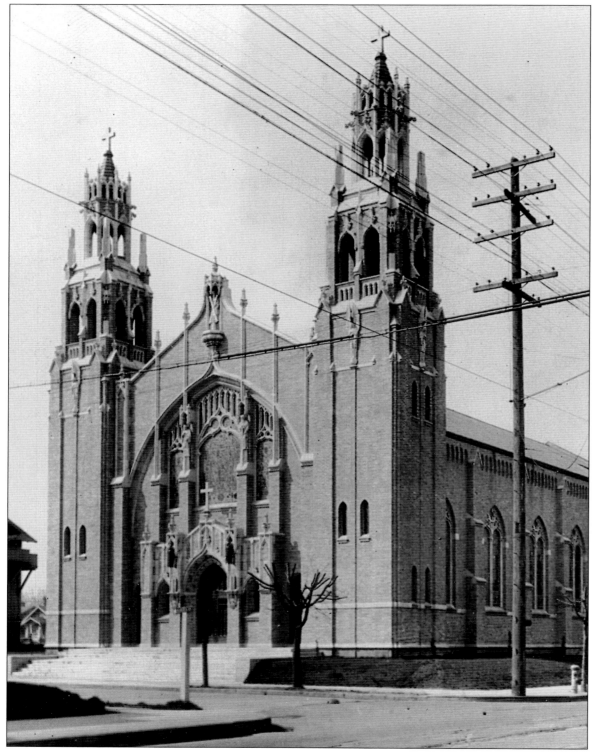

In 1908 St. Andrew's Parish School and Chapel was built at a cost of $105,000 at Northeast Ninth and Alberta. Twelve years later, a fire damaged the building and services were moved to a tent. After repairs were made, the building functioned until 1928, when it was replaced by the present twin-tower brick and stone sanctuary. *Oregon Historical Society, # OrHi 102312*

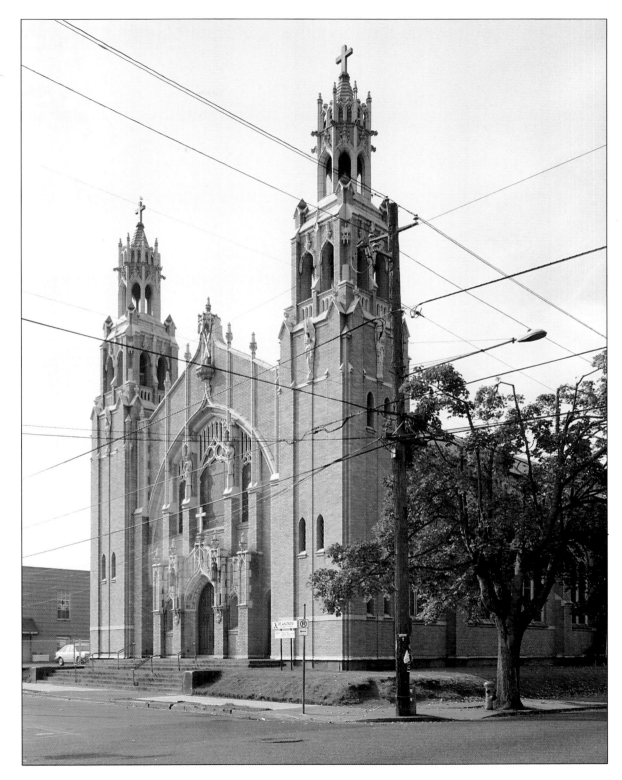

Seventy years after construction, St. Andrew Catholic Church remains a prominent feature of Northeast Alberta Street. The church's exterior is little changed, but since the 1960s its membership has become more diverse. Today the church is involved with a variety of programs that include social action and charity concerns.

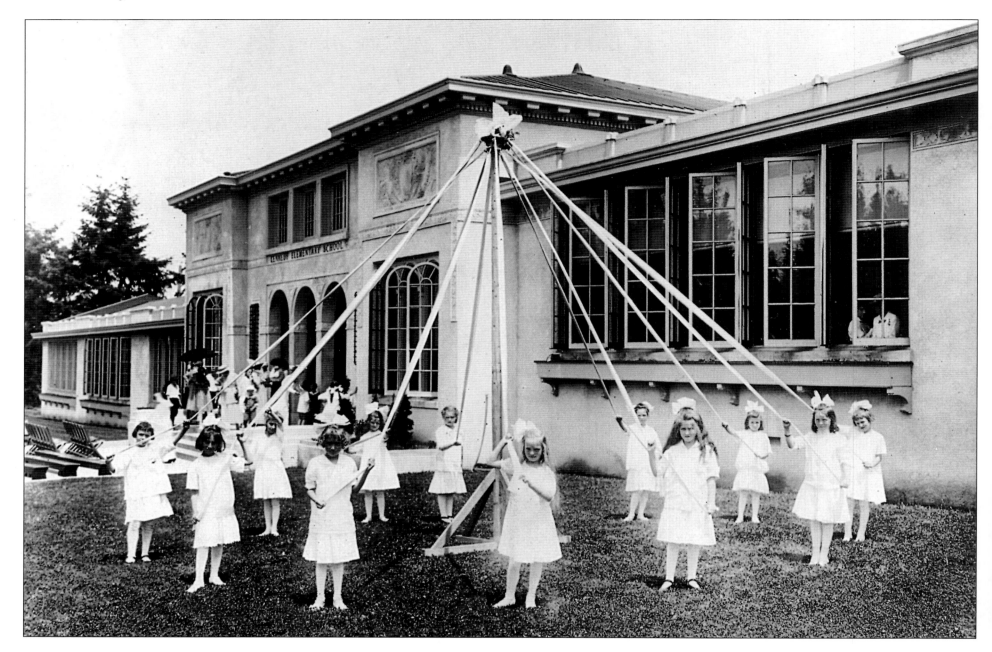

Kennedy School, commemorating Irish immigrant and local resident John D. Kennedy, opened its doors in 1915 on a four-acre campus along Northeast Thirty-third. The elementary school's sprawling, expandable design made it rather revolutionary in educational circles—so much so that in 1916 the school and this photo of its Maypole celebration were featured in *Ladies Home Journal*. The article was captioned "First One-Story School of Its Kind in Nation." *Oregon Historical Society, # OrHi 80964*

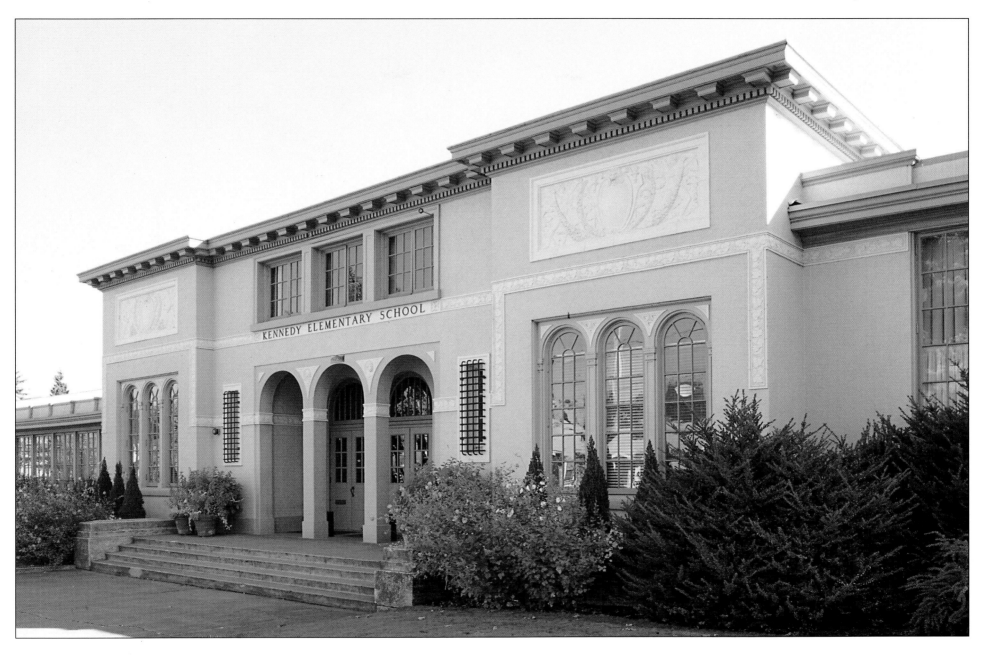

Today, Kennedy School is a National Register-listed resource and an historic preservation success story. Although the school closed its doors in 1975 and was abandoned in 1980, the neighborhood association and alumni worked to save it from demolition. After a number of alternatives were considered, the building was sold to McMenamins Pubs & Breweries to become a mixed-use property featuring a restaurant, movie theater, bars, bed and breakfast, and community meeting place.

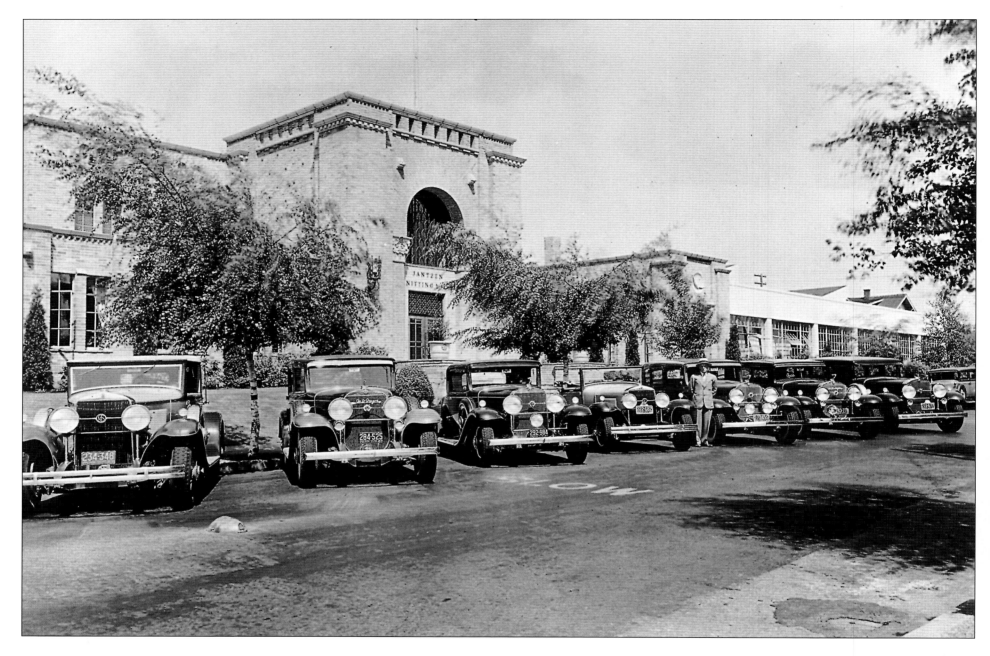

The Portland Knitting Mills, founded in 1910, became Jantzen Knitting Mills in 1918. From its first products—heavy sweaters, gloves, and socks—the company went on to specialize in the manufacture of rowing gear and swimwear. By 1925 the firm produced 431,000 garments, many sold under the company's slogan, "the suit that changed bathing to swimming." Featured on its popular swimwear was the company's new logo, the famous red-suited Jantzen diving girl. *Oregon Historical Society, # OrHi 75625*

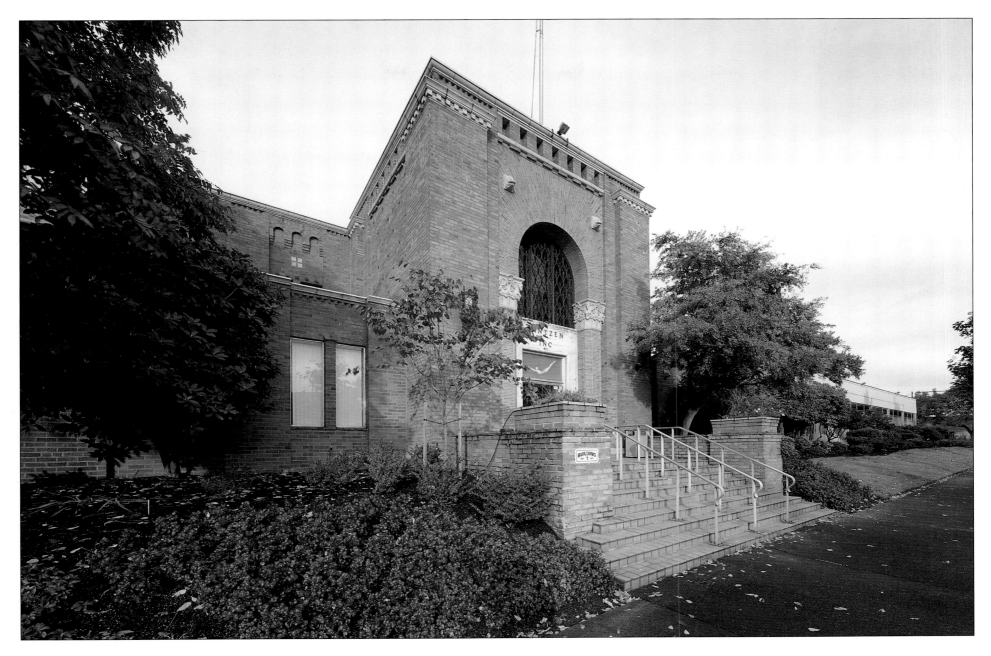

Jantzen's success enabled it to commission Portland architect Richard Sundeleaf to design new administrative offices in 1928. The building, constructed in the art deco style, was sited within the company's manufacturing complex just off Northeast Sandy Boulevard. Since the 1980s the enterprise has been a subsidiary of the VF Corporation of North Carolina but has retained the old headquarters building. Note the Jantzen logo over the main entrance.

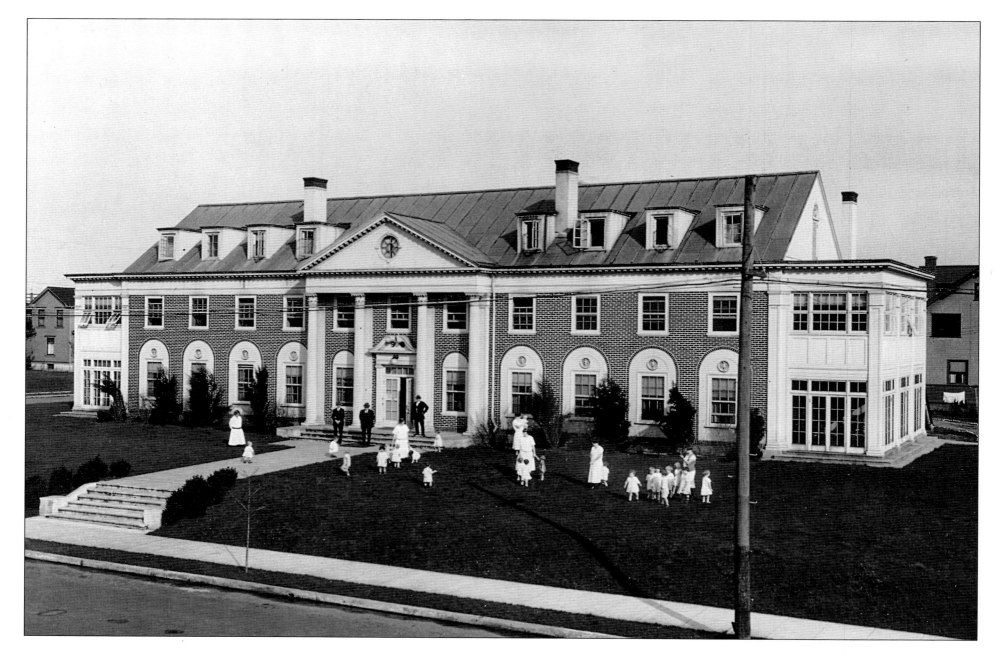

The Albertina Kerr Center on Northeast Twenty-second traces its history to a social service organization founded in 1907. When his wife died in 1913, businessman Alexander Kerr, perfecter of the Kerr jar, generously donated his former home for use as the Albertina Kerr Nursery. In 1921 further donations from the Kerr family and from the community funded completion of this handsome Georgian Revival style brick building. *Oregon Historical Society, # OrHi 102313*

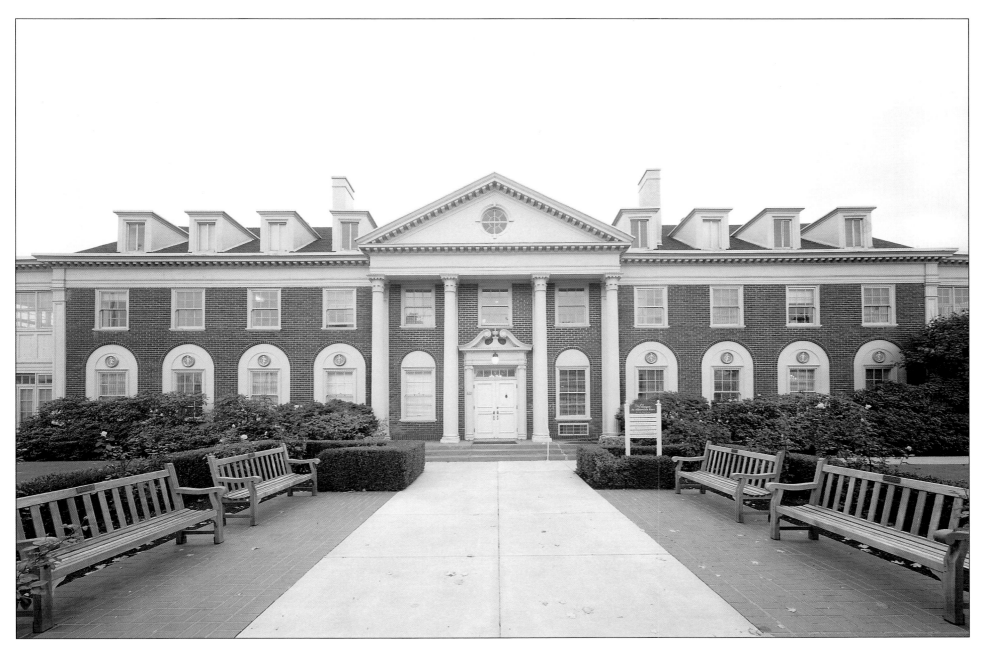

Today, the former nursery is part of the Albertina Kerr Centers network. The historic building, with its volunteer-operated restaurant and shops, is used in fund raising. These endeavors lend support to the organization's mission as one of the state's largest providers of care, treatment, counseling, residential placement, and education for children, adults, and families at risk or in crisis.

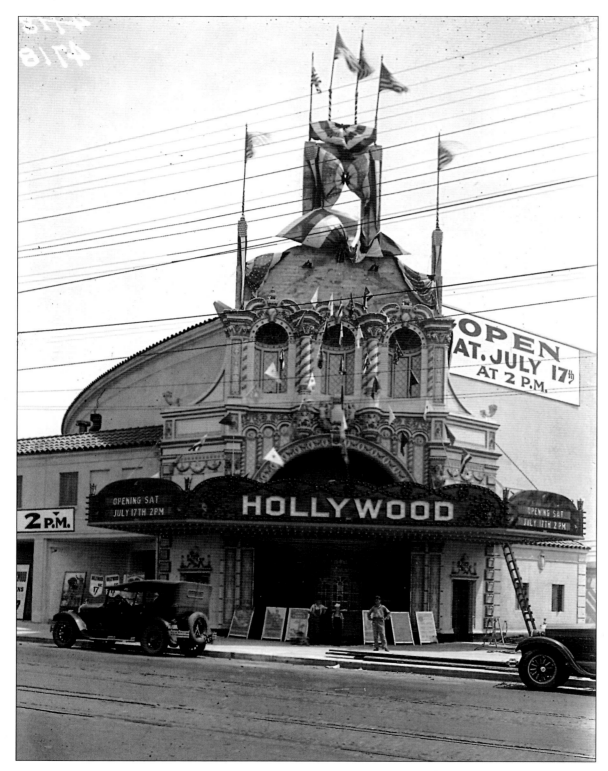

Festoons, flags, posters, and signs announced the opening of the new Hollywood Theatre in 1926. The theater, built in the heyday of movie palaces and vaudeville, presented an ornate facade along Sandy Boulevard and featured a bold Byzantine Rococo tower detailed in architectural terra cotta. The theater had such an impact that the neighborhood surrounding it also became known as Hollywood. *Benjamin Gifford photo, Oregon Historical Society, # Gi 4718*

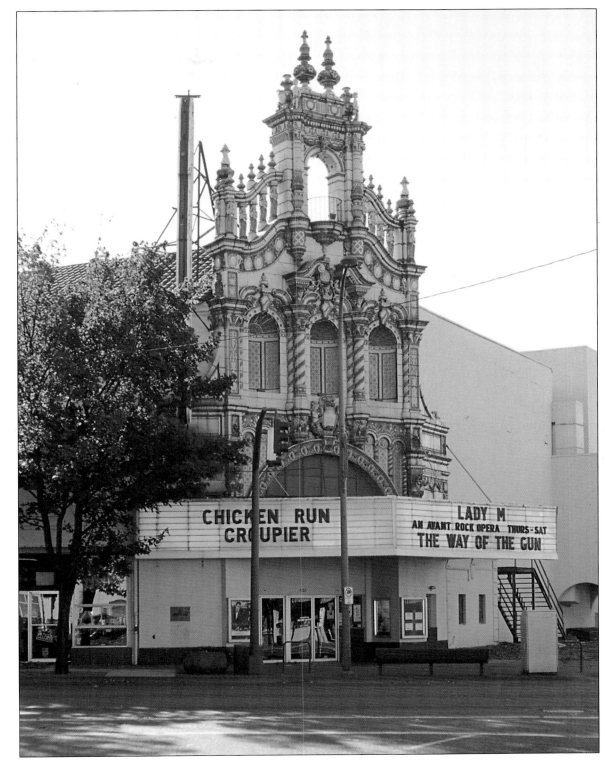

Following years of disrepair and a near-disastrous fire in 1997, the Hollywood Theatre is experiencing a renaissance. Soon after the fire, the National Register-listed property was acquired by the Oregon Film and Video Foundation, which has been engaged in efforts to repair and preserve it. Happily, the Hollywood is now a venue for both first-run movies and live performances, as well as lectures, fund raisers, and locally produced films.

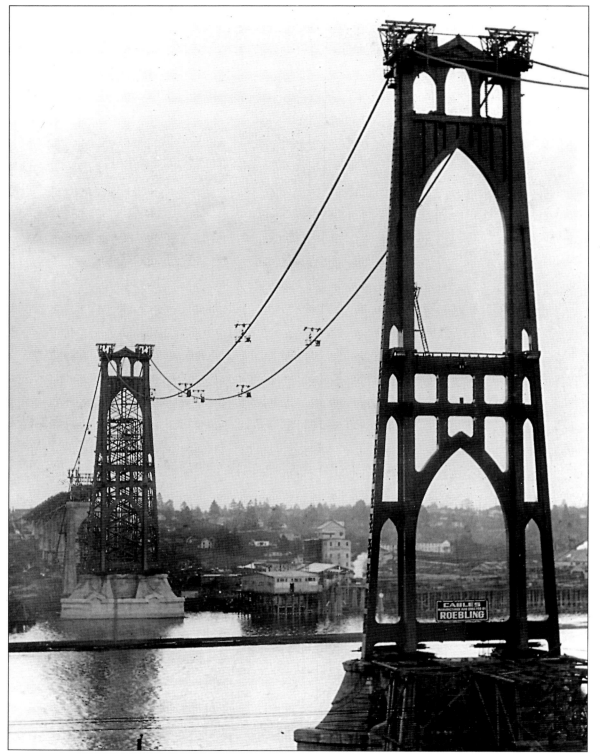

The graceful St. John's Bridge, erected from 1929 to 1931, was a major construction effort for Multnomah County. The four million dollar structure was designed by suspension bridge expert David B. Steinman of New York City and featured lofty towers reaching 408 feet above the water. Its cables were made of twisted galvanized wire strands weighing 1,200 tons. At the time, it was the longest suspension bridge west of Detroit. *Oregon Historical Society, # OrHi 25543*

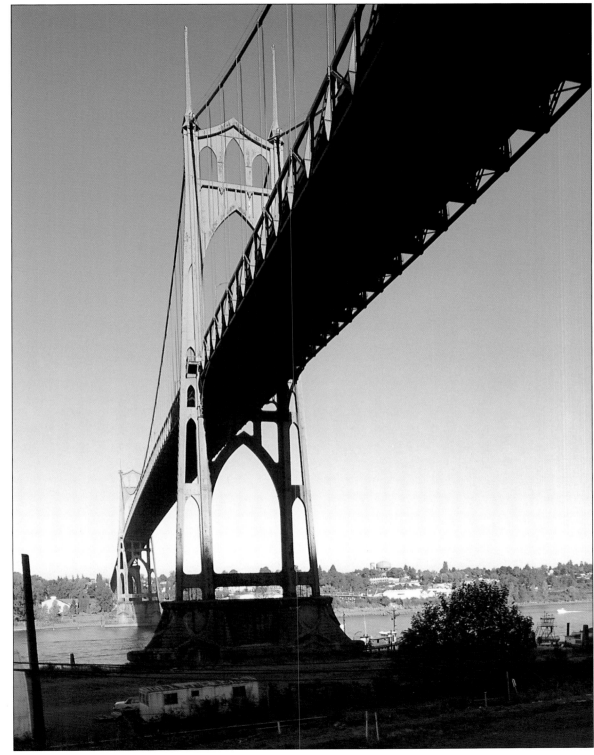

The St. John's Bridge towers remain true to the "verde green" color specified by the bridge designer more than seventy years ago, and the structure continues to serve as the only direct connection between the Peninsula area and West Portland. Although the record-setting length of the St. John's has been eclipsed by later suspension bridges, the structure remains the only major bridge of this type in the state. Multnomah County transferred it to the Oregon Department of Transportation in 1976.

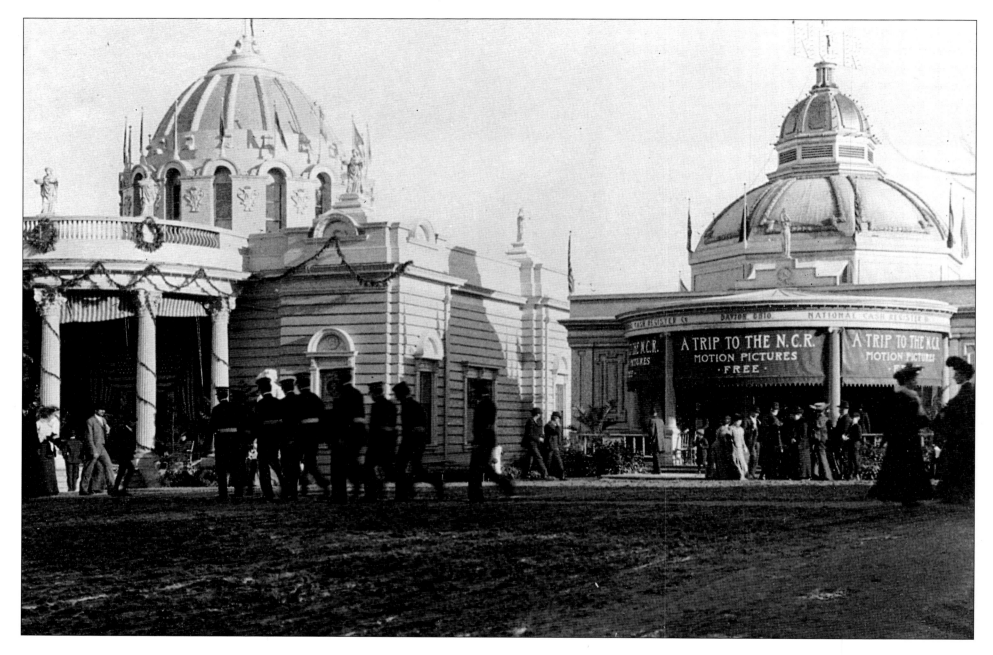

The National Cash Register Company Building (*right*) was a popular site at the 1905 Lewis and Clark Exposition, where it offered stereoptican and motion pictures to the public. According to one account, "No feature at the whole exposition attracted more attention than this lecture pavilion." When the fair closed, barges carried the structure down the Willamette to the bottom of Richmond Street, where horses hauled it uphill to its present site. *Oregon Historical Society, # OrHi 59768*

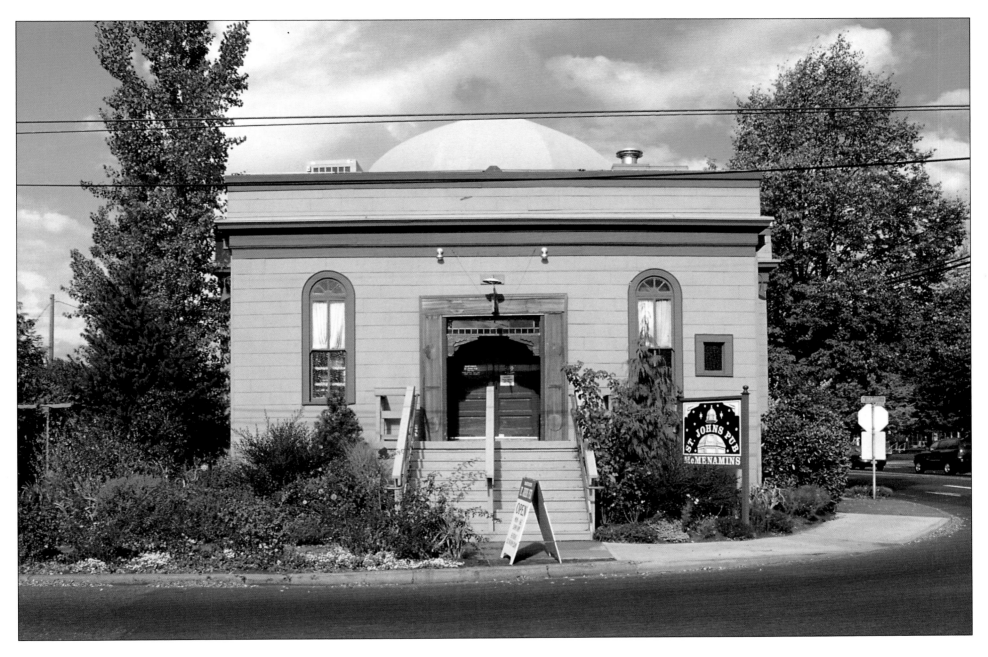

After it was moved to the corner of North Ivanhoe and Richmond streets, the cash register building served a variety of functions—as a Congregational church, Lutheran church, Odd Fellows Hall, YWCA, and American Legion Post 98. The building persevered through these changes, although it lost its distinctive cupola. In the 1980s the structure was converted to a pub and is now the McMenamins' St. Johns Pub.

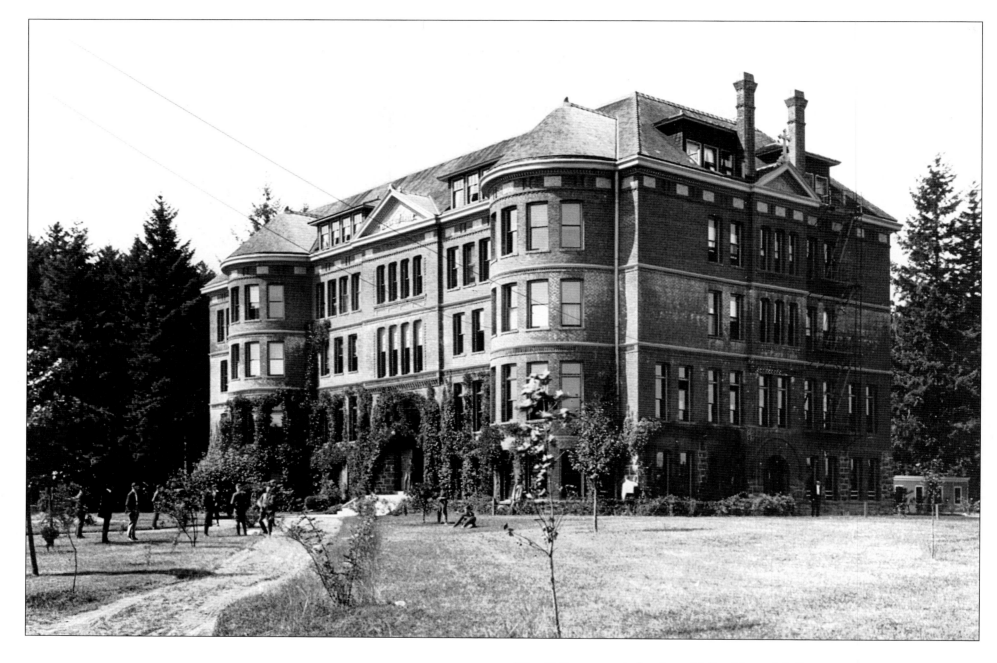

West Hall, patterned after Sever Hall at Harvard College, is a classic example of the Richarsonian Romanesque style of architecture popularized in the late nineteenth century. Built in 1891 for Methodist-affiliated Portland University, the hall housed the entire institution. A few years later, financial crisis forced closure, but in 1901 the Congregation of the Holy Cross, which founded Notre Dame University, bought the school and renamed it Columbia University. *Oregon Historical Society, # OrHi 24307*

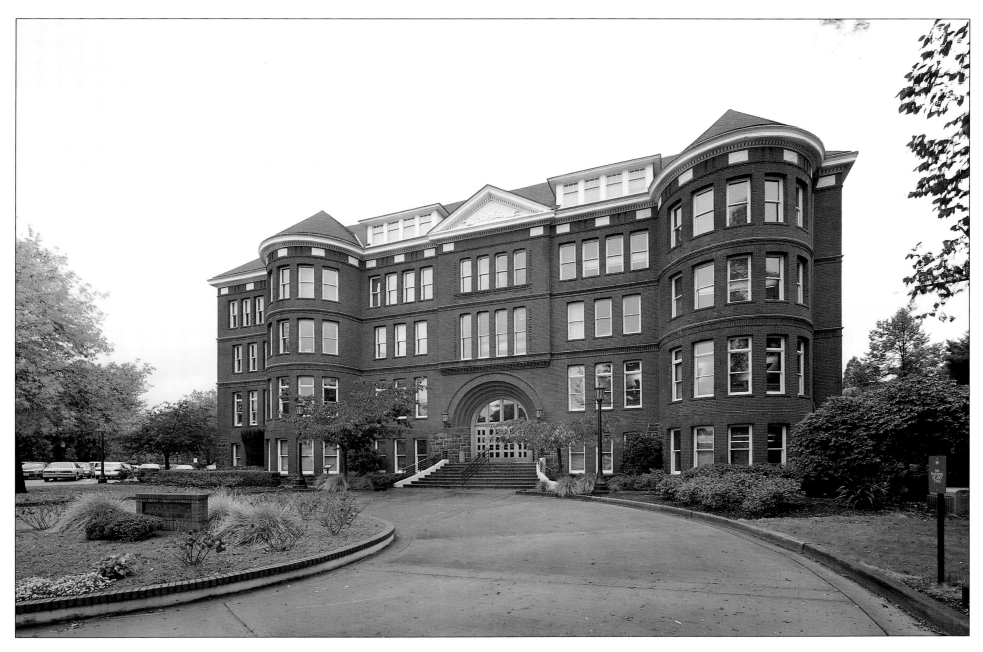

In 1935 the university was renamed the University of Portland, and in the 1960s it began operating under lay leadership. In 1992 West Hall was renamed Waldschmidt Hall, commemorating Oregon bishop and former university president Paul Waldschmidt. Today, the hall continues to function as the university administration building, although three of its rooms are still used as classrooms. The building is listed on the National Register of Historic Places.

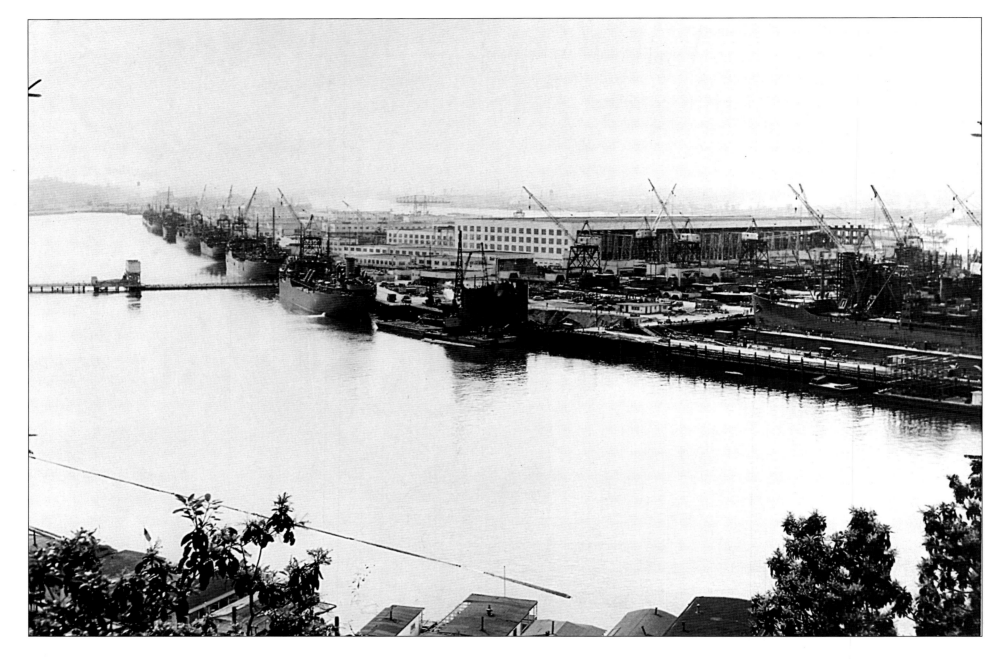

In 1921 the Port of Portland acquired 253 acres on Swan Island, and by 1927 it had built the city's first municipal airport. In less than a decade, the airport was declared obsolete, but soon the property was leased to the U.S. Maritime Commission for construction of Kaiser Shipyards, which produced 147 T2 tankers for use in World War II. The first ship was built in a record ten days.
Oregon Historical Society, # OrHi 76663

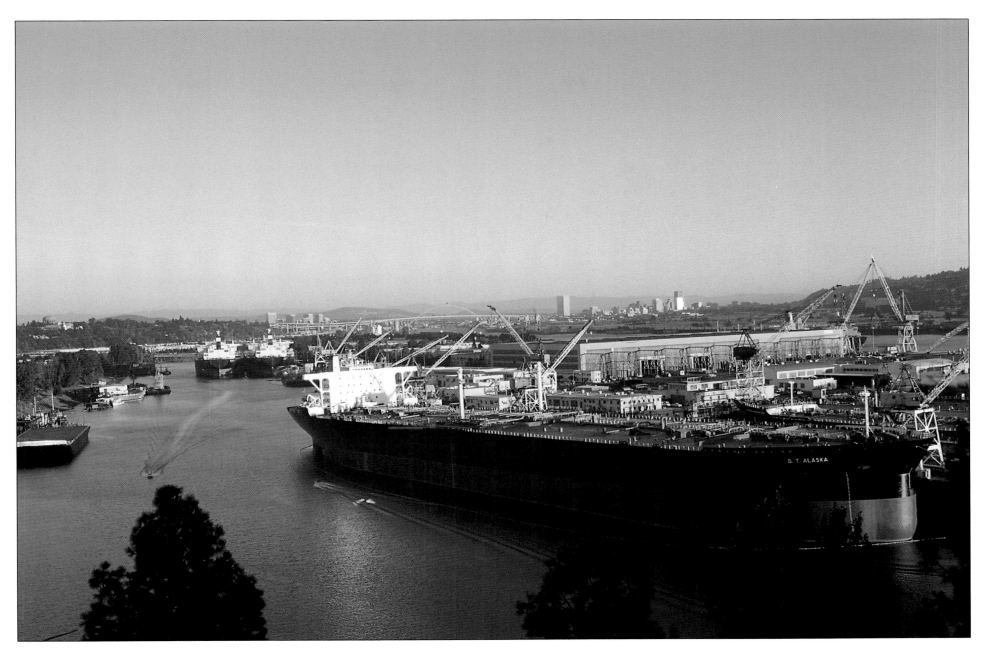

At the war's end, Swan Island was envisioned as a major industrial area, so the Port of Portland reacquired the island and purchased improvements from Kaiser Shipyards. The property has since thrived as an industrial site, with shipping interests figuring prominently among almost 100 Swan Island businesses that together employ some 7,000 workers.

INDEX